RUBENS

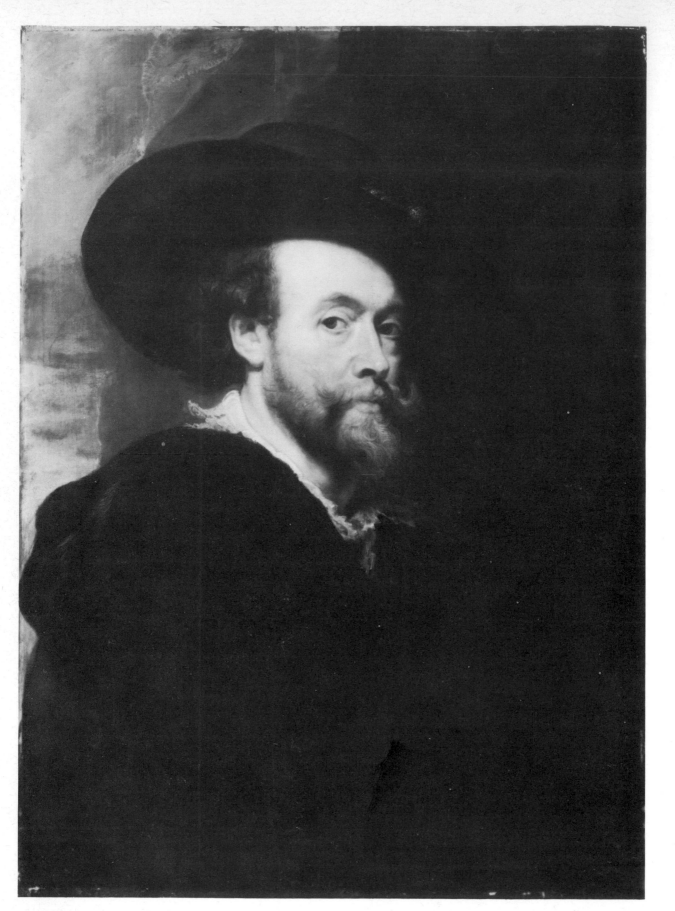

1 **Self-Portrait** *Signed and dated* 1623 Panel 86 × 62 *Windsor Castle*

RUBENS

by Kerry Downes

1980

JUPITER BOOKS

FOR MICHAEL FRANKS

First published in 1980.
JUPITER BOOKS (LONDON) LIMITED
167 Hermitage Road, London N4.
ISBN 0 906379 04 0

Printed and Bound in Great Britain by
Tonbridge Printers Limited.

PREFACE

I am indebted first of all to Michael Franks and the late Johannes Wilde. Then to Robert Oresko who originally commissioned this book and who made me think about what I really meant. Among my colleagues, to Peter Fitzgerald and Harry Redman for helpful conversations and wise judgements; likewise to Neil MacGregor who also read the first draft. I would also thank especially the late Count Antoine Seilern, Allan Braham, Kristin Belkin-Lohse, David Bomford, Christopher Brown, David Freedberg, Elizabeth McGrath, Sir Oliver Millar and Frank Simpson in London, and Rocío Arnáez (Madrid), Björn Fredlund (Göteborg), Katharine Fremantle (Hollandsche Rading), Jan van Gelder (Utrecht), Frances Huemer (Chapel Hill), Ulla Krempel (Munich) and Christoph Thoenes (Rome) all of whom helped with information or with particular problems or with access for study. Thanks are due, although in the end I worked over the subject again, to Jeremy Wood for his analysis of the Jesuit ceilings. The Research Board of the University of Reading made a grant towards travelling. My wife, constant companion in travel and discussion, not only accepted exceptional clutter and a rampant garden but also typed the whole manuscript in both its first and its final forms.

Plate 1 is reproduced by gracious permission of Her Majesty the Queen; the publisher and author would also thank all those owners who have allowed the reproduction of works in their charge. Photograph credits are due to: A.C.L., Brussels (XII, XXXII, 2, 32, 46, 68–9, 71–2, 74–5, 83, 98); Archives Photographiques (61–2); BBC, London (XXXI); Edelmann, Frankfurt (81); Frequin, Voorburg (18, 53); Gabinetto Fotografico Nazionale, Rome (43–5); Giraudon, Paris (63); Mangin, Nancy (41); Meyer, Vienna (V, XXIV, XXV, XXVII); National Gallery (1, 99, 100); Photo Studios, London (52); Piccardy, Grenoble (42); Gerhard Reinhold, Leipzig-Mölkau (VI); Walter Wachter, Schaan (25, 29).
Note: in measurements, which are in centimetres, height precedes width. Pictures are in oil and drawings are on white paper unless otherwise noted in the captions.

CHRONOLOGY

1577 *28 June.* Peter Paul Rubens born to Jan Rubens and Maria Pypelinckx at Siegen, Westphalia. The surname was originally spelled *Ruebens;* the change was probably based on the Latin form, *Rubenius.*

1578 The family moved to Cologne.

1587 *27 June.* Jan Rubens died. Subsequently the family moved to Antwerp.

1590 Peter Paul left Verdonck's school in Antwerp and became page to the Countess de Ligne.

1591 In Tobias Verhaecht's studio *c.* 1591.
 October. Isabella Brant born.

1592 Approximate date of apprenticeship to Adam van Noort.

1596 Approximate date of move to studio of Otto van Veen (Vaenius).

1598 Master in Antwerp Guild of St Luke.

1600 *9 May.* Left Antwerp for Italy.
 July. Venice, Mantua.
 October. Florence. Attended proxy marriage of Marie de' Medici to Henri IV of France.

1601 *July.* In Rome until April 1602.

1603 *March–December.* Journey to Spain.

1604 Returned to Mantua via Genoa.

1605 *May.* Completed pictures for SS. Trinità, Mantua.
 November. Rome.

1606 Genoa and Rome all year.

1607 Genoa and Rome.
 March. Vincenzo Gonzaga bought Caravaggio's *Death of the Virgin.*
 June. Completed first Chiesa Nuova altarpiece.

1608 Rome.
 February. Contract with Fathers of the Roman Oratory for altarpiece for Fermo.
 19 October. Rubens's mother died.
 28 October. Left Rome on news of mother's illness.

1609 *Adoration of the Kings* for Antwerp Town Hall.
 April. Twelve Years Truce began.
 23 September. Appointed court painter to the Regents.
 3 October. Married Isabella Brant.

1610 *June.* Commission for St Walburga altarpiece.
 November. Bought site for house on the Wapper.

1611 *21 March.* Clara Serena Rubens born (daughter).
 Commission for *Deposition* altarpiece.
 28 August. Philip Rubens died (brother).

1612 *June.* Visited Leiden and Haarlem.
 November. Writing letters for Jan Brueghel.

1614 *1/6 April.* Helena Fourment born.
 4(?) June. Albert Rubens born (son).

1615 Foundation stone laid of Antwerp Jesuit Church.

1616 Moved into house on the Wapper.

1618 *March.* Nicolas Rubens born (son).
 April. Began dealings with Sir Dudley Carleton.

1620 *29 March.* Contract for Jesuit Church ceilings.
 July. Portrait of Lady Arundel.

1621 *February.* Jesuit Church ceilings completed.
 April. Twelve Years Truce ended.

1622 *January–February.* Paris. Medici cycle commissioned.
 November. Four *Constantine* cartoons reached Paris.
 Palazzi di Genova published.

1623 *May.* Ill with a bad foot.
 May–June. Paris, with nine Medici pictures.
 October (?). Clara Serena Rubens died (daughter).

1624 *Adoration of the Kings* for St Michael, Antwerp.
 June. Ennobled by Philip IV of Spain.

1625 *February–May.* Paris. Medici cycle completed.
 May. Attended proxy marriage of Henrietta Maria to Charles I of England. Met Duke of Buckingham.
 July. Infanta Isabella visited Antwerp studio.
 August. Moved to Laeken near Brussels until February 1626.
 September–October. Diplomatic missions to Dunkirk and the German border.

1626 *20 June.* Isabella Brant died (wife).
 November. Sold collection of Antique sculpture and some paintings to the Duke of Buckingham.
 December. Calais, Paris.

1627 *July.* Holland, Delft, Amsterdam, Utrecht, with Balthasar Gerbier and Joachim Sandrart.
 Designs for *Eucharist* tapestries.
 Retouched *Raising of the Cross* in St Walburga according to contract.

1628 *Madonna and Saints* for St Augustine, Antwerp.
 28 August. Left Antwerp for Madrid.

1629 *May.* Brussels via Paris; London via Dunkirk.
 October. M.A. Degree conferred at Cambridge.

1630 *3 March.* Knighted by Charles I at Whitehall.
 6 April. Antwerp.
 November. Treaty signed between England and Spain.
 9 December. Married Helena Fourment.

1631 *July.* Knighted by Philip IV.
 September. Marie de' Medici visited Rubens in Antwerp.
 December. Mission to The Hague.

1632 *18 January.* Clara Johanna Rubens born (daughter).
 February. Completed St Ildephonsus altarpiece.
 August. Mission to Maastricht via Liège.

1633 *12 July.* Frans Rubens born (son).

1634 *August.* Whitehall ceiling paintings completed.

1635 *April–July.* Ill with gout.
 17 April. Entry of Cardinal-Infante Ferdinand to Antwerp.
 3 May. Isabella Helena Rubens born (daughter).
 12 August. Bought the castle of Steen at Elewijt near Malines.
 October. Whitehall paintings dispatched.

1636 *April.* Appointed court painter to Cardinal-Infante Ferdinand.
 Commission for Torre de la Parada paintings.

1637 *1 March.* Peter Paul Rubens born (son).

1638 *May.* Torre de la Parada paintings reached Madrid.
 June–July. Ill with gout.
 July. Designs for triumphal car celebrating victory at Calloo.
 October. Seriously ill.

1639 *August.* In good health.

1640 *January.* Onset of further attacks of gout.
 9 May. Last known letter, from Antwerp to Lucas Fayd'herbe.
 27 May. Made new will.
 30 May. Died in Antwerp. Buried in St James.

1641 *3 February.* Constantia Albertina Rubens born (daughter).

1642 Sale of collections.

1644 Helena Fourment married Jan Baptist van Broeckhoven, later Count of Bergeyck.

1657 Sale of drawings.

1 LIFE AND CHARACTER

Peter Paul Rubens is one of those artists to whom it is impossible to be indifferent. In his lifetime praise was nearly universal, and it became a cliché to call him the modern Apelles, the re-incarnation of the most famous painter of Antiquity. The scholarly Dutchman Constantijn Huygens called him one of the wonders of the world, praising particularly a Medusa head that was so graceful but also so horrible that it was normally covered by a curtain. Late in the seventeenth century the French painter and critic Roger de Piles, who is best known for his achievement in compiling a numerical table of merit for the great masters, acted as Rubens's champion in the French Academy against the admirers of Poussin, and awarded his hero a score of 65 out of a possible 80, a figure only matched by Raphael. Both during his life and after his death in 1640 Rubens's works were sought by collectors and princes, copied by pupils, by lesser painters on behalf of those admirers who could not afford or obtain originals, and, later, by artists like Watteau who wished to learn. For over a century the formulas he developed for narration, for the technique of painting and even for the act of vision itself were of value to generations of artists. In the later eighteenth century Sir Joshua Reynolds – who was a far more sensitive observer and painter than is sometimes allowed – recognized Rubens's merit in spite of, almost because of, what early Neo-classical taste saw as his faults. The enthusiasm of artists was matched by that of collectors, though Sir Thomas Lawrence counted as both. The energy of Rubens's compositions and the richness of many of his themes appealed to the Romantics, while the admiration of Delacroix for his mastery of colours and brushwork, and for his cultured prosperity, spread a new and somewhat tinted image of the great Antwerp master. Many an aspiring painter in the last hundred years has seen himself in a large-brimmed hat set at a jaunty angle like that in the self-portrait of 1623 which was painted at the request of Lord Danvers for Charles I as Prince of Wales (Plate 1); few, however, have achieved either the restraint of Rubens's depiction of himself, dressed in black and placed before a dark rocky background and grey clouds, or the brilliance and directness of technique visible in the florid complexion, slightly greying chestnut hair and beard, and the streak of pink in the sky over his shoulder.

An artist with such prodigious production and so long and copiously, if unevenly, documented a career would have been a gift to collectors and scholars alike even without being, as Rubens was, both a superb craftsman and a creative genius. On the other hand,

establishing the exact nature and boundaries of his creation presents problems that are endless and sometimes insuperable. Max Rooses's *oeuvre*-catalogue, begun in the ter- centenary year of the painter's birth and published in 1886–92, was no sooner finished than it needed additions and revisions, and the new Corpus Rubenianum, based on the late Ludwig Burchard's projected replacement for Rooses, and being undertaken by a whole range of scholars, is still very far from completion. At once there is an enormous obstacle to modern understanding of this artist, and paradoxically his popularity has decreased in the very century in which art history has come of age as a scholarly discipline – and first of all because the 'ordinary reader' who looks at art books and goes to galleries is not concerned with the minutiae of authenticity but with coming face to face with 'the essential Rubens'.

Rubens in fact is held to be a popular artist, because he is a household name and some of his images are extremely familiar and frequently admired (Plate xvii). Yet recently and often his popularity has been doubted, qualified and even denied. Because indifference is impossible many people do not like his works – and for a variety of reasons which are actually more significant of the artist than are the usual criticisms made of him. To start with, the romantic image of the artist in a large hat is now old-fashioned, and our contemporary idea of romance is a different one to which Rubens does not conform: he was rich, successful, learned, surprisingly reticent, well balanced, apparently totally without neurosis, and technically impeccable. Then there is the difficulty (since the Renaissance taught us to value the immediacy of the autograph work) of distinguishing between those pictures in which his own handiwork speaks directly to us and the workshop productions which can convey only general forms and intellectual ideas. Even in the autograph works Rubens's education and beliefs can come between painter and beholder. Few of us are at all familiar with the range of ideas with which he grew up, ideas drawn from the Bible, the lives of the Saints, the teach- ings of the Roman Catholic Church of the Counter-Reformation, the greater and lesser classics of Greek and Roman literature and the glosses of Renaissance scholars upon them, and a range of natural history which was at once more comprehensive and far simpler than our own view of the sciences. His century was an age of doubts and disasters as much as our own. The Antwerp of his youth had seen ruthless plunder, massacre and exodus; in his maturity the city was dying on its feet. He lived through two-thirds of the Thirty Years War. Yet life for him was regulated by a great awareness of elementary certainties: the authority of God, the Church, monarchy and parents (Plate 26), the recurring succession of the seasons (Plate xxviii), the certainty of Truth itself, and finally the Four Last Things, Death, Judgement, Heaven and Hell (Plate 82). If we are not disposed to allow the authority or the optimism of the ideas for which he was so often commissioned to form images, if we simply cannot make out what is happening in his pictures, then only formal values are left to us: composition, scale, draughtsmanship, colour and form.

Then again, composition can often be understood only in relation to the ideas to be con- veyed (Plate xix); scale in itself can be disturbing when it involves massive groups of figures rather than, as with some modern artists, abstract areas of colour. We are more disposed to distrust virtuosity in representational art and conventional perspective than to admire the

skill with which Rubens could place an arm or a foot both on the page and in space (Plate 51). Colour can only speak clearly to us in originals, not through even the best of transparencies and prints; form properly means the human figure, and presents the most fashionable stumbling-block of all. The part played by models of various kinds in Rubens's working methods is not fully understood, and will be discussed later (p. 153), but at the outset three comments are desirable. First, it is unfair to blame Rubens for observing the conventions of his own time and place in regard to the construction and cladding of the human figure. Second, much of this particular kind of criticism is based on hearsay, not on observation. Third, there is a singular unsubtlety in the fact that his 'fat women' are condemned, never his muscle-bound men or his smooth androgyne angels.

Since preaching is always either to the converted or to the receptive, it is only of service in bringing about a re-examination of the subject. Rubens's greatness, other than as historical fact, is perhaps a matter of insurance values and gallery attendances; it does not need to be established or re-instated. What matters, for as long as we value what the past has to say to us, is the possibility of our receiving his message with the greatest clarity and the least interference in transmission. What is needed is a good connection between the terms in which he saw himself and those to which we are limited by our own condition; to know where the transmission is obscured or weak is the first step towards improving it.

The story of Rubens's birth is dramatic enough. The painter's father Jan (1530–87) came from an Antwerp of small tradesmen in what was still a prosperous city. Of the possible steps up the social ladder he took not wholesale trade but the intellect, completing his studies in Italy with a doctorate in civil and canon law. In 1561 in Antwerp he married Maria Pypelinckx and in the following year he became an alderman; soon Jan joined the growing number of converts to Protestantism in the city. The Low Countries were part of the hereditary empire of the Spanish Hapsburgs; whereas the Emperor Charles V was identified as a European and prepared to compromise with the Reformers, the rigidly Spanish and Catholic attitudes of his son King Philip II precipitated demands for both political and religious self-determination. In Antwerp Cornelis Floris's huge new Town Hall was begun in the year of Jan Rubens's marriage and finished in 1566; that same year Antwerp suffered a wave of violent iconoclasm, and in 1567 the city was forcibly 'pacified' in the name of the Spanish king by the Duke of Alva. In 1568 William I of Orange-Nassau (William the Silent) began the interminable war, whose conclusion was not ratified until the peace of Münster in 1648, but which resulted before the turn of the century in the virtual separation of the northern United Provinces – which we now call Holland – from the Spanish, Catholic, southern Netherlands, or modern Belgium. In 1568 also Jan and Maria Rubens and their four young children left for Cologne, where Jan's profession and a degree of religious dissimulation in an alien community made them relatively safe.

But through a compatriot Jan became legal advisor to William the Silent's estranged wife Anna of Saxony, who had also moved to Cologne at about the same time. The unfortunate and unbalanced princess, 14 years his junior, made immoderate demands first on the time of her lawyer and then on his fidelity. In March 1571 the princess was pregnant:

Jan was arrested and confessed his part in the affair. For adultery the penalty might well be death; Anna demanded it for herself and for Rubens, but the injured parties saw otherwise. Maria Rubens immediately offered her husband forgiveness, if he would accept it, in the spirit of the Lord's Prayer. At the same time she began a campaign of petitions, to any and all authorities, for her husband's life. Rubens was confined with reasonable civility at Dillenburg in Nassau as evidence for the divorce suit which William began against Anna. Maria Rubens's persistence and an enormous forfeit in bail secured first her husband's transfer in 1573 to nearby Siegen (where the family could be united though Jan was under house arrest) and ultimately, by degrees and further payments, his freedom.

The four children born to Jan and Maria before this episode have left little trace in history, in spite of hearsay that the eldest was a painter. The surviving sons of the reconciliation were Philip (born 27 April 1574) who became a scholar and lawyer like his father, and Peter Paul, who thus came to be born, on 28 June 1577 (the eve of his name-saints' day) in Siegen, although a few months later the family was allowed to return to Cologne. Jan died there in 1587 on the eve of Peter Paul's tenth birthday. He had been able to resume his practice, and had also returned to the Catholic faith, in which the sons were brought up. Maria and her children soon – although we do not know how soon – returned to Antwerp. Their stay in Siegen was never mentioned, and they sought to blot out all memory of the events that led to it. They succeeded so well in establishing a record of unbroken residence in Cologne that the truth remained hidden until 1853. The faithful Maria recorded on her husband's epitaph that they had lived together for twenty-six years without differences; the painter wrote that he had lived in Cologne until his tenth year.

For the Rubens family Antwerp was home, the source of their roots and traditions, and with the father's death there can have been little to detain them in Cologne. Nevertheless the Antwerp to which they returned was very different from the city they had left. The 'Spanish Fury' of November 1576 had completed what the iconoclasts had begun ten years earlier: mercenaries, in mutiny against a bankrupt Spain, sacked the city, burning about a third of it and killing six or seven thousand inhabitants. In 1583, when the city was officially Protestant and William the Silent was in control, his ally the Duke of Anjou attempted a *coup* on his own account. The recapture of Antwerp in 1585 by Alessandro Farnese, Duke of Parma, set the seal on Belgium's Spanish and Catholic allegiance and led to a second Protestant exodus from the city: in two decades the population of Antwerp decreased from 100,000 to less than half that number. Moreover the city was entering a period of economic decline that was to last two centuries. For in answer to the Duke of Parma the United Provinces effected what became a permanent blockade of the River Scheldt, crippling the great port and with it the whole commerce of the city.

However, there were to be hopeful signs. The Eighty Years War approached stalemate though not resolution; the fighting moved out of Flanders and Brabant, and Philip II sought other means of saving at least part of his northern empire. In 1596 he appointed his cousin Archduke Albert of Austria to the Regency of the Netherlands; two years later, just before his death, Philip betrothed his daughter Isabella to Albert, with the southern Netherlands

as her dowry (Plates 19, 20). This kindly, conscientious, enlightened and cultured couple took possession of their nominally independent country in 1599; they resided in Brussels, and for a third of a century (he died in 1621, she in 1633) they ruled with a fairness and devotion so strong as to cushion their realm against the hidden strings which still bound it to Madrid (p. 15). Relieved of the strain of international status, Antwerp relaxed as a provincial city; she still had great resources, culturally and even financially. The return of the religious orders after 1585, and the beginning of a new and more optimistic phase of the Catholic Counter-Reformation, led to a massive campaign of restoration and new building of churches. The works of art destroyed in 1566 or removed in the second, more orderly, iconoclasm of the 1581 Calvinist City Council, were replaced by images designed to inspire the faithful by their beauty, instruct them with clarity and encourage them by example. Antwerp continued to be the home of artists and scholars, and of specialist families such as the Moretus, printers and publishers, and the Ruckers, harpsichord makers. The establishment of a royal court at Brussels by Albert and Isabella was also to set new artistic standards for Rubens's time; early in the new century they summoned to their service the artist and architect Wenzel Cobergher, and in 1609 Rubens was to become their most favoured servant.

After the Rubens family returned to Antwerp Peter Paul attended for some time the school near the Cathedral run by Rombout Verdonck, where he received a grounding in the liberal education of the time, which was principally the grammar, literature and thought of the Latin (and some Greek) classics. Rubens's erudition and intellect were later to impress contemporaries, and he had arrived at Verdonck's school with a taste and capacity for scholarship partly inherited and partly developed by his scholarly father and then by his elder brother Philip. In the autumn of 1590 he left school and shortly afterwards also left home, to become page to Marguerite de Ligne-Arenberg, widow of Count Philippe de Lalaing, at Oudenarde. The lad was soon disenchanted with petty court life and persuaded his mother to send him instead to live in Antwerp with, and learn painting from, Tobias Verhaecht (1561–1631), a kinsman by marriage. In about 1592 he moved to the studio of Adam van Noort (1562–1641), who is less known for his pictures than for his pupils; they numbered in all over thirty and later included Jacob Jordaens who was to hold the Antwerp stage after Rubens and Van Dyck were dead. Rubens probably stayed with Van Noort for the statutory four years of apprenticeship, transferring about 1596 to Otto van Veen (1556–1629), the most distinguished Antwerp painter of the time.

One of the current myths of genius is the devaluation of the influence of teachers on their greatest pupils, and it is important to remember that until he became a master in the Antwerp Guild of St Luke in September 1598 Rubens's education was not officially complete: the process was slow and its pace helped as much in developing the skills of the generality as in maturing the precocious few. Verhaecht, who specialized in the small landscapes for which the Netherlandish painters were famous even in Italy, would at least have taught his pupil the value of finely controlled drawing with the point of the brush. Van Noort was officially a portrait painter, and Rubens's first known inscribed and dated

work, a small portrait of 1597 on copper (Linsky Collection, New York, 21 × 14 cm.) of a man holding a compass, square and astrolabe confirms that he could have supported himself in that genre if his ambition had risen no higher. Otto van Veen, or Octavius Vaenius as he latinized himself in the humanist fashion, was altogether more substantial. He was of patrician birth like Rubens, he had travelled in Germany and to Rome, and besides his first-hand knowledge of Antiquity and the Renaissance he was conversant with Latin and with the language of emblems, on which he produced several books. What a young man of Rubens's intellect could learn from him was not limited to the finer points of painting. Art had for Vaenius something of the Italian Renaissance status of a gentle-manly and learned pursuit, and in craft-conscious Antwerp, this must both have reassured Rubens's mother and confirmed the direction of her son's progress. In the first half of the 1590s Peter Paul's study of Latin language, literature and thought continued with the help of his brother Philip, which although no doubt intermittent was the more significant be-cause Philip was then the pupil and protégé, at Liège and Louvain, of the great Latinist Justus Lipsius (Joest Lips, 1547–1606).

Vaenius's talent was considerable although it fell short of genius. In the last decade of the sixteenth century he arrived, like his Italian contemporaries Cigoli, Barocci and Cesari d'Arpino, at a style which combined the accumulated skills of Renaissance figurative paint-ing with a concern for clear pictorial legibility that was in itself a reaction against the Mannerist complexities and ambiguities of the preceding period. Vaenius's over-lifesize *Crucifixion of St Andrew* (Plate 2) in the Antwerp church of that saint was commissioned in 1594 but delivered only in 1599. Vaenius shows the saint, having preached from the cross to a huge crowd, about to give up his soul in a blaze of golden light as described in the traditional hagiology, the *Golden Legend*. Vaenius's smooth-limbed figures look rather marble-like, but he is able to organize effectively his picture on the surface and his crowd in depth against a background of Antique buildings. There is good observation in the horse's head and the leaping dogs on the right, and his colours are muted and concordant – pink, blue-green, ochre, plum, grey and purple.

Once he had graduated into the Painters' Guild, Rubens was entitled to set up his own studio, and he may have done so, though as there are early references to works of collabora-tion with Vaenius the two artists may have maintained a close business relationship. Attempts have been made in recent years to identify Rubens's work in the period 1598–1600; although it is not signed the most plausible as well as the most impressive attribution is the *Adam and Eve* now in the Antwerp Rubenshuis (Plate 1). Ever since Dürer's famous print of 1504, images of Adam and Eve had been used by northern artists to combine what were thought to be the classical canons of physical beauty with the moral message that the parents of mankind were perfect both spiritually and physically before their disobedience. Rubens certainly knew Dürer's engraving, but the poses are derived almost literally from a print of the subject by Marcantonio Raimondi after Raphael. Rubens gives the figures new life; his Adam is more muscular and more closely observed, and the head is turned out of pure profile to make the face more expressive. Eve is more idealized, perhaps because Rubens's

[6]

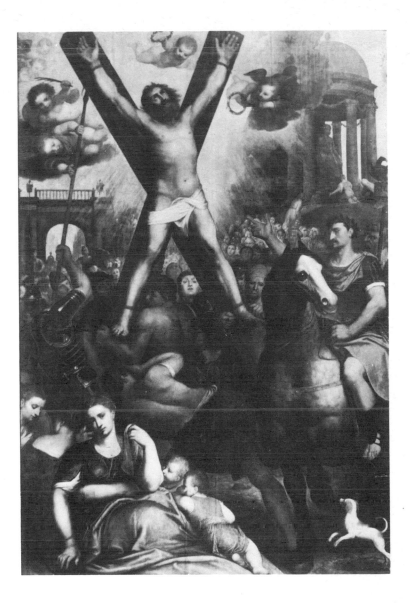

2 OTTO VAN VEEN (VAENIUS) (1556–1629)
The Martyrdom of St Andrew 1594–9
Canvas 437 × 287 *Antwerp, St Andrieskerk*

familiarity with the female nude was still limited; she is nevertheless softer and more sensuous than Vaenius's figures. Her raised hand encloses an apple as if she is about to bite it, and the close proximity of Adam's open hand to her arm – a gesture deliberately altered from Marcantonio – focuses the tension of the moment; the tips of the three bent fingers of Adam's left hand are characteristically highlighted. In the course of painting Rubens redrew the two juxtaposed forearms to make them thicker and more muscular, and in both figures – as elsewhere in his early work (Plate II) – he illustrates a personal observation that with a vertical light source nipples cast defined shadows. The discreet fronds are placed for propriety by Art, not by Nature or History, for the protagonists are here still in their last wavering moments of innocence, reflected in the strikingly beautiful paradise landscape, also absent from Marcantonio. The mysterious and intricate background, filled with trees, grassy slopes, water, birds and animals, is of a kind developed in the late sixteenth century

by painters, such as Coninxloo and Jan Brueghel, who worked on a much smaller scale. The panel has been cut at the top and the front part of the serpent is therefore missing.

Nothing is known of the early history of this picture, but it may be one of the works described as 'beautiful' which, according to Rubens's mother's will of 1606, he deposited in her house before leaving for Italy in 1600. We know no more about the history of the *Judgement of Paris* (Plate 11), which was probably painted shortly before Rubens's departure; on the other hand both the paint layers and external evidence tell us something about how this picture evolved. The story of the first beauty contest, between Juno, Venus and Minerva, has obvious pictorial attractions. It also has epic implications, since the offer with which Venus bribed Paris, son of Priam king of Troy, was the most beautiful woman in the world, Helen of Sparta; her abduction by Paris precipitated the Trojan War and the events of the *Iliad* and *Aeneid*. Drawings and an oil sketch (Vienna, Akademie) as well as painted-over changes in the picture itself, show that Rubens started by representing the incident in the story in which Paris, advised by Mercury to make his own rules for the contest he has been asked to judge, tells the goddesses to undress. Ultimately, however, Rubens chose the later and fateful moment when Paris awards the golden apple to Venus. From this decision ensued the great epics; history, time and nature are accordingly signified by the heavenly crowning of Venus, the attendant river gods and the satyr on the left.

Rubens here not only made use of a print after Raphael, but also borrowed the figure of Minerva, on the right, from a print of *Juno* by Rosso. The *putti* recall those of Vaenius, while the principal figures emulate Antique marble statuary. But this emulation seems to be the result more of enthusiasm than of knowledge; on the contrary the artificiality of colouring, in the dark blue-green landscape and the crimson flesh shadows, suggests that the picture was painted in Antwerp.

For Rubens in his twenty-third year the prospect of the new century cannot have been entirely clear. In the old medieval tradition of northern Europe a newly qualified master would travel to other cities to gain experience and seek commissions; indeed Rubens may have made or considered such excursions. But at the same time an idea must have been proposed to him by Vaenius or someone else, and once proposed it would have grown until it fully occupied his mind: the Mediterranean concept that has obsessed the North from Renaissance artists and patrons to twentieth-century art historians. Beyond the Alps lay a peninsula of city-states, republics, duchies and dependencies (like his own Netherlands) of the Spanish Hapsburgs, comprised geographically but not politically by the name of Italy, which offered a range of visual and intellectual experience totally different from anything in the North. For a young man with the desire to succeed, to learn and to paint pictures there was no choice. On 8 May 1600 he obtained from the Antwerp Council the customary traveller's certificate that the City was free from plague or other dangerous disease, and the next day he set off for the South: it would be over eight years before he returned.

Rubens still had much to learn, both in his art and in the school of life, but his education and character made him an apt and constant pupil. Before following his travels and his later life it is desirable, although not easy, to examine his character more closely. Of the vast

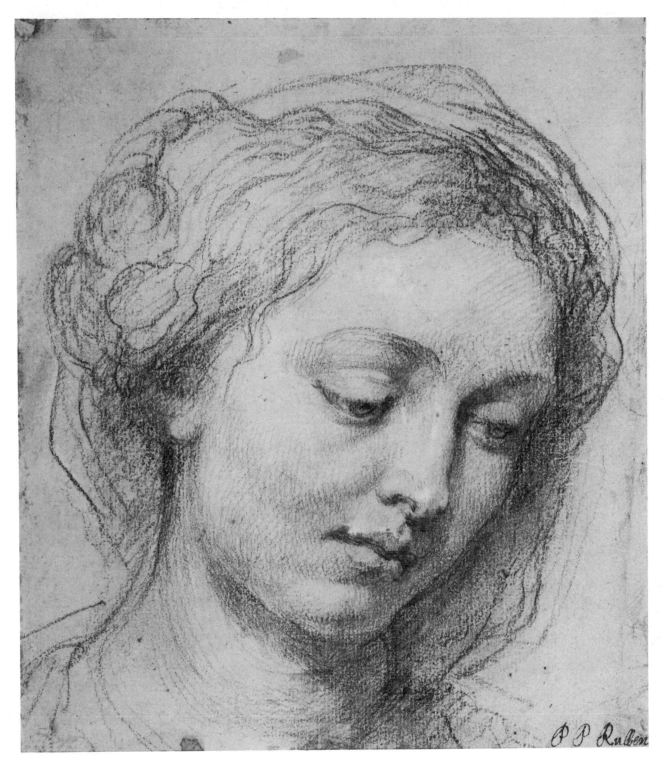

3 Study for the Head of the Virgin (Plate XXIV) 1630–31
Red and black chalk 19.3 × 16.7 *Vienna, Albertina*

number of letters, perhaps 8,000, he must have written during his life only about 250 survive, and three-fifths of those date from between 1625 and 1630 and are largely concerned with political and diplomatic matters. What the letters tell us about their writer, or the pictures about their painter, is scattered and incidental, and in consequence the distinction between accurate characterization and speculative historical fiction is a fine one. Contemporaries not only recognized his artistic talents but also clearly found him likeable, and he had the gift of endearing himself, as he did to the Regents, to Marie de' Medici in Paris, to Philip IV of Spain and even in 1628 to the haughty administrators of Madrid, who had considered a mere painter no fit person to engage in diplomacy. Indeed he had proved himself as a diplomatist on his first visit to Spain in 1603 on behalf of his employer the Duke of Mantua: he had tact, friendliness and a shrewd judgement of men and situations, and while he was not afraid to speak his mind when necessary he was used to saying less than he thought or knew. That habit he must have acquired in the difficult personal and religious circumstances of his childhood in Cologne and from his brief experience in the Countess de Ligne's household. He was not given to jokes, and what we know of his sense of humour is visual: the behaviour and attitudes of children and animals, or the wheel-barrow in the *Farm at Laeken* overflowing with vegetables like a cornucopia. He was normally rather solemn and often inscrutable; even his self-portraits are unrevealing, and few in number (only seven or eight originals) for so long and public a career.

By hard work, which he enjoyed, he developed and deepened a facility which is not very obvious in his earliest works; his drawings are sometimes magical (Plate 3) but never slick, and often betray the labour that is the greater part of genius. He enjoyed being, and being seen to be, successful; when Otto Sperling, a young Danish medical student, called on him in 1621, he found the painter 'just at work, in the course of which he was read to from Tacitus and moreover dictated a letter. As we did not disturb him by talking, he began to speak to us, carrying on with his work without stopping, still being read to and going on with the dictation'. The ancient scholar Pliny travelled in a litter so that a servant could read to him; for Rubens, who would have known this ancient precedent for saving time, the performance recorded by Sperling was probably habitual rather than a special display. Indeed, his nephew Philip, writing in the 1670s, recorded that after attending the first mass in the morning Rubens would set to work while an attendant read to him from Plutarch, Seneca or some other author.

His religious observance was thus evidently devout, although we can only deduce that its foundations were orthodox. While in the twentieth century great church music has been written by agnostics, Rubens's conviction of the realities of his faith shines from his pictures (Plate XXXII). As a scholar he naturally had close friends among the clergy (Plate 97), and no special importance can be attached to the fact that they included members of the Antwerp community of the Society of Jesus, the bogeymen of rationalist historians. The work on optics of the Antwerp Jesuit Superior, Father Aguilon, was known to him, and he worked with Father Daniel Seghers the flower painter, but his work for the decoration of the Jesuit Church in Antwerp was a regularly contracted commission rather than a sign of a special

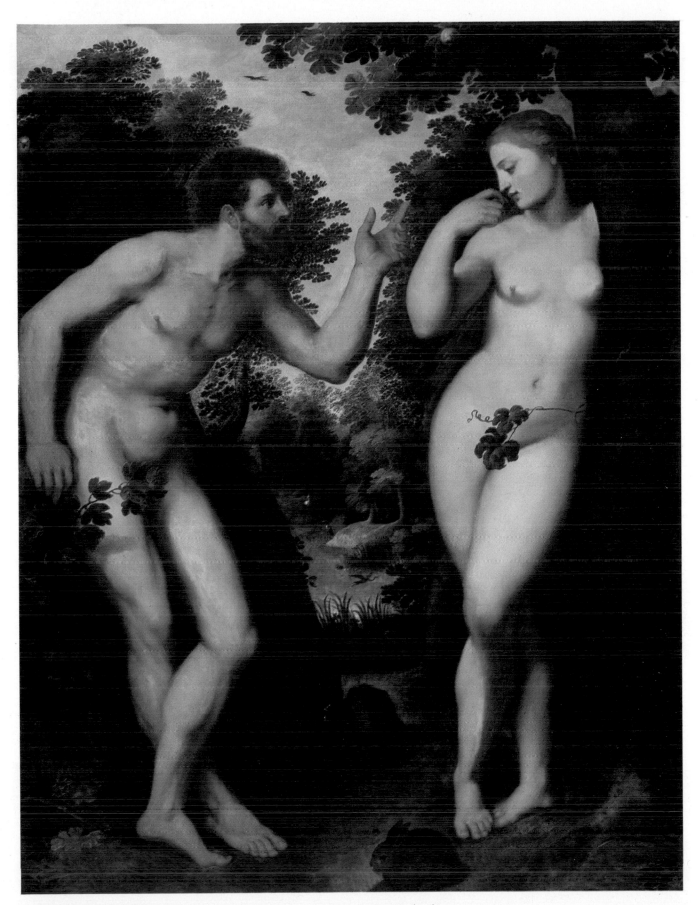

I Adam and Eve in Paradise *c.* 1599 Panel 180.5 × 133.5 *Antwerp, Rubenshuis*

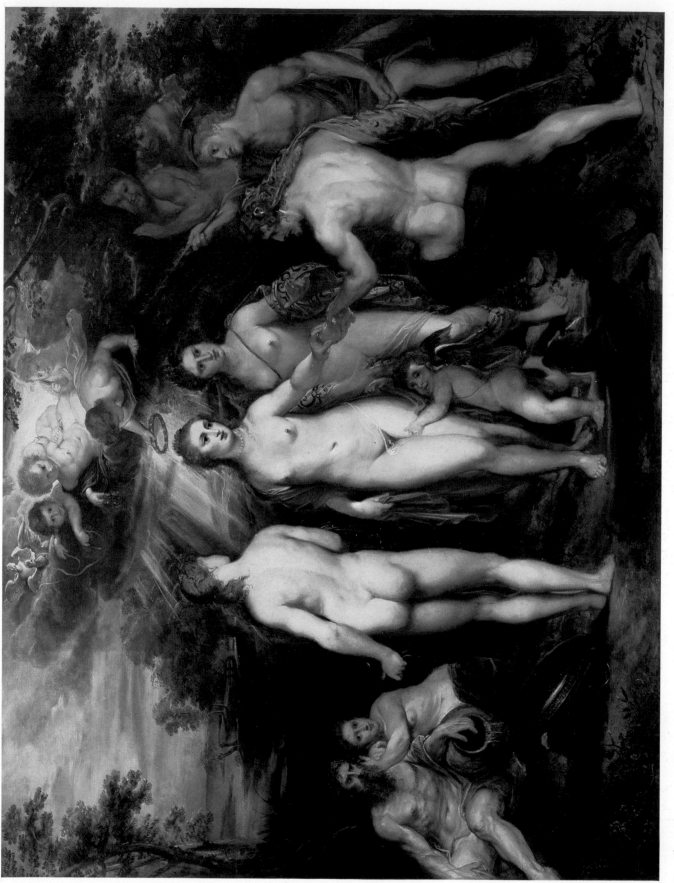

II **The Judgement of Paris** *c.* 1600 Panel 133.9 × 174.5 *London, National Gallery*

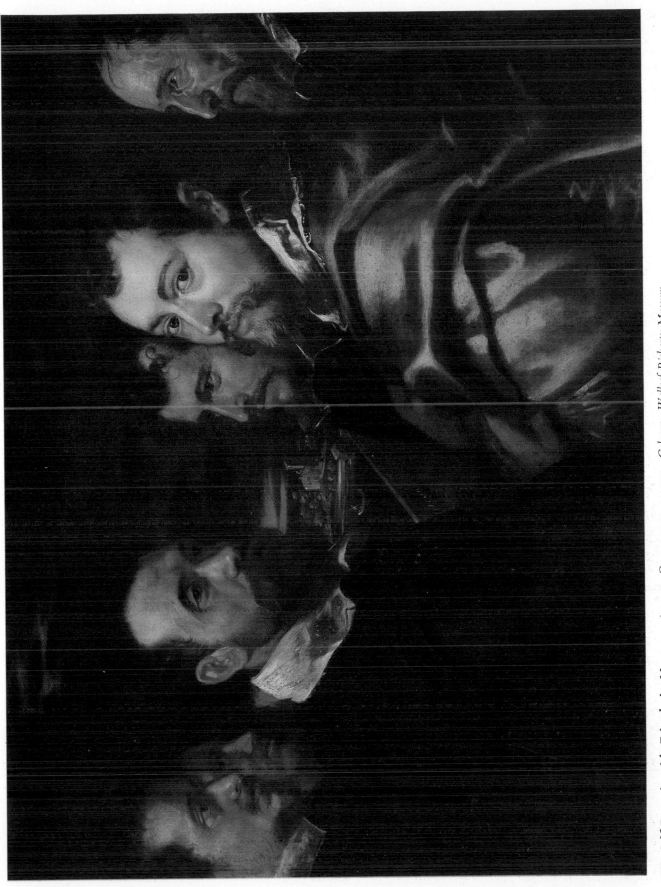

III **Self Portrait with Friends in Mantua** 1602–03 Canvas 77·5 × 101 *Cologne, Wallraf-Richartz Museum*

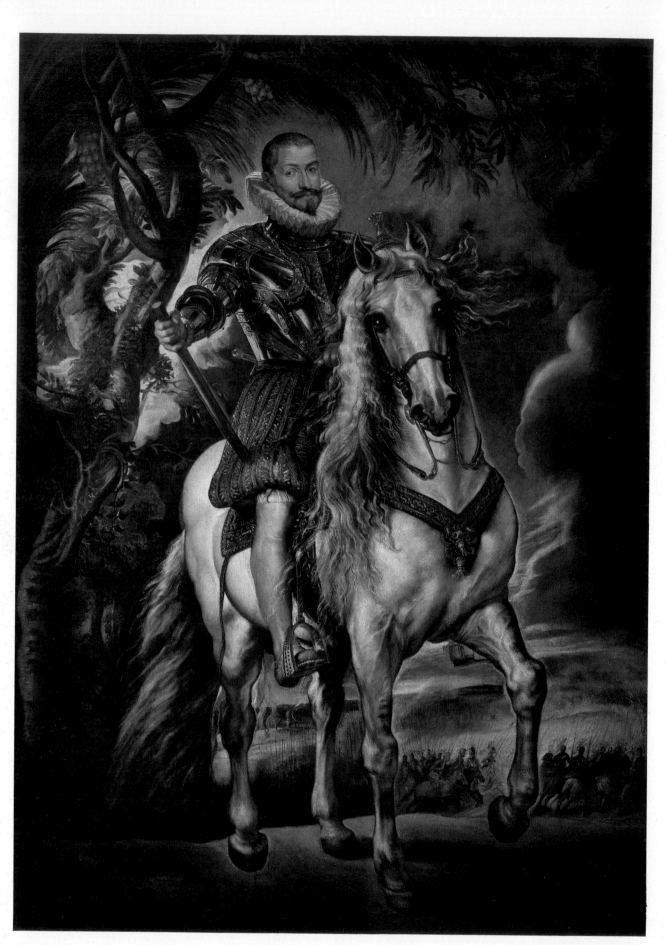

IV Francisco Gomez de Sandoval y Rojas, Duke of Lerma *Signed and dated* 16[03] Canvas 283 × 200 *Madrid, Prado*

V Francesco IV Gonzaga *fragment* 1604–05 Canvas 67 × 51.5 *Vienna, Kunsthistorisches Museum*

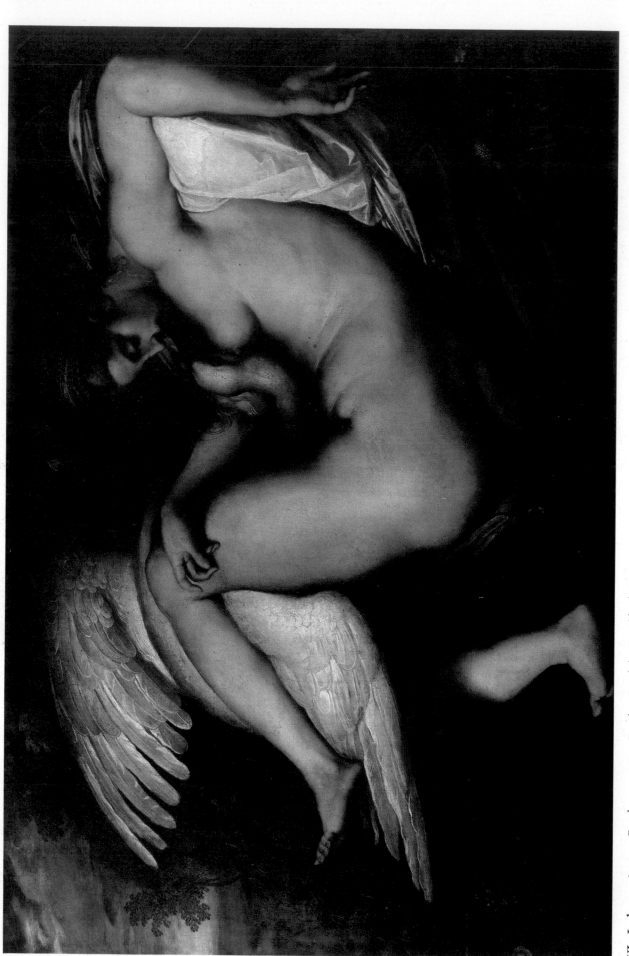

VI **Leda** *c.* 1601–02 Panel 122 × 182 *Dresden, Staatliche Gemäldegalerie*

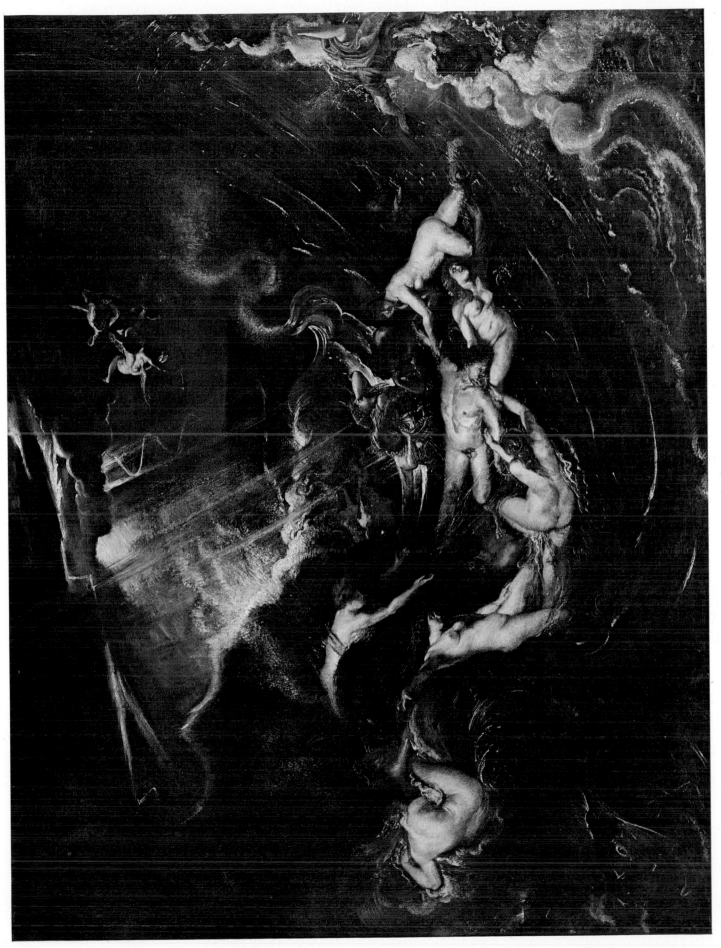

VII **Hero and Leander** c. 1605 Canvas 96 × 128 New Haven, Yale University Art Gallery

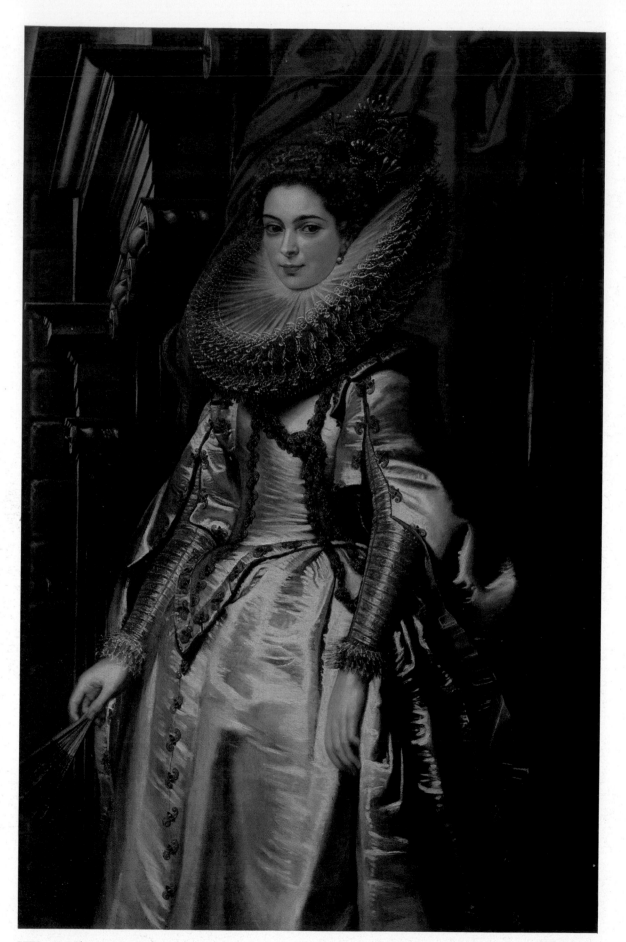

VIII **Marchesa Brigida Spinola Doria** 1606 Canvas 152.2 × 98.7 *Washington, National Gallery of Art*

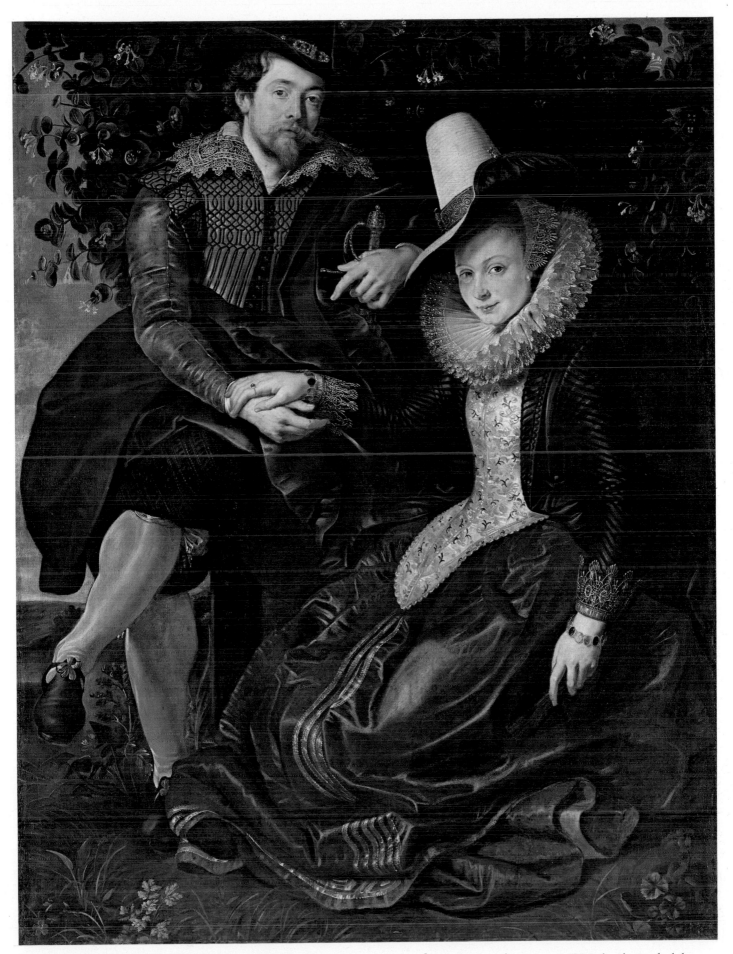

IX Rubens and Isabella Brant in a Honeysuckle Bower 1609–10 Canvas mounted on panel 178 × 136 *Munich, Alte Pinakothek*

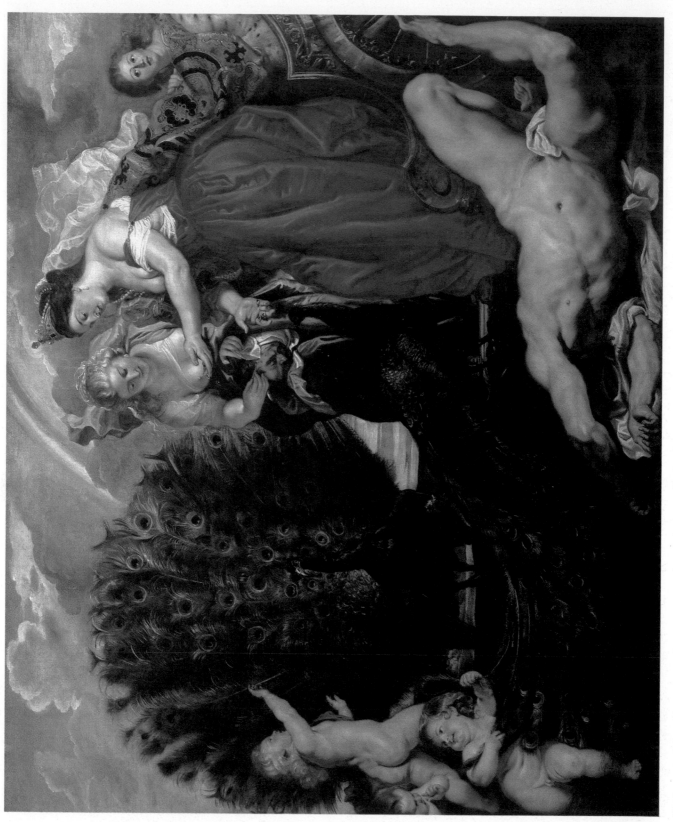

X **Juno and Argus** *c. 1610* Canvas 249 × 296 *Cologne, Wallraf-Richartz Museum*

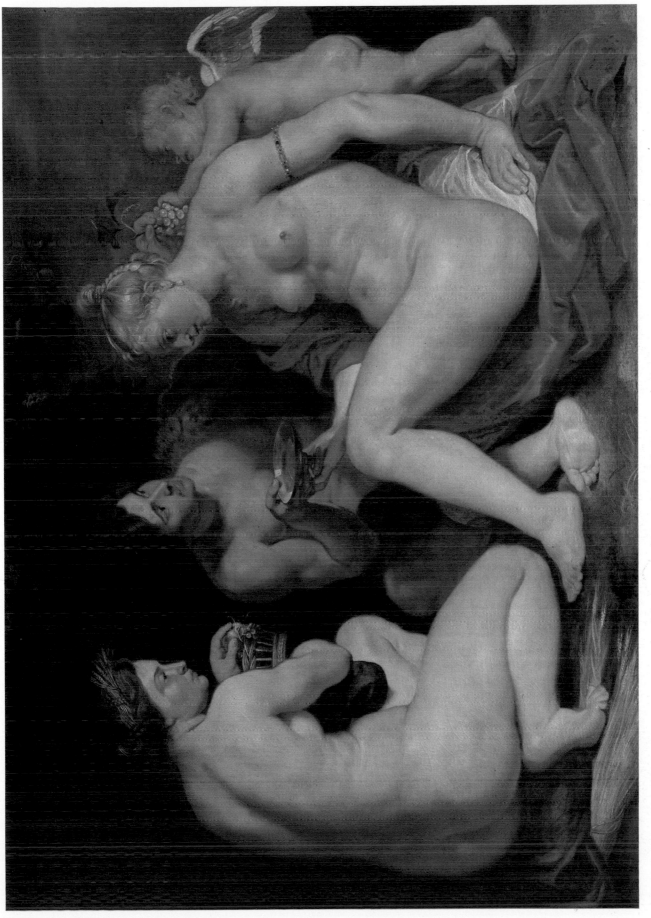

XI Venus, Cupid, Bacchus and Ceres *c. 1612–15* Canvas 140.5 × 199 *Kassel, Staatliche Kunstsammlungen*

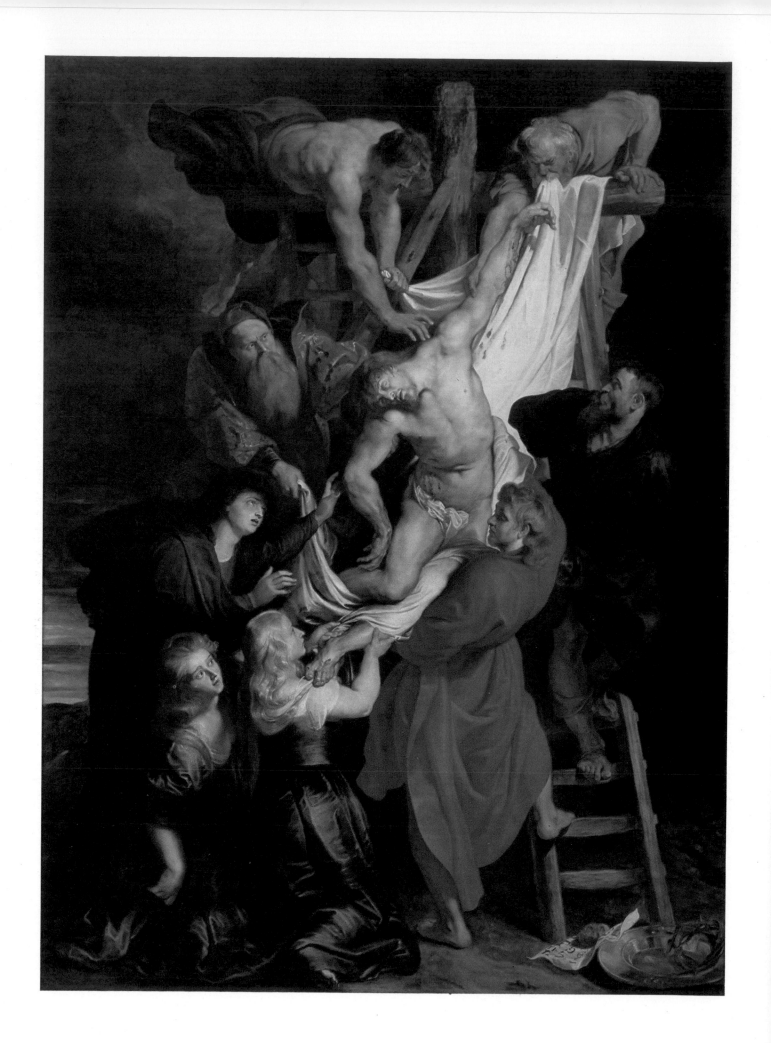

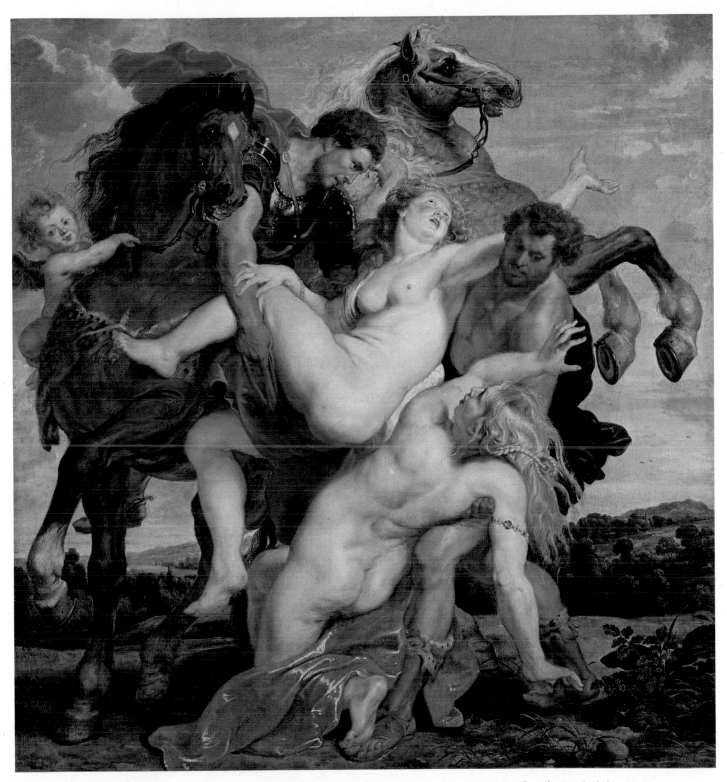

XIII **The Abduction of the Daughters of Leucippus** *c.* 1616 Canvas 222 × 209 *Munich, Alte Pinakothek*

XII *opposite* **The Deposition** 1611–14 Panel 420 × 310 *Antwerp, Cathedral*

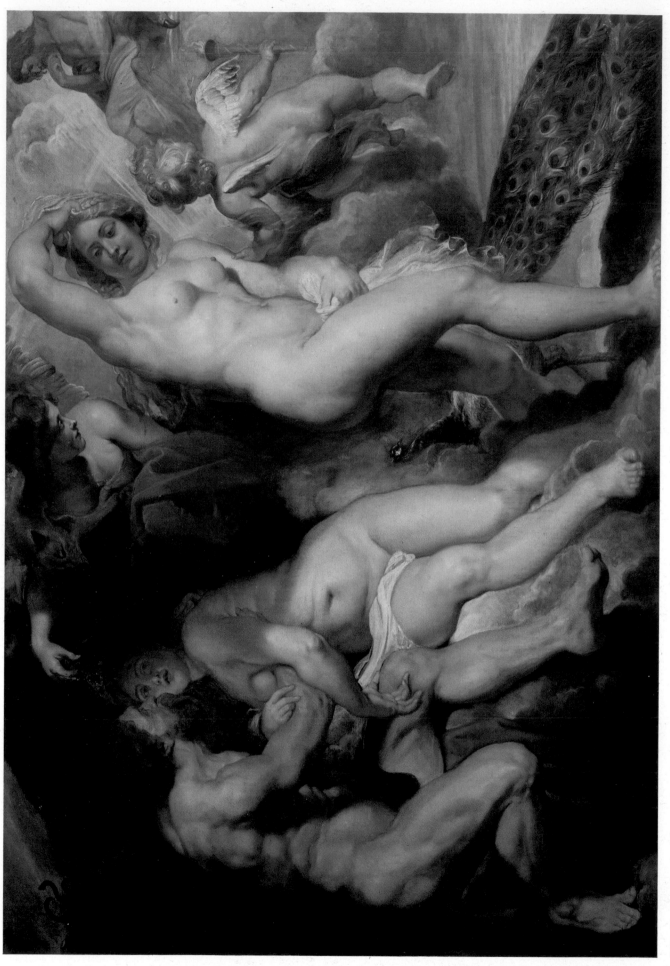

XIV Ixion Deceived by Juno *c.* 1615 Canvas 171 × 245 *Paris, Louvre*

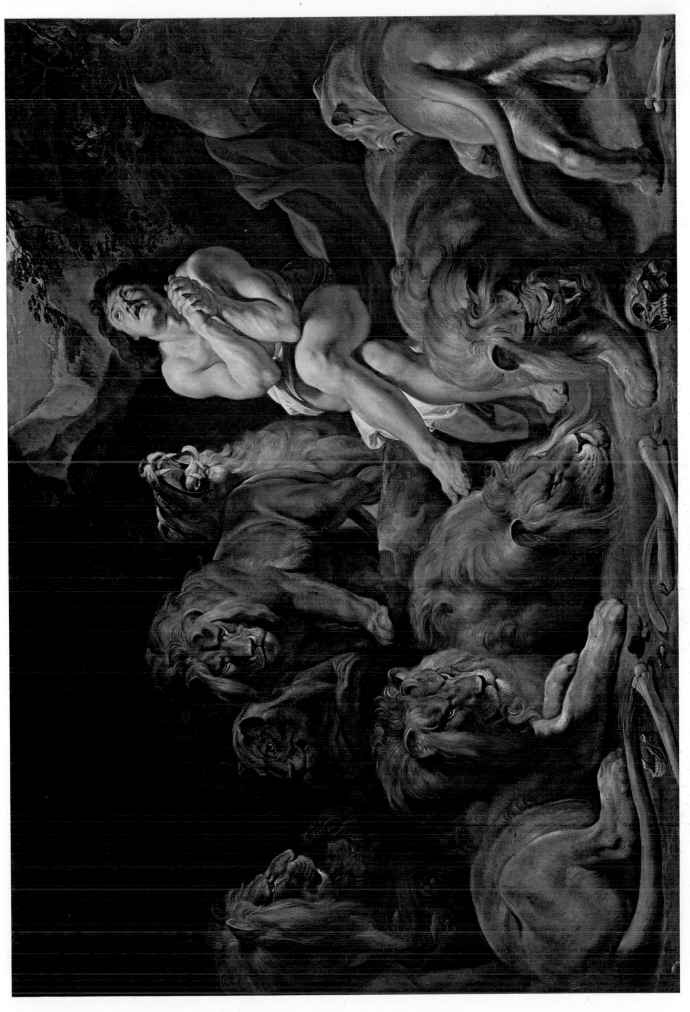

XV Daniel in the Lions' Den c. 1615–16 Canvas 224.3 × 330.4 Washington, National Gallery of Art

XVI Aletheia Talbot, Countess of Arundel 1620 Canvas 261 × 265 *Munich, Alte Pinakothek*

relationship between artist and patron (Plate 50). Rubens worked for others among the many religious houses in the city, and the fact that the Jesuit Church was so lavish as to provoke a rebuke from headquarters in Rome speaks rather of the persuasiveness of his artistic personality and the zeal of a community on the frontier of the Counter-Reformation than of the painter's personal involvement.

Rubens's character must have owed more to family influences than to outside ones. Until the age of ten he would have absorbed the learning and the wisdom, bred of experience, of his father; thereafter much would have depended first on his mother, whom contemporaries praised for her intelligence and devotion to her children, and afterwards on his elder brother. Through Philip, three years his senior and the favoured disciple of Lipsius, Peter Paul was the first great artist of the seventeenth century to absorb the ideas of Neo-stoicism. Lipsius sought to reconcile with Christianity the character exemplars of Plutarch and the philosophy of Seneca (Plate 70). While eschewing the pantheism of the Ancients and Seneca's suicide, he advocated stern gravity, the pursuit of goodness, the avoidance of extremes, self-control, the belief in Reason (mathematical and logical order), Virtue (moral order) and Nature (physical and temporal order) and the acceptance of Fate and the evils of Nature, such as disease and pests, as part of the Divine Plan. Unlike his brother, Peter Paul was probably never Lipsius's pupil, and perhaps never read any of his rather tedious moral writings. Nevertheless, he twice portrayed himself with the philosopher in imagined situations (Plates III, 21), and it was by these lights that he set the course of his life just as, in the writing of Latin prose, he adopted the laconic style which Lipsius had developed from Seneca, Tacitus and Plutarch – the three authors, incidentally, that we know were read to him.

Neo-stoicism would have reinforced a gravity that was inherited and a probity that was early inculcated. This amalgam is both illuminated and reflected by what we know of the most private side of Rubens's life. Until the end of his Italian period only one incident is recorded, and although his polemical friend Caspar Schoppe in recounting it used Rubens as a foil to denigrate another character, Daniel Lhermite, and may have exaggerated a story of high spirits, there is no reason to doubt its kernel. One day in 1606 on an excursion from Rome with some other young Flemings, Lhermite was the leader in obscene ribaldry and later in drawing graffiti in the inn at Tivoli; Rubens, like Schoppe, kept aloof from this behaviour. Neither of the Rubens brothers married until 1609, basically because like many of their class they were preoccupied with professional concerns. Their father had spent seven years in Italy and married at the age of thirty-one. In 1601 Philip followed his younger brother to Italy, the source of Antiquity; he was tutor to the son of Jean Richardot, President of Archduke Albert's Privy Council, but Philip also managed to take, as his father had done, a doctorate in laws. Though he returned to Antwerp in 1604 he was back in Rome the following year as librarian to Cardinal Ascanio Colonna. He found this employer uncongenial, and, in addition, his mother's health became a matter of concern; by November 1606 he had again returned to Antwerp, where in January 1609 he became one of the four Secretaries of the City. Now was the time to think of marriage and family, and on 26 March

Philip wed the daughter of Antwerp's First Secretary.

Peter Paul returned home late in 1608 a master of repute, and within a year was a privileged servant of the Regents. His reaction in April 1609 to Philip's marriage had been 'I myself will not dare to follow him, for he has made such a good choice that it seems inimitable'. However Philip's bride had not been easily won, and Peter Paul had helped to settle the match. He went on, 'I find by experience that such affairs should not be carried on coolly but with great fervour'. Six months later, on 3 October, he married his sister-in-law's eighteen-year-old niece, Isabella Brant, daughter of another of the City Secretaries and a fellow classicist (Plate 98). While the ambience of the match was one of scholarship and 'white-collar' success we should not under-estimate its romantic aspects. Certainly in the wedding souvenir (Plate IX) while the painter's own portrait is concerned with his status and his future, that of his bride leaves no doubt that the Latin epithalamiums of his colleagues did not exaggerate her beauty. In 1626 she died, probably of the plague, and stoicism did not suffice. Rubens wrote to Pierre Dupuy, 'I have no pretensions about ever attaining a stoic equanimity; I do not believe . . . that one can be equally indifferent to all things in this world'. Yet even here, as he admitted Time to be his only helper, he clad his feelings in Latin tags. Three years later, writing in condolence to his friend Gevaerts, he switched from Flemish to Latin to press on him the consolations of philosophy. Rubens had sought solace in travel and in diplomatic service, but on 6 December 1630 he was married again, to Helena Fourment, a beauty of sixteen he had known from her childhood (Plate 24). There is no doubt at all that this apparently unequal match was successful, fruitful and passionate. Rubens's only recorded comments are in the letter written four years later in which he brought his antiquarian friend Peiresc up to date after a silence caused by the embarrassments of politics: 'I made up my mind to marry again, since I was not yet inclined to live the abstinent life of the celibate, thinking that, if we must give the first place to continence, we may thankfully enjoy lawful pleasure. I have taken a young wife of honest but middle-class family [and] chose one who would not blush to see me take my brushes in hand'. Again he broke into Latin, quoting Sallust and paraphrasing St Paul. Again, although his pictures of the 1630s owe more to Titian than to his wife, they do say much more about her than his words.

These details are important because there is a common post-Romantic myth that artistic creativity needs release through a measure of sexual licence and a good deal of alcohol – Rubens's opinion of the latter figures in another discussion (p. 151). In our own time there is also a myth that cool thought is inimical to creation. Artists are as various as any other group of mankind; there are those who need to be wound up, those who need to unwind, and those for whom the conquest of indiscipline or other handicaps is a necessary catalyst. Rubens indeed lamented the 'idleness' of the Frankfurt painter Adam Elsheimer, because to Rubens, used to doing at least two things at once, the concepts of fruitful inactivity and periodic depression were foreign. Like Titian, he would turn a difficult canvas to the wall and continue with another. Richard Strauss, whose music has much of the same apparent facility in the finished product as Rubens's work, composed for three hours every

morning as a matter of discipline; what we do not know is how much he re-wrote or discarded. Inspiration is often a matter of application.

Rubens left Antwerp on 9 May 1600, probably going through Paris and Fontainebleau, and made for Venice, perhaps because Northerners feel at home there, perhaps because of a sympathy, still barely formed in his mind, with Titian, the greatest painter among sixteenth-century artists. By chance, according to his nephew, he met there, and showed his work to, a courtier of Vincenzo I Gonzaga, Duke of Mantua; the Duke engaged Rubens as one of his court painters. But the previous summer Vincenzo had been at Spa and in Antwerp, and had witnessed the Archdukes' entry into Brussels; if he heard of Rubens then, the engagement was less fortuitous than Rubens ever knew. Vincenzo seems to have collected Flemish artists, in addition to Rubens and an unidentified 'Jan' he added to his establishment in September 1600 the portraitist Frans Pourbus. In October Rubens attended in Florence the proxy marriage of Vincenzo's sister-in-law Marie de' Medici to King Henri IV of France. His duties at Mantua, besides those of a courtier, were to paint portraits of the Gonzaga family, copies of famous works, and additions to the series of beautiful women which were part of court furniture like the later series by Lely at Windsor Castle. Vincenzo's capacity to use Rubens was limited by the inadequacy of his exchequer; Rubens had ample opportunity to travel in order to improve his art – which would indirectly benefit his employer. He was also in a strong moral position to prolong his absence from the Mantuan court when commissions occurred elsewhere, to compensate for the dilatory payment of his salary. By July 1601 he had reached Rome with a ducal recommendation to Cardinal Montalto, and by December his brother Philip reckoned that Peter Paul had visited most of the important cities of Italy.

In March 1603 Vincenzo sent him on a goodwill mission to Philip III of Spain, in charge of costly gifts including horses and a carriage, jars of perfume and a number of pictures. During an exceptionally wet trek through Spain most of the paintings were damaged by rain, and on arrival Rubens speedily and skilfully restored or altogether replaced them. He saw for the first time some of the treasures of the Spanish royal collection. He learned, and acquitted himself with honour in, the art of diplomacy, since the Gonzaga agent in Spain resented his intrusion and there were further difficulties with shortage of money. He also showed a mind and inclination of his own. When the paintings for presentation were found to be damaged he declined the suggestion that he should do some landscapes to replace them: that was the genre for which the Flemings were noted, but Rubens's aspirations were towards the nobler kinds of history-painting. He also declined to return through France in order to copy a series of beauties: having completed the stunning equestrian portrait of the Duke of Lerma in Spain (Plate IV) he felt that such copies would be hack work indeed. He returned to Mantua early in 1604 by way of Genoa, and that was also significant as he spent a considerable time there in 1606, creating new portrait types for the tight-lipped Genoese mercantile aristocracy. When he was not there or in Mantua he was in Rome, where he spent the winter of 1605–6 and most of 1607–8. Thirty or forty paintings survive from his Italian years, as well as sketches and many drawings, but a large proportion of the

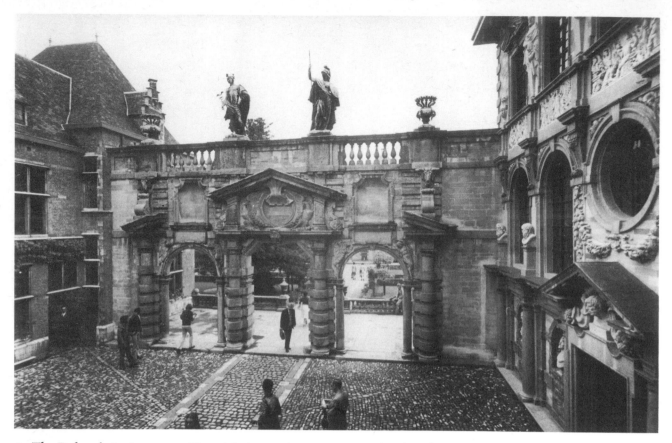

4 The Rubenshuis, Antwerp The original screen between courtyard and garden

drawings are studies after other works of art. After eight years abroad, at the age of thirty-one, it was time for him to settle down.

Having shown himself equal to the principal painters of Rome, and having acquired a relish for Italy, Rubens was strongly tempted to settle there, as many other Northerners did. The sun, history and the warm scents of the South usually leave their mark for life; once back in Antwerp he would think of returning to Italy, and part of him would always be expatriate. Italian was not only the diplomatic language of the day but his favourite in correspondence although he was fluent in French, Spanish, Flemish (the domestic tongue) and of course Latin. In late October 1608 news reached him that his mother was seriously ill (he could not know that she was already dead); his duty, though filial, was not that of the eldest. Subscribing the letter 'Rome, 28 October 1608, mounting horseback', he sent Anni-bale Chieppio, the Mantuan Secretary of State, an apology which amounted to a resignation. In August 1607 Archduke Albert had solicited his return from Vincenzo Gonzaga on the pretext of Rubens family matters, and received the reply that the artist was free but did not wish to leave. But on 1 March 1608 Philip Rubens described his brother as thinking of home and fluttering his wings (he used the Greek word for the action of fledglings). If the moment of his flight was sudden the prelude to it had been long enough. Antwerp for him, as it had been for his mother twenty-one years earlier, was home.

'Antwerp and its citizens would satisfy me if I could say goodbye to Rome', he wrote to a Roman friend on 10 April 1609. The previous day in the Town Hall the Twelve Years

Truce had been signed; the Scheldt stayed blocked, but otherwise Antwerp had breathing space. On 29 June Rubens was enrolled in the Romanists, the Brotherhood of Saints Peter and Paul, consisting of those artists and others who had been to Rome. He was commissioned by the City for a large and sumptuous *Adoration of the Kings* for the Chamber of the States— the room in which the Truce had been signed, facing Abraham Janssen's overmantel personification of the Scheldt and Antwerp. (Three years later the City Council did him no less honour in giving the picture to Oliva, the envoy of the King of Spain; it was afterwards bought by Philip IV and in 1628 in Madrid Rubens retouched and extended it for that monarch.) It was probably fortuitous that Vincenzo Gonzaga had been in Brussels and Antwerp again in August 1608, for Rubens was not with him. Yet Archduke Albert's approach of the previous year may have been calculated, and in 1609 the Regents succeeded, in Philip Rubens's phrase, in binding the painter 'with chains of gold' – literally so, for the order to the jeweller for a chain and medal survives – and on 23 September 1609 their patent appointed him court painter, with exemption from city taxes and guild obligations, an annual salary of 500 florins, and probably no obligations other than painting the Archducal portraits when required. He was also allowed to live in Antwerp instead of Brussels. Marriage soon followed, and children. In November 1610 he began to buy a site just off the Meir in Antwerp, where he built his palace – for the Rubenshuis was no less (Plate 4) – which he filled with works of art and antiquity. He was flooded with commissions both private and public, and with applications for tuition: in May 1611 he reported that he had had to refuse over a hundred would-be pupils including relatives. He established, and managed, a workshop, for producing paintings of every degree of finish from those entirely by assistants to those entirely from his own hand. Before the end of the 1610s there were also tapestry designs and whole cycles of pictures (for example the ceilings for the Jesuit Church), and there were arrangements for reproducing his pictures in engravings. In his spare time (and therefore normally at six months' notice) he designed title-pages for books printed by his friend Balthasar Moretus.

If the 1630s can be called Rubens's golden decade, the 1610s were perhaps his silver one. The intervening years, although prosperous, were somewhat clouded. In 1621 the Truce ran out and was not renewed; Archduke Albert died and his widow ruled alone for twelve years more, knowing that with no child to succeed her the country would eventually revert to Spain. In 1622 Rubens visited Paris and began work on the Luxembourg cycle of paintings for Marie de' Medici (Plate 56). The next year he was in Paris again, and before the winter he was involved in foreign diplomacy for the Archduchess Isabella; his eldest child, Clara Serena, died aged twelve. The war which had begun almost unnoticed in Prague in 1618 was beginning to draw out towards its eventual Thirty Years and to affect all western Europe. In June 1626 Rubens's wife died, and he travelled more and more in the role of peacemaker from discussion to discussion, visiting France in 1626, Holland (where he had first been in 1612) in 1627, Madrid in August 1628 whence in June 1629 he journeyed straight to London. Before he returned home in March 1630 the groundwork had been laid for a successful treaty between England and Spain. Charles I and Philip IV both knighted him,

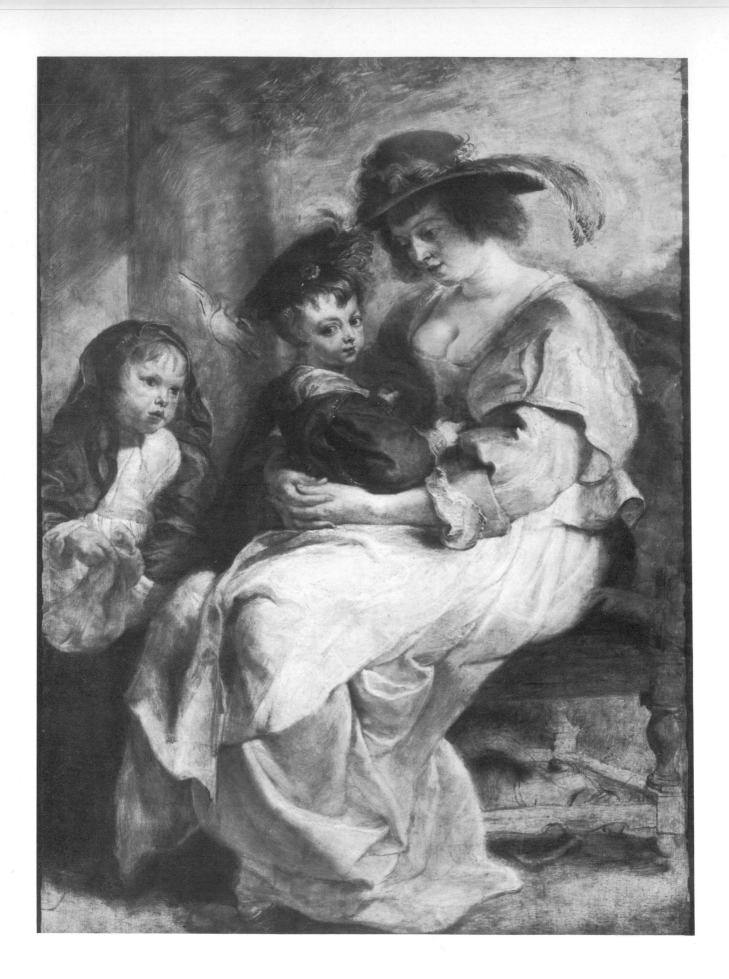

the University of Cambridge gave him an honourary degree, and he received the commission for the ceiling of the Whitehall Banqueting House. Inevitably in the 1620s his studio was to a greater extent than ever in the hands of managers and assistants, yet close examination of the Whitehall panels shows the extent to which he was able to transform pictures worked up by others from his sketches by applying the final decisive and entirely personal strokes. In Madrid and London he was able so far to adapt protocol as to have his own studio; he was captivated by the richness of English collections and the English countryside, and in Spain he took up again the study, making several large copies, of his beloved Titian (Plate 101).

6 Isabella Helena Rubens *c.* 1636
Black, white and red chalk on light
brown paper 39.8 × 28.7
Paris, Louvre

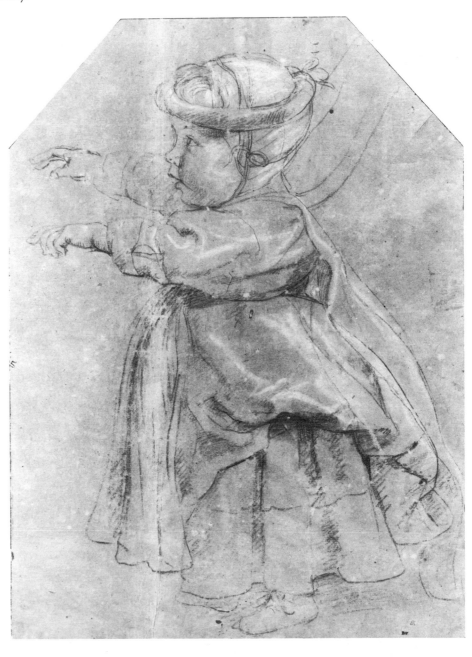

5 *opposite* **Helena Fourment**
with Clara Johanna and Frans Rubens
c. 1636 Panel 113 × 82 *Paris, Louvre*

When in December 1630 he married Helena Fourment he had two aims, domestic happiness and painting for himself. He painted more family pictures and landscapes (Plate XXVIII) although there was no shortage of commissions and the demands of Philip IV were ceaseless. And although he had tried to retire from politics he was led to continue by the vain hope that with his tact and his understanding of the personalities of the day he could contribute towards a more general and lasting peace. In 1635 he designed the triumphal decorations for the reception in Antwerp of the new Spanish Regent Cardinal-Infante Ferdinand, in which he combined art and diplomacy in a personal message from the City to its ruler (p. 87). He bought the castle of Steen near Malines; only then, disillusioned, did he retire altogether from politics to enjoy his family, his painting and his correspondence as far as increasing attacks of gout would allow him.

An unfinished painting of *c.* 1636 shows Helena with their children Clara Johanna (1632–83) and Frans (1633–78) (Plate 5). It was later cut down to make it look 'finished' although only the upper halves of the figures are nearly completed; the rest is lightly laid on a brush drawing. The missing figure, Isabella Helena (1635–52), whose hands appear on the right of the painting, is known from the chalk preparatory drawing (Plate 6). In the painting, which is datable by the children's ages, their mother wears a white summer robe and a hat with a pink feather. Her pose and thoughtful expression may refer to the expectation of another child, Peter Paul, born 1 March 1637. Frans, like his half-brother in an earlier picture (Plate 25), holds a peg with a little bird on a string.

With retirement the chronicle of Rubens's life became sparser and less eventful; inevitably also he stood increasingly alone. Archduchess Isabella, who had died in 1633, had been as much a friend as a patron. Peiresc, the Provençal antiquary he had met in Paris in 1622, died in 1637, his first father-in-law and fellow scholar Jan Brant in 1639. Since none of his children took up painting, the training he gave the young Malines sculptor Lucas Fayd'herbe (1617–97) was paternal as well as professional. The consolations of his freedom and his family were undoubtedly matched by physical difficulties, but as with Rembrandt, who died a generation later also at the age of sixty-three, his brush lost none of its brilliance nor his eye its perceptiveness.

Rubens brought to portraiture his sense of form and colour and his exceptional ability to balance the individual perception of truth, physical and psychological, with the hieratic, the typical, the ideal, the universal in man, woman or child. His account of himself is no less the product of editing; however, because he was capable of diplomacy but not falsehood, we may see a little more in it than he intended to convey. In his last self-portrait (Plate 7) he looks tired and worn. The picture cannot be precisely dated: the face is that of a man of about sixty, but the hand that is his means of life (being painted in a mirror it appears as the left hand) looks younger. He wears the elegant grey gloves, black garb, great hat and sword appropriate to a knight and courtier; the column beside him confirms his status. This is without doubt the image by which he wished to be remembered.

Rubens was still writing and painting a few weeks before his death on 30 May 1640 in his Antwerp house. A few days previously he had agreed to his family's wish to build a

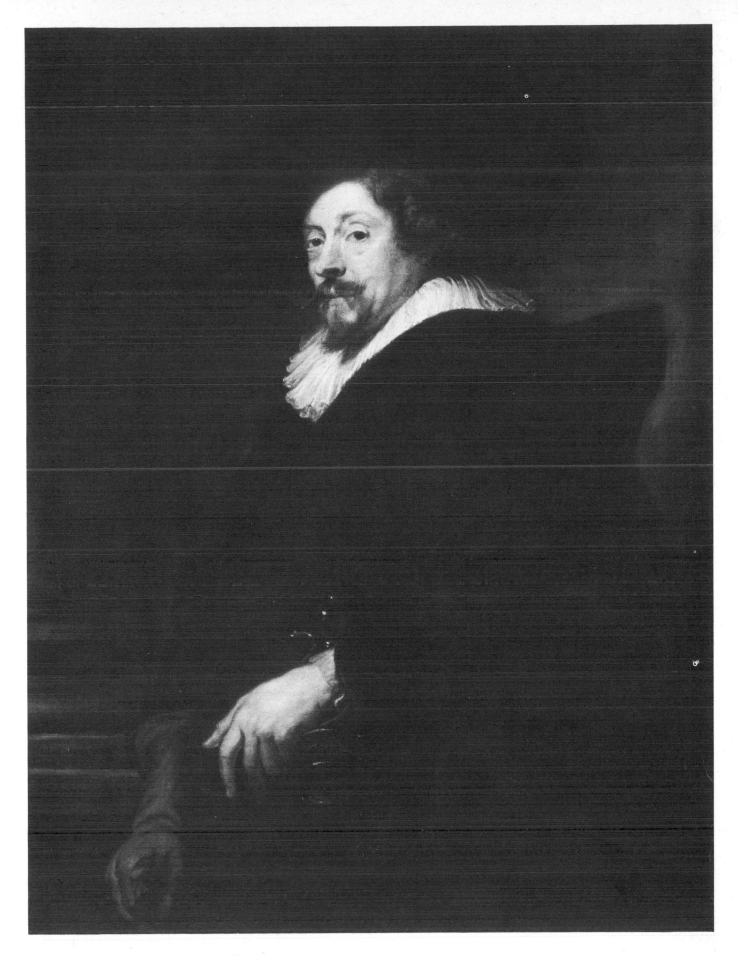

7 Self–Portrait *c.* 1633–9 Canvas 109.5 × 85 *Vienna, Kunsthistorisches Museum*

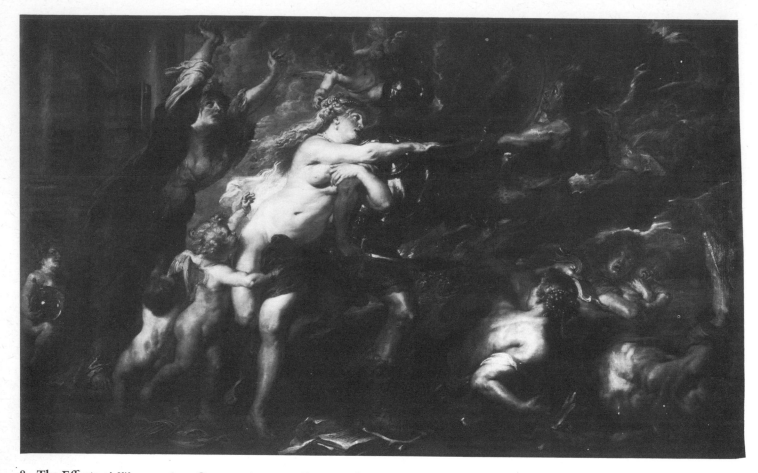

8 The Effects of War *c.* 1637 Canvas 206 × 345 *Florence, Palazzo Pitti*

burial chapel in the parish church and to the installation there of the *Madonna and Child with Saints*, with a marble *Virgin of Sorrows* by Lucas Fayd'herbe. A man of Rubens's orderly temperament may well have prepared the painting some time earlier specifically for his epitaph, but there is no key either to the choice of saints – George and Jerome are identifiable by their dragon and lion, the Magdalen holds a perfume jar – or to the identity of the cardinal and the two women in the centre (Plate XXXII).

The fifth child of his marriage with Helena was born posthumously in February 1641. Thereafter his pictures alone would speak for him.

II THEMES AND MEANINGS

The theory and criticism of literature have always preceded those of art and music, for the adequate reason that in literature theory and practice share the same medium – words – and the same product – writing: indeed the best of criticism is itself literature. The most literary pictures are still visual images made from marks on a surface; not only are different aptitudes required to produce or to 'read' them, but even to describe them requires mental translation from their medium to equivalents in another. In Rubens's time it was universally held that paintings were created, and should be read, like poems, and read in several ways together; one way led ultimately to the Victorian anecdotal picture. Few of Rubens's surviving letters concern painting, and most of his 'criticism' is to be found in copies or derivations he made from his own and others' work (Plate XXVI). But one letter describes a painting of his own, in a way that is instructive in both its method and its content. It was written by Rubens to Justus Sustermans, court painter to the Grand Duke of Tuscany, on 12 March 1638 when the *Effects of War* (Plate 8), probably commissioned by the Grand Duke, was on its way to Florence:

'As for the subject of the painting, it is very clear, so that with what little I wrote to you at the start, the rest will become clear to your discerning eye better than through my description. All the same, in obedience to you I will explain it with a few words. The principal figure is Mars, who, leaving the temple of Janus open (which in time of peace, according to Roman custom, stayed closed) goes with shield and bloodstained sword threatening some great disaster to the people, taking little heed of Venus his lady, who strives with caresses and embraces to hold him back, accompanied by her Amors and little Cupids. From the other side Mars is pulled by the Fury Alecto with a torch in her hand. There are monsters nearby, which signify Plague and Famine, the inseparable companions of War. On the ground with her back turned lies a woman with a broken lute, denoting Harmony, which is incompatible with the discord of War. There is also a mother with a child in her arms, showing that fruitfulness, procreation and charity are wrecked by War, which corrupts and destroys everything. There is moreover an architect upside down with his instruments in his hand, to say that what in time of peace is built for the convenience and ornament of the city, goes to ruin and is thrown to the ground by the violence of arms. I believe, if I remember rightly, that you will also find on the ground, under the feet of Mars, a book and some sort of drawing

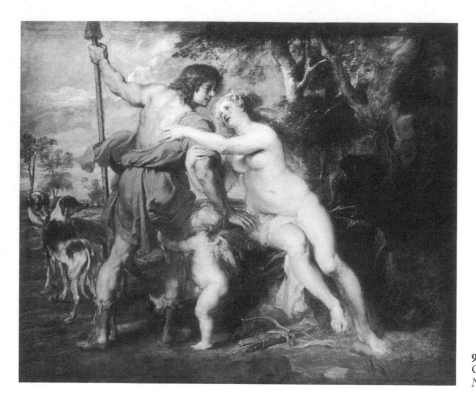

9 Venus and Adonis *c.* 1635
Canvas 197 × 241
New York, Metropolitan Museum of Art

on paper, to indicate that he tramples on literature and other beautiful things. There should be in addition a bunch of darts or arrows with the band that held them together untied, which was, when they were bound up, the emblem of Concord. So also the caduceus and the olive-branch, symbol of peace, which I represented thrown aside. That grieving woman clad in black and with torn veil, and robbed of her jewels and every sort of ornament, is unhappy Europe, who now for so many years has suffered plunder, outrage and misery, which are so hurtful to everyone that it is not necessary to go into detail. Her emblem is that globe, held up by a little angel or genius, with a cross on the top, which denotes the Christian world. This is as much as I can tell you, and it seems to me too much, for with your own sagacity you will have easily understood it.'

The method of the description recognizes that we build up an image by scanning, directing and accumulating the messages to the eye. Rubens starts in the middle and reads the scene roughly clockwise – although this sequence does not necessarily apply to all his pictures. The content of the description is more complex, although Rubens flattered his original correspondent with the assumption that he would have no difficulty. Each figure has a purpose; each is identified, for example Mars, or an architect. At once a proper name or an activity, or a colour (the black of Europe's garb for instance), conveys precise and profound meaning. Moreover, to the visually literate facing the picture this meaning does not need conscious translation into words.

Accessories or proper actions make clearer identity and meaning. We recognize the architect from his instruments. Venus tries in vain to restrain Mars; her gesture involves her

whole body, with the axis of the shoulders displaced sideways from that of the pelvis. In Rubens's repertory of figures this indicates attachment and restraint, and it recurs in various representations of the parting of Venus and Adonis, who is about to set off on a fatal journey (Plate 9). Today we may need Rubens's explanation that a bundle of arrows signifies Concord and an undone bundle therefore Discord, but the olive-branch and the cross still figure in our everyday imagery.

So much might be true of schematized figures: indeed we enjoy finding alternative meanings in road signs which their designer tried to render quite unequivocal. But Rubens's picture is rightly treasured as a work of art, and his own estimation of it is clear when he expresses concern that in travelling a fresh painting 'might suffer a little in the colours, particularly in the flesh tones'. He explains also that Mars tramples on literature and beautiful things. He knows and intends that colours, tones, lines, shapes and above all the human figure, in which humanity recognizes itself, are all part of the picture's meaning.

The theme of Peace and War was one of Rubens's preoccupations in the late 1620s and the first half of the 1630s. The *Effects of War*, painted after his final retirement from politics, is his last sad comment on the Thirty Years War; the allegory of the Anglo-Spanish treaty, which he painted in England in 1629–30 and presented to Charles I, is full of optimism (Plate 10). It represents *Peace and War*, according to Charles I's cataloguer Abraham van der Doort, or more specifically *Minerva protecting Pax from Mars*. We do not have any description by Rubens of the picture and no specific source is known for the allegory; however resonances can be found elsewhere in his work of the period and the general tenor is clear from emblem books. Peace, giving milk to the infant Plutus (god of wealth), is at the centre of a group representing plenty and happiness; the woman on the left brings in rich vessels and jewels. The leopard and satyr and the woman with a tambourine represent Bacchus, who as the original vine-grower was a lover of peace. The boy facing right with a torch is Hymen, god of marriage, which flourishes in peacetime. Behind these Minerva, helmeted, drives out Mars together with a Fury and a Harpy, while a flying boy holds a caduceus and olive wreath for prudence, concord and peace. The pyramid of peaceful figures with Minerva's helmet at the apex recalls Venetian *Holy Families*, but this resemblance was less marked before Rubens enlarged the canvas and added the left-hand woman, the leopard and strips at the top and right.

Even without the help of any contemporary description, we can learn much not only from the postures and attributes of the figures but from the use Rubens made of some of them in other works. Several figures were re-posed in a partly studio work on the same theme (Munich, Alte Pinakothek) and some of the London figures also relate to a gouache representing the *Hero Taking Occasion to Conclude Peace* (Weimar, Staatliche Kunstsammlungen) which is usually dated *c.* 1627–8. Whether the gouache is from Rubens's own hand or, as some scholars believe, a studio replica, it is notable for recalling the London picture not only in ideas and composition but also in its strong rich colours. In Rubens's mind association went further, for the modest nude figure representing *Occasio* whom the hero rushes forward to grasp re-appears, clothed but almost identical in pose, and flanked by

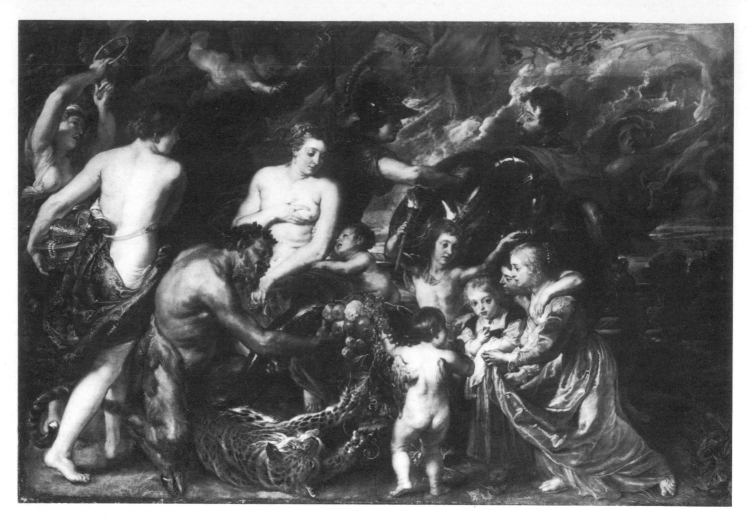

10 Minerva Protects Pax from Mars (Peace and War) 1629–30 Canvas 203.5 × 298 *London, National Gallery*

similarly corresponding figures, in a later and different scene of reconciliation of the early 1630s, in which Briseis is restored to Achilles (Plate 60). Moreover, another colourful gouache of *Hercules and Minerva Fighting Mars* (Paris, Louvre) links the London figures of Minerva and Mars to the foreground clutter of bodies in the *Effects of War*.

Nor is this all that we can discover from comparing images. The two small girls and Hymen in *Peace and War* are based on portrait drawings of children of Sir Balthasar Gerbier, Rubens's host in London. Rubens also painted a group portrait of Mrs Gerbier (her husband was not then a knight) and her children, of which the best versions surviving are at Windsor Castle and in the National Gallery in Washington. Comparison shows that Rubens must have used another set of drawings for this group portrait, since although the faces are recognizable they are differently posed. For Pax he used an ideal figure, and as she re-appears almost exactly in a painting of *Mars, Venus and Cupid* (Dulwich College) we ought to ask whether in the artist's mental filing system there was a cross-reference between the goddesses of peace and of love.

Finally the boy Hymen, who is formally at the centre of *Peace and War*, re-appears as Cupid, the instigator, in a picture which Rubens must have painted soon after his return to

[24]

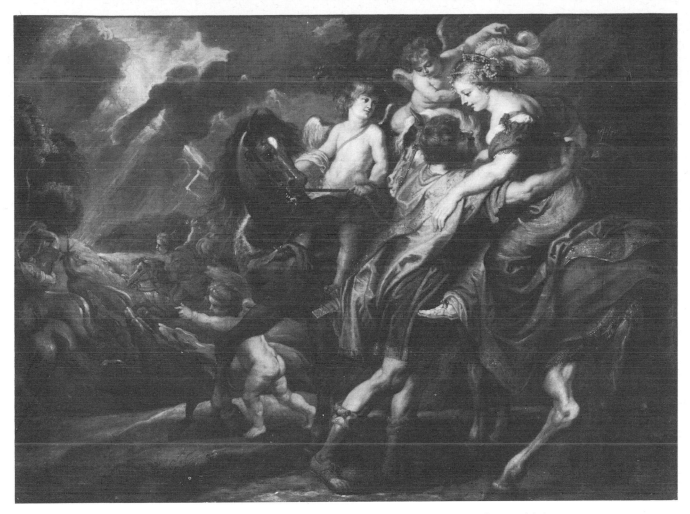

11 Dido and Aeneas Sheltering from the Storm *c.* 1630 · Canvas 214 × 298 *Frankfurt, Städelsches Kunstinstitut*

Antwerp in 1630 and in which he used the same brown ground, dark tonality and saturated colours: *Dido and Aeneas Taking Shelter from the Storm* (Plate 11). Virgil relates (*Aeneid* IV; 117–72) how Aeneas and Dido, Queen of Carthage, went hunting, were caught in a storm precipitated by Juno, and consummated their love in a conveniently located cave. Rubens shows them stopping at the entrance while the rest of the hunt rushes onward to the left under a thundering sky. Aeneas has dismounted and Cupid has already replaced him in the saddle, turning his chestnut horse (and the beholder's eye) away from the hunt to the core of the action: Aeneas helps the Queen down in what is already an embrace. Her crimson cloak and golden ornaments (described by Virgil) and Aeneas's blue tunic and gold and grey cloak contrast with the grey and lemon sky and varied greens of the landscape. While it is risky to relate Rubens's themes or physiognomies to his private life, the concentrated enthusiasm of this painting is bound to remind us that before the end of 1630 he had courted and married a new wife.

In accordance with the Counter-Reformation emphasis on the didactic value of art, the message of Rubens's religious paintings was usually simple, although how much the beholder saw in them depended on how well he knew his religion. The *Circumcision* is still

in S. Ambrogio (formerly the Jesuit Church) in Genoa, for which Rubens painted it in 1605; the altarpiece (492 × 277 cm.) was commissioned by the Jesuit Marcello Pallavicino, brother of Vincenzo Gonzaga's banker. Plate 12 reproduces the original *modello* which is somewhat less elongated in proportions and was possibly painted with an arched top in mind, although some of the discrepancy in shape may be due to trimming of the sides of the actual altarpiece when its frame was enlarged in 1615. The subject is an act of small-scale ritual surgery, for which Rubens was historically correct in providing a domestic setting; the apprehensive *putto* on the left adds a human touch to Counter-Reformation demands for didactic realism. The obvious and superficial message of the picture is merely the humility of Christ in conforming with the normal treatment of every Jewish male infant, but that message in itself does not account for the choice of subject.

The strongly modelled glory of angels which occupies most of the upper half of the canvas was not introduced merely for pictorial reasons, or in order to form a 'cupola of figures', as it does, over the scene, echoing the cupolas over the aisle chapels in the church. For the church in Genoa was initially the Gesù, dedicated to the name of Jesus (meaning Saviour) which Christ was given at the Circumcision; the Feast day commemorating that event (1 January) was therefore the patronal feast of the Gesù. Moreover, the ritual act was the first shedding of the Saviour's blood. The emphasis on the compassionate Madonna in the altarpiece is explained by the prominence accorded to her in the liturgy of the feast of the Circumcision. Probably, too, the choice of a night setting was more than an occasion for the painter to emulate the strong and harmonious colouring of the night *Nativities* of Correggio. For light shining in darkness is the constant metaphor of Christian salvation, while for a seventeenth-century writer 'the name of Jesus is . . . more beautiful than the dawn and the light'; in the final picture the infant Saviour reflects light from the heavenly source above, in which is inscribed the Hebrew form of the name, Yehôšûa'. To find other examples of dramatic divine light we need go no further than Rubens's immediately preceding large work, the three pictures for another Jesuit church, in Mantua (Plates 39–41).

One of the rewards of studying Rubens is his orderliness: he rarely did anything in art without a firm reason. We may of course mistake his reason, or err equally in excluding alternatives; one of the felicities in his kind of painting, as in poetry and architecture, is the resolution of more than one kind of problem with the same stroke. This is the art that hides art, and the best formal solution is usually that which also presents the content most clearly. Thus in the *Abduction of the Daughters of Leucippus* (Plate XIII) Hilaeira and Phoebe, hijacked by the demi-gods Castor and Pollux on the way to an arranged marriage, have lost their clothes not according to the story but because they must be shown as physically desirable by seventeenth-century standards. Moreover, since he knew the Classical world principally through its literature and its sculpture, Rubens naturally thought of Classical subjects in terms of Antique sculpture and of the nude. The group is composed like a freestanding sculpture, isolated in space by the low horizon and distant landscape, and touching the ground only at a few points of balance. But since it is actually a painting the real problems of balance are not mechanical but pictorial ones: the group is no less securely woven into the picture

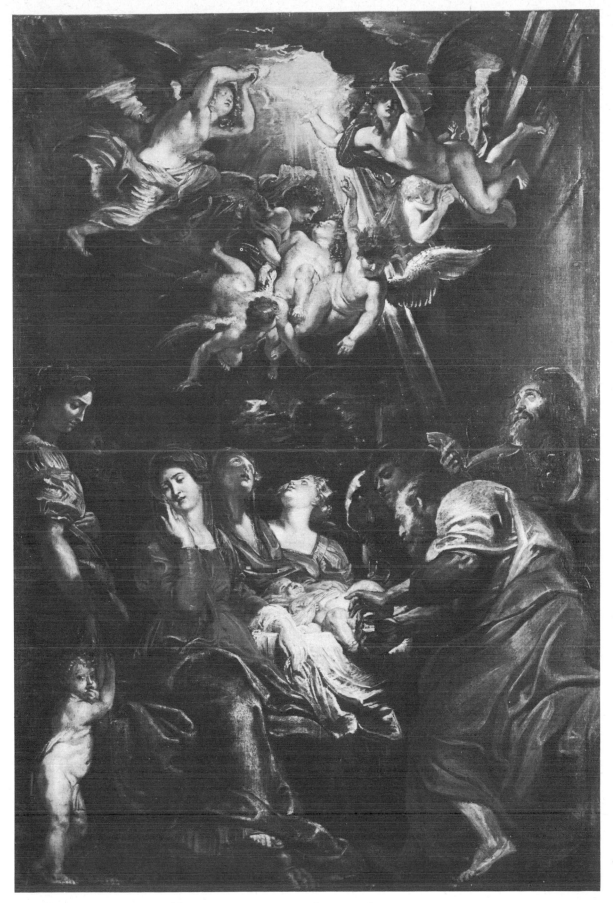

12 The Circumcision *modello* 1605 Canvas mounted on panel 105 × 74
Vienna, Akademie der Bildenden Künste

surface, for under the marvellous free pattern of figures lies a lozenge superimposed on a rectangle. Rubens added to the main canvas a broad L-shaped piece at the top and right, and in the absence of scientific evidence it may be asked whether this irregular enlargement could have been made during painting to accommodate the dapple grey horse and give more space for figures and background.

The eye goes first, and always returns, to the key figures, the brightest and least un-broken forms, the two clear-skinned young women (that this is due to the picture and not to the spectator, to formal and not to associative causes, can be shown by viewing the reproduction upside down through half-closed eyes). They are closest to the beholder and overlap all the other forms, though it is of course true – and essential to the narrative – that their pearly skin beguiles the eye. They are also formally complementary: in Jakob Burck-hardt's words 'one presents exactly the view not presented by the other'. However, while theirs is the title role, none of the participants lacks significance: the horse-tamers, Castor and Pollux, needed powerful steeds for their exploit. Nor is the intervention of the cupids accidental, for they have taken the reins. Rubens did not follow Ancient depictions, for he recalled that the Heavenly Twins, the sons of Jupiter and Leda, married their captives. This is an image not of sexual violence but of stratagem and acceptance; what is shown happening is not rape, but abduction which resulted in marriage. Romance, not violence, is the key-note. Phoebe is still off balance and surprised, her pose derived, through a category in Rubens's repertory for figures caught up and held, from the Laocoön group (p. 144). Hilaeira, above, floats like the dead Christ in the *Deposition* (Plate XII), supported by the composition and not by her captors. Her pose recalls to the point of quotation that of the heroes' mother (Plate VI); by her face and outstretched arm she appears to be welcoming her rescuer.

Rubens also knew that in late Antiquity this particular abduction symbolized angels carrying souls to heaven; thus to a sensuous rendering of a pagan mythology was added a philosophical and Christian significance. As we do not know for whom it was painted it is impossible to discern any more private meaning or to connect the Twins' other ancient function as protectors of navigation with Antwerp's fading glory. But if it is generally true that seventeenth-century imagery was enriched by the possibility of alternative meanings, the calibre of Rubens's education and intellect enabled him to bring a philosopher's mind to both common and rare subjects and to invent new ones.

The *Virtuous Hero Crowned* (Plate 13) seems to represent a theme of Rubens's own in-vention. It is probably the 'Christian knight, crowned by Victory, on panel' in the mortuary inventory of his collection (No. 156). The following item in the inventory, *Hercules Drunk*, is probably the panel now in the Dresden gallery, and was certainly designed as a pair to it. Replicas of both are known, but Rubens probably painted the originals, uncommissioned, as moralistic examples of the hero winning and, in *Hercules Drunk* losing, in inward personal combat. The *Hercules* is based on a Roman relief, but the *Virtuous Hero* has no identifiable visual source. The hero tramples on Silenus (representing Intemperance); rejected Venus weeps, and snake-haired Envy is cast into shadow. The armoured hero derives from Rubens's

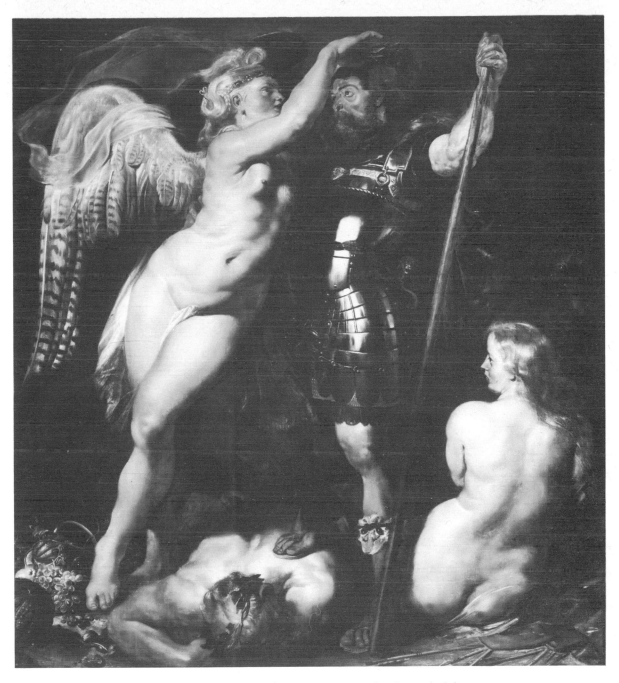

13 The Virtuous Hero Crowned *c.* 1611 Panel 216 × 196 *Munich, Alte Pinakothek*

Roman martyrs (Plates 42, 43) while the female types, like the assured and economical modelling in strong tones, belong to the period immediately following his return to Antwerp. Venus recurs in the same pose, at her *toilette*, in a painting in the Liechtenstein Collection in Vaduz.

Like his teacher Vaenius and like every other artist who accepted the canons of Renaissance Italy, Rubens most valued history painting – the representation or allegory of human and superhuman affairs. Deity was for him the God of Abraham, the Crucifix and the Eucharist; the Classical divinities and nature spirits he saw as personifications of ideas which live in men's minds and have spiritual but not supernatural reality. While in history painting as a whole he did not prefer either Christian or Olympian subjects, mythical or factual narrative, as a rule his religious paintings were commissioned. Major exceptions are religious paintings for domestic appreciation rather than for churches; some of these, like a greater number of secular works, were painted in the hope of eventual sale or simply because the subject or artistic problems interested him. In 1618 he exchanged a group of such works (Plates xv, 76, 78) for the Antique sculptures collected by Sir Dudley Carleton, James I's Ambassador to The Hague. Rubens's list of pictures on offer to Carleton is preserved, and subsequent correspondence shows that he retouched those which Carleton bought to bring them stylistically up to date or (as some included assistant's work) technically up to standard. Other autograph pictures he kept unsold all his life: not only late works like *Bathsheba* and the *Three Graces* (Plates 104, 17) but the *Bacchanals* after Titian, the *Rest on the Flight*, the *Prodigal Son* (Plates XXVI, 92, 32) and even the earlier *Virtuous Hero* (Plate 13) and its companion.

In the decade after his return from Italy Rubens laid the basis of fame and fortune with single history paintings of all kinds: altarpieces, epitaphs, allegories, mythologies and historical narratives (Plate 70). There were distant commissions: hunting scenes for Maximilian, Duke of Bavaria and the '*Great*' *Last Judgement* (Plate 82) and other altars for the Duke of Neuburg. In 1621 a Polish nobleman, who came to Antwerp seeking funds for the war against the Turks, went home without money but with a *Deposition* of Rubens's invention and from his studio (now Kalisz, St Nicholas). But most of the production of this decade gained good prices from compatriots: besides Madonnas for private devotion, works like the *Four Continents*, *Neptune and Amphitrite*, Diana going to or returning from the chase, and *Venus, Cupid, Bacchus and Ceres* (Plate XI) must have graced the living rooms of prominent Antwerp citizens. In a period of decline luxuries like works of art often seem more desirable than savings or investment, and Rubens's patrons shared his education and ideals. Two overlapping groups of works also evidently appealed to them: scenes of metamorphosis (based on Ovid) and what Evers called *Gewalttatten* (deeds of violence). Death and war were facts of life; in 1626 Rubens relayed a report that in Hesse the roads were full of human corpses and innumerable swine, and in his later years man's inhumanity was one of Rubens's preoccupations. There is, too, an objective necessity in the realism of the Passion of Christ and the martyrdoms of saints (Plates 46, XII, XXXI) as the gateways to heavenly glory. More disturbing pictures of the 1610s found buyers. *Prometheus* (Plate 76), though painted before 1612, was only sold in 1618 to Carleton, but the *Betrayal of Samson* (c. 1610, Private Collection, formerly Neuerberg Collection, Hamburg) hung above the fireplace of Burgomaster Nicolas Rockox. The biblical hero's strength-giving hair is cropped as he lies slumped on the lap of the bare-breasted Delilah; not only the event but the strong modelling

in contrasting lights and tones arrests the eye. Moreover the unity of the picture surface as wall furniture is disrupted by the dramatic juxtaposition of large foreground figures with the background soldiers who enter to blind the hero.

Rubens painted also *Judith beheading Holofernes* and the *Rape of Lucretia*. In single combats between Samson or Hercules and a lion, man displays animal ferocity and the animal takes on a human dignity, so that violence and metamorphosis are compounded. In savage but magnificently composed *Hunts* he showed conflict within Nature, since horses and dogs are man's allies. The relationship of man and animals is a theme common, like the relationship of the sexes in mankind, to both Classical and Northern story-telling. From the time in Antiquity when hunting became more ritual than a means of survival the chase has acquired a mystique compounding primitive animism with semi-religious and stately ideas; Rubens's *Hunts* are thus not only exotic decorations but also assertions of human authority. He painted four *Hunts* about 1615 for Maximilian of Bavaria for the Altes Schloss at Schleissheim. In the *Hippopotamus Hunt* (Plate 14), as in the *Daughters of Leucippus* (Plate XIII), a low horizon isolates the groups spatially. Here the apparent tangle of figures is controlled and animated by combining radial lines with concentric rings: in the very centre the teeth of hounds and hippopotamus are juxtaposed to the spear-point.

The *Lion Hunt* which hangs near this picture in Munich is not one of the series, but a later work which Rubens described in September 1621 as almost completed. Among many differences from the Schleissheim series, in accordance with his changing attitudes to both life and composition, the combat is equal, or even in the lions' favour (Plate 15). The action is spread out and not bounded by the frame, but the front plane is maintained as if by a sheet of glass. The forms are softer, limited by changes of tone rather than by outlines, and linked by a lattice of limbs and weapons. There are connections between the *Lion Hunt* and the Medici cycle (begun 1622, Plate 56) both in style and in the existence of oil sketches for both on the two surfaces of a single panel (Marquess of Cholmondeley's Collection).

Many Classical and biblical stories are erotic. Early in the Italian period Rubens had explored the strange coupling (Plate VI) in which Jupiter disguised as a swan seduced Leda, who subsequently bore the twins Castor and Pollux. The Ancients were fascinated by this story, and Rubens's composition derives from Roman cameos as well as from Michelangelo's painting then at Fontainebleau. Michelangelo's original, apparently destroyed in the 1630s as indecent but known from copies, conveyed metaphysical rather than sensuous eroticism. But Rubens's consummation takes place on a bed of crimson and white against a warm afternoon landscape; Leda's folded posture became for him an image of physical and emotional acceptance (Plates VII, XIII). The larger painting of this theme which he later offered to Carleton is lost. In *Hercules Drunk* he examined the hero's subjection to the darker passions of Nature, and in another painting which he never sold, the *Triumph of Silenus* (Munich, Alte Pinakothek), he treated of the procreation of animals and of the semi-human world of satyrs with the same discreet but unmistakable verve that he brought, on a higher plane, to the sons of Leda and daughters of Leucippus (Plate XIII). He made the ambiguous story of Jupiter's love of the boy *Ganymede* (Vienna, Schwarzenberg Collection) into an elegant

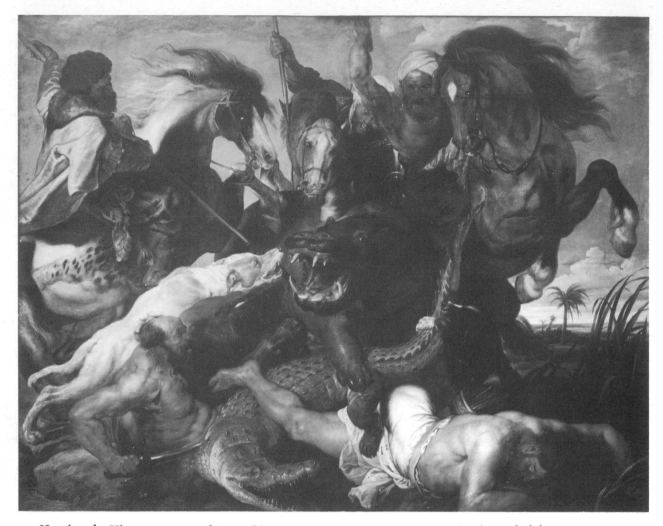

14 Hunting the Hippopotamus and Crocodile *c.* 1615 Canvas 247 × 321 *Munich, Alte Pinakothek*

allegory of the mind transported to divine contemplation, with the youth gracefully enclosed by the protecting wing of Jove's eagle.

Ixion deceived by Juno is one of the most beautiful of these pictures, both in its cool flesh colours, cerulean blues and strong reds, and in its linear rhythms and sensuous nudes (Plate XIV); when Rooses was compiling his catalogue raisonné in the 1880s the picture was in the Westminster collection but had been withdrawn from view, evidently on account of the nudity of the figures. Ixion, king of the Lapiths, had killed his father-in-law. When none of the neighbouring princes would redeem him, Jupiter took pity on him and purified him on Mount Olympus. There the ungrateful Ixion fell in love with Juno, but Jupiter beguiled him with a cloud in her likeness. Ixion was condemned for his lustful ingratitude, the outcome of which was the birth of a centaur. Rubens's painting shows Ixion embracing the fictive Juno, whose face and bosom are seen in the half-shadow of Juno's mantle which Iris, who also assists Juno in *Juno and Argus* (Plate X), holds over the couple; Iris wears a fox-skin to show that she is a party to the deception. Behind Ixion a Fury waves a fistful of snakes. The S-curve of the fictive Juno's pose, which was for Rubens appropriate to an

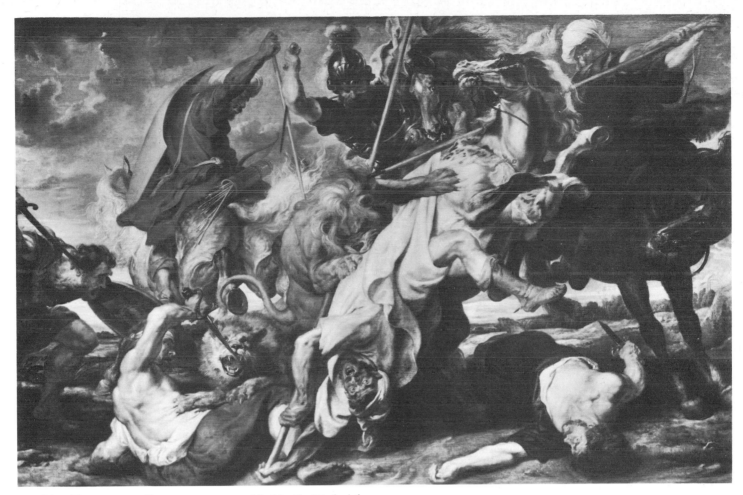

15 Lion Hunt 1621 Canvas 247 × 375 *Munich, Alte Pinakothek*

amorous goddess, should be compared with those in Plates 8 and 9. To the right is the real
Juno; her hair falls loose, as her diadem is being worn by her counterfeit. She turns away as
if stepping out of the illusory figure, and is led by Cupid to Jupiter who sits on the extreme
right. In such mythologies of the 1610s, probably painted for overmantels, for the learned
beholder a moralistic message is cloaked in rich colours and opalescent flesh tones.

In *Juno and Argus* similar pictorial qualities offset the repulsiveness of the final incident
in a tale of Olympian jealousies. This picture is generally accepted as the one mentioned by
Rubens in May 1611 when he wrote to an art dealer that he had found a purchaser for it. It
depicts the mythical origin of the 'eyes' in the peacock's tail. Jupiter, enamoured of the
princess Io, and anxious to conceal her from Juno, changed her into a heifer; but Juno was
aware of the disguise and placed the hundred-eyed Argus to guard her. When Mercury, on
Jupiter's orders, decapitated Argus, Juno transferred the hundred eyes to the tail of her
emblematic bird. In Rubens's painting the eyes are extracted by Iris, the messenger of the
gods and the personification of the rainbow, while Juno directs her and collects the eyes;
these two figures are adapted in pose from a picture by Mantegna of Judith with the head of
Holofernes. The headless body of Argus is based, by way of Raphael, on an antique proto-

type; the woman on the extreme right is more probably Juno's servant than Io or any other named personage. The picture is dominated by the scarlet of Juno's dress and the blues of the peacocks and the other costumes.

War was too familiar for the period of the Twelve Years Truce to have engendered a taste for violence in art. A psychoanalytic explanation is equally improbable, for Rubens was quite conscious of the implications of his subject matter. Nor should any reader of Shakespeare need such speculation: Rubens's subjects came from the Classics and from the Old Testament, and in both a moral message is implicit in the most appalling of stories. Such subjects had long been familiar in painting, more especially in prints, and their inter-pretation at more than one level was no novelty. What was new was the realism both of Rubens's brilliant technique and of his gift for narrative.

The historical paintings of the 1610s also bear another mark of Rubens's intellect. In that decade he went further than any other previous painter, even Vaenius, in bringing scholarship to the co-ordination of eye, hand and mind. The years after 1619 are the period of cycles and series of paintings and tapestries (p. 74); in the Italian years travel and the treasures of Antiquity and Renaissance had offered ever new stimuli to eye and mind. In the 1630s, apart from the themes of Peace and War (p. 21), Rubens's subject matter seems to have been chosen more often for formal than for thematic reasons – figures and groups and landscape (Plates 91, 92, XXVIII). But in the 1610s especially he developed particular kinds of subject. Evers divided his account of the secular works of this decade according to themes: *Metamorphoses*, *Gewalttatten*, geographical and animal pictures, victory and battle, love and fecundity. Again, in later years Rubens expressed in landscape the relation of man to the natural world and its seasonal and biological cycles. In the 1610s he saw the natural order through the treasury of ancient knowledge that was the school and the study material of Northern humanism, although he also brought to bear on it the newest learning. His account with Balthasar Moretus shows him in these years buying folios on geography, travel and natural history. The oriental costumes and figures in the *Miracles of St Francis Xavier* (Plate 87) would hardly have been possible without Theodor de Bry's *Indiae Historiae* (begun 1597) or the eagles of *Ganymede* and *Prometheus* (though the latter was drawn (Plate 79) by Snyders) without Aldrovandus's *De Avibus* (1599).

Although some of the paintings so far discussed are almost static while others show strong movement, they are all large, about life-size, and with few figures. They conform with the principle, to be most memorably defended by Andrea Sacchi in the Roman Academy of St Luke about 1636 but already familiar by analogy with Aristotle's prescription for tragic poetry, that history painting should be simple and without superfluous figures. The nature of these paintings, however, appears more clearly by comparison with other categories of Rubens's work that contain many figures. A *Last Judgement* (Plate 82) requires a multitude; an Olympian assembly, whether for Mantua (Plate 64) or for the good auguries of Marie de' Medici, made similar demands. Elsewhere many saints had to be accommodated for de-votional reasons (Plate XXIII) or a rich composition was needed for didactic or decorative purposes, to combine several miraculous events or personify a historical situation (Plates

XIX, 85) or to animate large spaces (Plates 40, 55).

In 1616 Sir Toby Matthew complained of a *Hunt* 'so bigge as that it cannot be hunge up in the house of lesse than a Prince' but Rubens also painted small intricate works with many figures, which Evers called *ballades*. Whereas most of the large works were destined for the background or the foreground of religious ceremony or the stately life of a Baroque ruler, the small pictures were truly collectors' pieces, to be appreciated both in a general view and by the detailed reading at close range of every figure: their analogue is not tragic but epic poetry. *Hero and Leander* (Plate VII) is an early example from his Italian years. Leander swam the Hellespont each night to visit Hero; when her guiding lamp failed in a storm Leander, in the centre, was drowned. Hero (on the extreme right) plunged into the straits to join him in death. In a translucent sea (which is now brown with traces of green) Rubens poetically unites, not on a heroic scale but on an intricate domestic one, themes of love, tragedy and the course of nature. Hero, guided by two flying genii, rushes headlong into the picture towards the heroic but lifeless Leander. The sea is not their element, whereas the nereids, one in a pose similar to that of Leda (Plate VI), yield to the overwhelming swell and are part of it. (A later version, in Dresden, is of disputed quality.)

One of the finest of these pictures, crowded with figures and incidents, is the *Battle of the Amazons* which belonged first to Cornelis van der Geest (Plate 16). It was probably Rubens's thanksgiving for the commission for the *Raising of the Cross* (Plate 72); if so, the date of *c.* 1615 given by the painter's nephew is historically as well as stylistically apt. Certainly the picture occupies the best lit eye-level position – for it is a dark painting – in a contemporary view of Van der Geest's house gallery (by Willem van Haecht: Antwerp, Rubenshuis). The lessons Rubens learned at second hand from Leonardo da Vinci's fragmentary *Battle of Anghiari* were not confined to the broad depiction of furious energy: Leonardo like Rubens was a master of detail. The Amazons were a mythical race of warrior women in Asia Minor, who figure in many Classical stories; the scene depicted here is almost certainly their rout by the Greeks under Theseus on a bridge over the River Thermodon. A firm arch of figures contains the whole mass of violent movements and warm colours and dominates the masonry bridge, on which the Athenians overtake the Amazons as the battle moves in one direction, from left to right; the bridge is too small for the figures, and horses and riders topple, hurtle or slither from it. Horses snort, prance and bite. Weapons are raised and thrusts made and parried; on the crown of the bridge, from which dangles the arm of a headless body, a man on foot tugs the Amazon standard from a rider already thrust through with a spear. On the left bank the dead are plundered. The water too is full of figures, falling, swimming, shielding themselves from falling bodies and flailing hooves. Every figure adds to the narrative, while on the skyline a city burns, its smoke sweeping up behind the seething mass of bodies and continuing its motion into the sky.

Rubens distinguished consistently in his mind between the large and the small format, and understood scale as many nineteenth-century artists failed to do: large works need to be simple, are often to be seen at a distance and take on some of the nature of decoration or even of architecture; small pictures may be more detailed and complex. He also understood

that, whatever the degree of detail, every brush stroke must be made with scale in mind.

The large works with few figures also show Rubens's appreciation of time in painting in a way closely related to his experience of Antique art. At a glance the small *Battle of the Amazons* or the large *Miracles of St Ignatius* can only be seen as a general pattern; neither formal arrangement nor story or symbolism can be absorbed except by the sort of scanning process described in connection with the *Effects of War* (p. 22). This process occupies time in a way that may be called 'active'. On the other hand a picture like the *Daughters of Leucippus* (Plate XIII) can be taken in at a glance, although we do not immediately notice details like the second cupid, or the landscape, or indeed the subtleties of composition and the details of line and shape and colour that make it a masterpiece. The gradual appreciation of these things occupies time in a way that may be called 'contemplative', and we react much as the believer does in contemplating what the Germans call an *Andachtsbild*, a private 'devotional image'. Such images as the Madonna and Child instead of the Adoration of the Kings, or the Crucifix instead of the Crucifixion, are excerptions from narrative and from time; they 'tease us out of thought as doth eternity'.

That is no arbitrary comparison, for Keats's imagery like Rubens's was founded ultimately on Antique sculpture. Except in relief, in which the art comes closest to painting, sculpture is concerned with simplification, the elimination of inessentials in favour of the characteristic. Giambologna (1529–1608), a Fleming who like Rubens moved to Italy but unlike him stayed there, embodied the *Rape of the Sabines* in a monumental group of only three figures: a Roman carrying off a Sabine woman from an older Sabine man. Thus sculpture sheds the detail and the temporality of epic; like the figure on Keats's Grecian Urn the action is frozen, uncompleted, in one instant. In the great Antwerp *Deposition* (Plate XII) Rubens suppressed the traditional incident of the Madonna swooning and involved her instead in the single action and instant of the other figures. His Christ in another great altar (Plate 46) and his St Peter (Plate XXXI) are eternally almost raised upright. In these paintings, in which image takes precedence over narrative, he approaches the character of free-standing sculpture, seeking by the use of colour and light to clothe the abstract monumentality of sculpture in the realism of the accidental and the momentary. The Antique is full of victors (Plate 96), dying warriors, poised athletes, Venuses born from the sea or surprised at the bath (Plate XXVII); even the river god with flowing urn who marks the passage of time (Plates II, 58) is himself timeless. Rubens's Prometheus is for ever devoured, ever renewed (Plate 76), his Seneca, like Christ, for ever bleeds (Plates 70, XII). Like the marble allegories on a tomb, St Ildephonsus for ever kisses the vestment presented to him by Our Lady (Plate XXIV) and in *Bathsheba* the sequence of events is concentrated into one moment (Plate 104).

It should not be imagined that Rubens invented this sort of picture, in which description and symbol are united, nor, in spite of his remarkable sculptural feeling for form, should we forget that these images are painted. Rubens himself warned of the dangers of working from sculpture (p. 144) and his particular achievement was to give symbols the actuality of sculpture and at the same time to give sculptural images the movement, colour,

variety and living breath which 'realistic' painting can convey. This is perhaps clearest of all in the late painting (c. 1638) of the *Three Graces* (Plate 17). The Graces, daughters of Jupiter and Venus, are figures whose characters are known only in the etymology of their individual names (beauty, happiness and the bloom of Nature) and whose being was handed down only in metaphor, in emblems and in sculpted groups. In *De Beneficiis* Seneca explained the Graces as emblems of an endless cycle of generosity, giving, accepting and returning, and Rubens placed his Graces so that they are all interlocked, instead of using the conventional formula of two frontal figures joined symmetrically by a back view. But he followed artistic tradition in replacing the loose transparent garments which Seneca prescribed 'because benefits should be seen' by the nakedness of Truth; only a long veil winds round the group

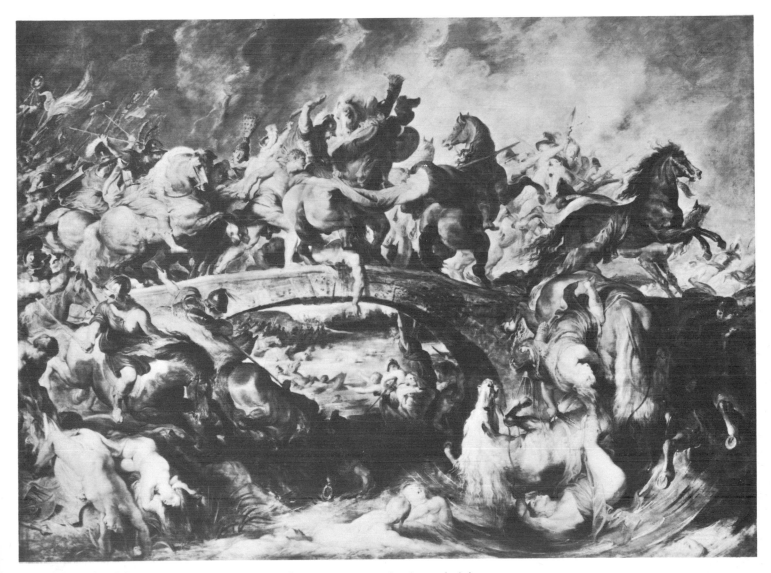

16 **The Battle of the Amazons** *c.* 1615–17 Panel 121 × 165 *Munich, Alte Pinakothek*

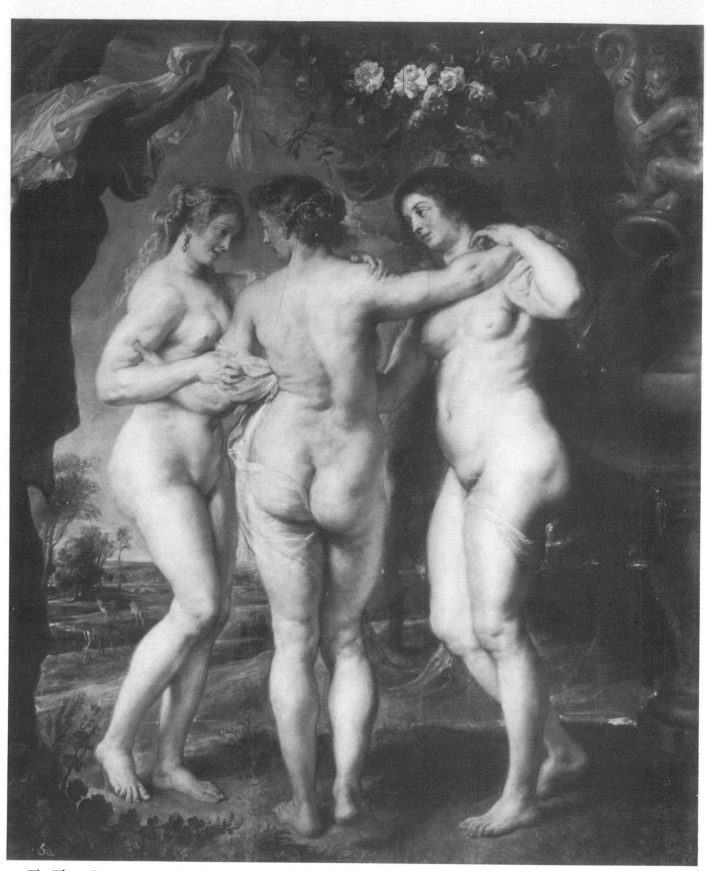

17 The Three Graces *c.* 1638 Panel 221 × 181 *Madrid, Prado*

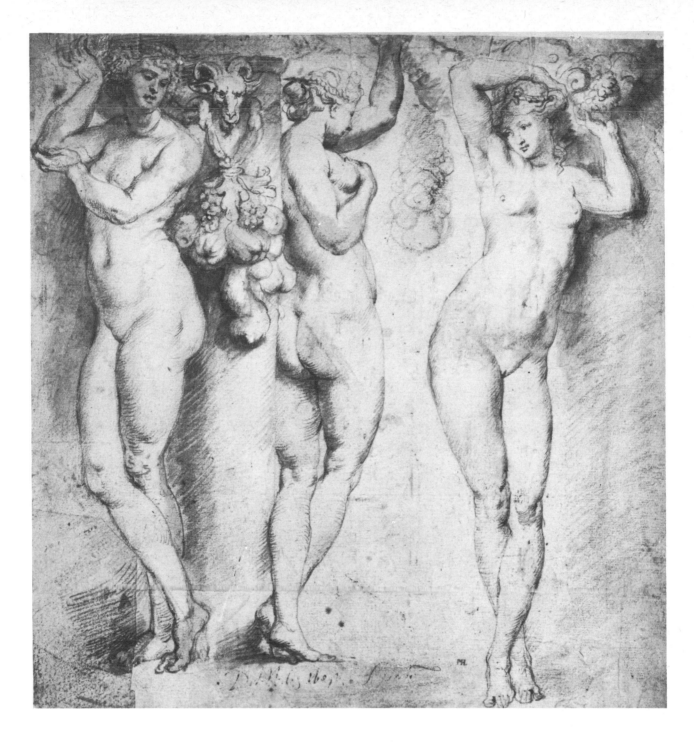

18 Three Caryatids
after Primaticcio c. 1622–5
Red chalk, watercolour and
white body colour 26.9 × 25.1
*Rotterdam, Museum Boymans-
van Beuningen*

While working for Marie de' Medici in the early 1620s Rubens had visited Fontaine-
bleau and there studied both paintings and stuccoes by Primaticcio. A study on the back of a
Fontainebleau School drawing he had acquired is a free version of three caryatid figures,
two from one pier and one from another, in the Chambre de la Duchesse d'Etampes (Plate
18). Rubens kept Primaticcio's elongated proportions, but instead of the smooth surfaces
of the stuccoes the dimpled skins of the figures in the drawing convey the vigorous muscula-
ture that lies within active bodies and is quite appropriate to the caryatids' function as
architectural supporters These figures may have been related in Rubens's mind to a com-

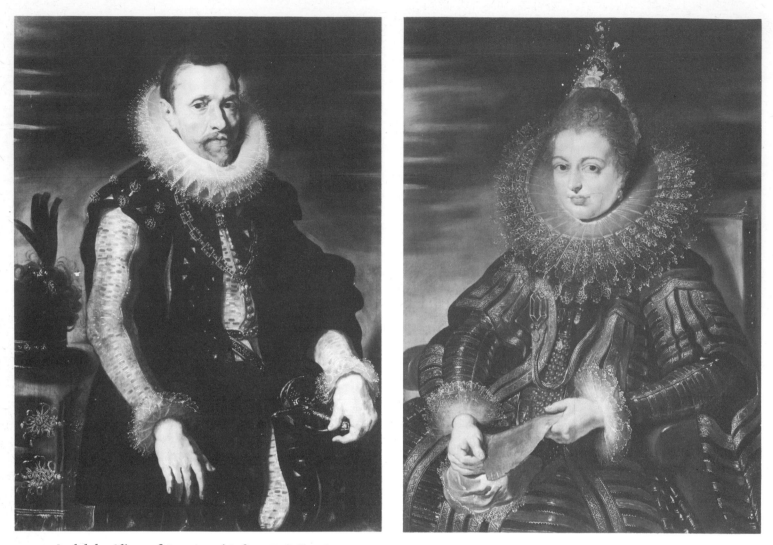

19–20 Archduke Albert of Austria and **Infanta Isabella Clara Eugenia** *c.* 1612–13
Panels each 105 × 74 *Vienna, Kunsthistorisches Museum*

position of this period of the *Three Graces* holding aloft a basket of flowers (Vienna, Akademie).

The figures in the later painting (Plate 17) are no less ideal than the elongated nudes of Primaticcio, and facially they are types, not portraits. By giving these solid yet insubstantial personages all basically the same pose Rubens shows their sisterhood as well as their ideal nature, and by framing them formally with drapes and a garland he recalls their origin in metaphor. But at the same time he brings them individually to life with the accidents of dimpled skin and subtly differentiated reactions to touch and pressure. However, both ideal and emblem come to warm-blooded life at one instant in a Rubensian landscape. In marble the closed circle of glances which signifies *gratiarum actio* or thanksgiving would raise a barrier between the group and the beholder; these figures, however, we seem to discover accidentally and unawares.

[40]

III PORTRAITS AND LANDSCAPES

In portraiture unawareness can only be pretended, since portraiture is a collusion between artist and sitter. Rubens made even the absent and the dead aware, live and speaking (Plates III, 21) but nowhere is the fusion of the individual and the ideal more evident than in his portraits. Because portraiture deals more with the particular and accidental than with the heroic and ideal and intellectual it was considered inferior to history painting. On the other hand, because portraits were in demand as likenesses, symbols, gifts, memorials and even collectors' pieces, they offered a fairly reliable way for a competent painter to make a modest living – and for a clever one to make a fortune.

Rubens's duties at the court of Mantua included portraiture when Frans Pourbus was absent, although painting French beauties was another matter (p. 13). As court painter to the Regents in Antwerp, his official duty was probably to paint the Archducal portraits, devising new ones from time to time or for special purposes, and providing replicas to represent his masters abroad. This obligation cannot have distressed him much, since as sitters for the originals they soon became friends, while the production of replicas was in the hands of assistants. In the pair acquired by the Kunsthistorisches Museum in Vienna in 1921 (Plates 19, 20) a few details appear unfinished, and this led them to be considered the original state portraits of 1609 on which the several other surviving versions depend. But recently tree-ring evidence has dated one, and therefore probably both, of these paintings not earlier than 1612–13; this dating is consistent with stylistic evidence and does not exclude the probability that Rubens painted most of the Vienna portraits himself. In devising patterns for state portraits he looked back to his great precursor Titian; like Titian he infused the official portrait's primary function as a symbol of authority with both corporeal likeness and psychological insight.

Since Post-Impressionism critics have tried to ennoble those portraits which have notable 'formal values' as opposed to those which show psychological insight, but such arguments were unknown to Rubens. Again like Titian he painted almost every kind of picture; although 'pure genre', which excludes idealization, hardly figures in his *oeuvre*, he did own seventeen peasant and tavern scenes by Brouwer. Indeed, while copying old masters was part of his job in Mantua he copied for himself Titian's portraits in particular; his early copies were made to learn how, like Titian, to see and paint the whole first and the

details (for which the Flemish were generally renowned in Italy) subordinately. He was never afterwards in danger of becoming a 'professional' portraitist to order, but could afford to choose his sitter. Often he painted friends, whether rulers, clerics, intellectuals or his own family.

Two composite group portraits survive in which Rubens included his own likeness with those of other persons, living or dead. They combine functions of portraiture as likeness and icon with those of history painting, although the occasions they commemorate are not known with complete certainty. The *Self-Portrait with Friends in Mantua* (Plate III) seems to refer to the visit of Philip Rubens (1574–1611) to his brother in the summer of 1602. The location is given by the twilight Mantuan view in the centre, but the group is partly imaginary and is composed from heads observed at different times. The figures have been identified most recently as (from the left) Caspar Schoppe or Scioppius (1576–1649), Guillaume Richardot (identity probable), Philip Rubens's pupil in Italy (1578–16??), the painter Frans Pourbus (1569–1622), Philip Rubens, Peter Paul Rubens, and on the right the philosopher Lipsius (1547–1606), who must be the key to the whole group although he cannot have been present on the occasion.

The frieze-like arrangement of heads may be a conscious reminiscence of Roman cameo groups, taking precedence over the desire for spatial realism. On the other hand, a later group with equally strong Antique associations, *Justus Lipsius and his Pupils*, shows Rubens well able to integrate spatially an equally diverse assembly of portrait figures (Plate 21). Many authorities relate this second picture, alternatively known as the *Four Philosophers*, to the death of Philip Rubens (seated on the left) in 1611, but on grounds of both style and association a more plausible date is 1615. The painter stands on the extreme left, behind his brother, and the other figures are Lipsius, in the ermine collar, his executor Jan Woverius (1576–1635) and in the foreground Mopsus, one of Lipsius's three dogs. The prominence of the books on the table may thus be related to the publication in 1615 of Lipsius's edition of Seneca's works as well as of Woverius's edition of Philip Rubens's miscellaneous writings. In any case the meeting, with a view of the Palatine Hill outside, was imaginary. The bust is the pseudo-*Seneca* that Rubens owned; the tulips in the glass vase symbolize mortality, two being buds and two, for the dead persons, in full bloom. The curtain and marble column, which add to the sense of occasion, are taken from the repertory of Rubens's state portraits. How far he was prepared to extend this repertory is shown in the portrait of *Aletheia Talbot, Countess of Arundel* of 1620 (Plate XVI). In July of that year the Countess and the Earl's secretary visited Rubens in Antwerp. The secretary reported home that Rubens, although by then very choosy about portrait commissions, acknowledged himself honoured by a request from the English nobleman, 'one of the four evangelists, and sustainer, of our art'. The next day the Countess sat to him, but as Rubens had no large canvas prepared he painted the heads separately 'as they should be', including the buffoon and Robin the dwarf, and drew the poses and costumes and the dog. Later, wrote the secretary, 'he will copy with his own hand what he has done'. Rubens's real-life courtesy became royal treatment on canvas: elegant rather than pretty, with powdered face, the Countess sits regally with her

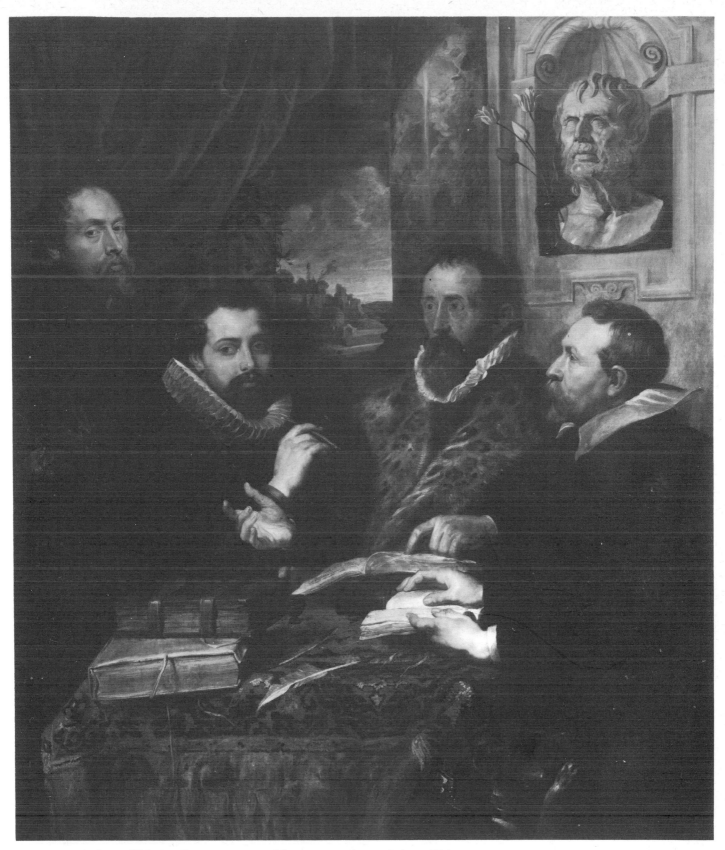

21 Justus Lipsius and his Pupils *c.* 1615 Panel 164 × 139 *Florence, Palazzo Pitti*

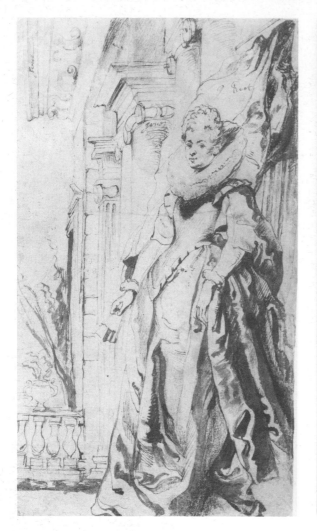

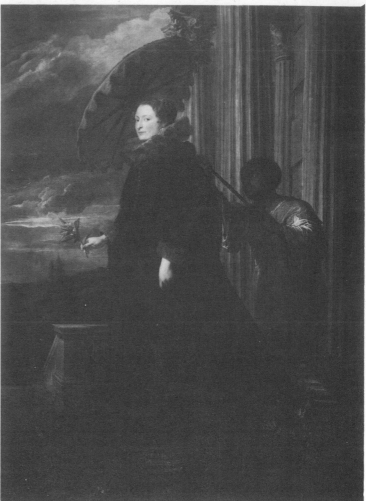

22 Portrait of a Lady *c.* 1621? Pen and brown
ink and wash over black chalk 31.5 × 18.5
New York, Pierpont Morgan Library

23 SIR ANTHONY VAN DYCK (1599–1641)
Marchesa Elena Grimaldi *c.* 1623 Canvas 247 × 173
Washington, National Gallery of Art

retinue before Salomonic columns, the Arundel arms appear in red, silver, gold and orange
on a great black curtain. Rubens's symphonic use of colour in this portrait seems to recall
his early experience of Titian, but may also show the influence of the young Van Dyck (p.
148). Black is a principal colour, used also in the carpet and the Countess's gold-trimmed
dress. Red recurs in her chair, the dwarf's coat and the hood of the falcon he holds. The
buffoon's gold costume is picked up in the distance, where lemon, pink and grey clouds
colour a blue sky above a golden sea-shore. No satisfactory identity, date or explanation has
been established for the man added on the right.

Rubens was not slow to recognize the calibre of a woman who would later confront
the Doge of Venice as an equal. If today such a painting, filled with the trappings of state,
seems unremarkable it is because Rubens invented or gave lasting life to formulas that
subsequently became commonplace. We expect a portrait to show an individual as himself,
whether the representation concentrates on physical features or a cast of mind. This expecta-
tion has been fulfilled wherever in Antiquity, as in the Renaissance and since, naturalism was

[44]

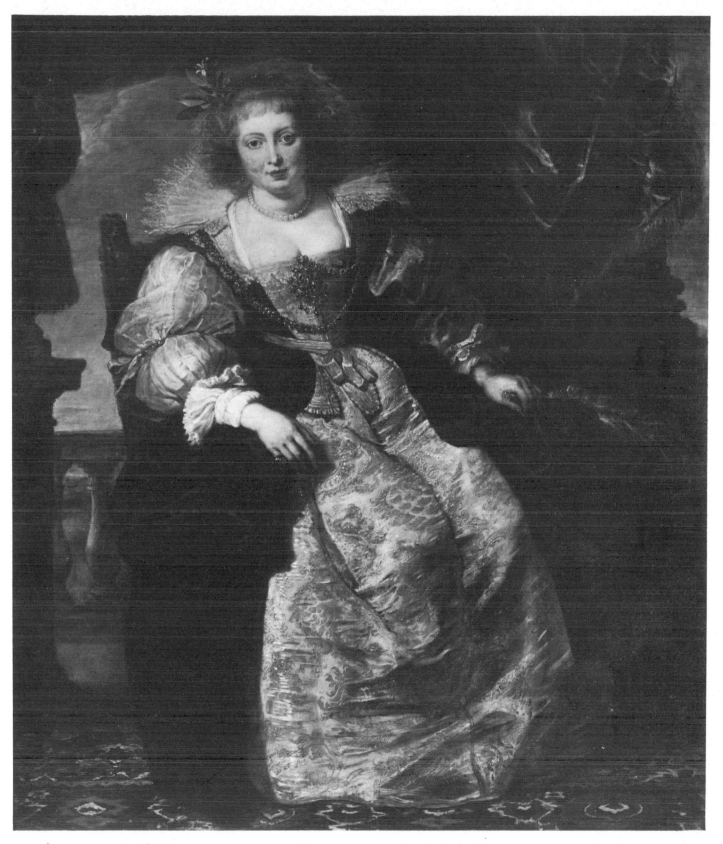

24 State Portrait of Helena Fourment *c.* 1631 Panel 162 × 134 *Munich, Alte Pinakothek*

valued. In our own day it is often argued that likeness should be conveyed by photography, but in remoter history and the Middle Ages portraiture had other aims. Only the mighty were then portrayed, and not their features but their power mattered; the state portrait is still today an icon with the function of representing an absent ruler. An icon conveys, and can even confer, status, and this is how Rubens built up his sitters. Lady Arundel with her retinue, a great heraldic curtain and venerable columns behind her and a carpet at her feet, was portrayed with sincerity and enthusiasm, because Rubens accepted the social structure of his day; questioning he reserved for the look of things and the events of history. Earlier he had brought architecture into the portraits of Genoese noblewomen in silks and millstone collars, framing them with niches or columns like saints in altarpieces (Plates VIII, 42). He combined an apparently speaking likeness of the Marchesa Spinola Doria with a high degree of idealization. The sitter married in 1605 and the portrait must have been finished in January of 1606, the year of a dated inscription, now lost. Architecture gives the Marchesa unprecedented stateliness; a crimson curtain billows out through the open window on to the balcony. Her silver-white dress with bronze lining and braid, her flawless complexion, brown eyes, reddish hair, and the background are painted from white, raw umber, crimson and yellow ochre; the columns are black marble. Even on her wedding day her skin cannot have been so beautifully matched to dress and accessories; nor can she, even by the illusionism of fashion, have stood the nine heads high that Rubens made her. The portrait was originally full-length, as we know from a lithograph of 1848 and a drawing (Plate 22). The latter is generally assumed to be Rubens's preparatory sketch, but careful consideration of what is included or omitted suggests that this is not so. The draughtsman altered the perspective and not only misrepresented but misunderstood Rubens's architecture; it is more probably a record made fifteen years later by Van Dyck, who took up in Genoa Rubens's portrait types, including his use of architecture and his elongated proportions, and adapted the standing to a walking pose (Plate 23).

Much later Rubens painted a state portrait of his second wife, Helena Fourment. He returned from England to Antwerp in March 1630 within days of Helena's sixteenth birthday; the child he had not seen for almost two years had grown into a young woman, whose features he first recorded in a coquettish half-length portrait in Brussels. On 6 December 1630 they were married. The full-length seated portrait, in black overdress, gold-decorated voile robe and white satin petticoat (Plate 24), is traditionally described as 'in wedding dress'. But although the myrtle in her hair is Venus's flower and the portrait was surely painted soon after the marriage her costume is but the height of fashion of the time: Van Dyck's portrait of the Marquesa Guzmán de Leganes in Washington (National Gallery) shows an almost identical outfit. The painter was an English and Spanish knight, his bride became Lady Rubens, and the plum-purple curtain, columns, balustrade and carpet make this a state portrait like those Rubens had painted in Genoa or that of Lady Arundel (Plate XVI). Yet formulas of state acquired new levels of meaning: Helena sits with knees and feet pressed together like Bathsheba in a late painting (Plate 104). Neither she nor the chair is straight, as if at any moment she may rock the chair or rise to her feet. And the direct captivating gaze

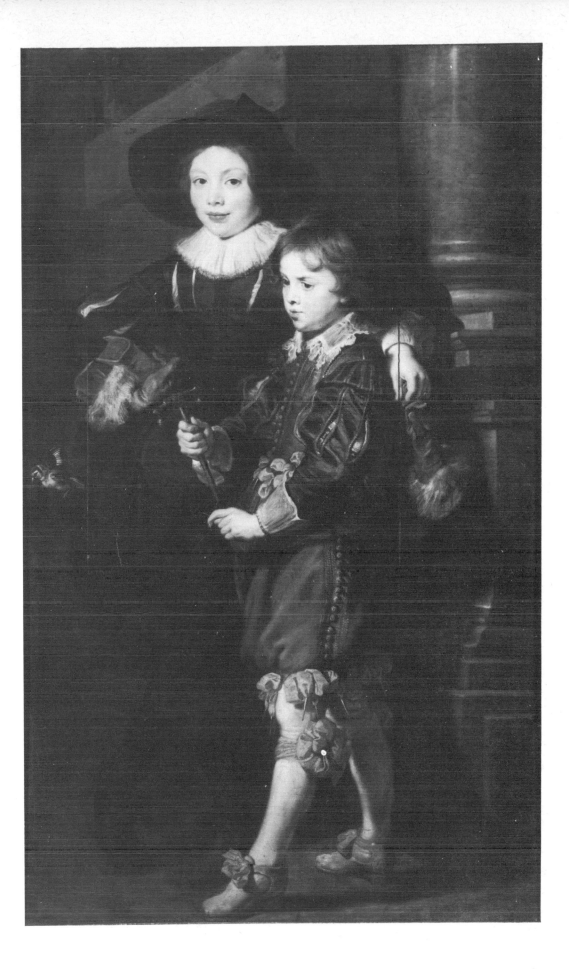

25 Albert and Nicolas Rubens
c. 1625 Panel 158 × 92
Schloss Vaduz, Collection of the
Prince of Liechtenstein

dominates everything, architecture, jewels, fine materials all painted with sparkling and detailed virtuosity.

Other occasions demanded other, equally innovative, types. In the equestrian portrait of the *Duke of Lerma* in 1603 (Plate IV) Rubens created a new portrait type and power-symbol. Lerma (1552–1625) was not only a connoisseur of pictures but also, as Philip III's First Minister, the most powerful man in Spain. He tried without success to induce Rubens to settle in Spain, but the painter did prolong his stay until December 1603 to finish this portrait. Whereas Titian's equestrian *Charles V* strides across the picture plane, Rubens for the strongest effect showed Lerma frontally, from below, solving the difficult technical problem of a sharply foreshortened trotting horse. He adapted to portraiture this arrangement from sixteenth-century representations of equestrian saints like St George and St Martin. Even his portraits with rearing or galloping horses never surpassed this image. But the painting is also a virtuoso performance in itself: the commander wears black and gold armour and a crimson doublet, and horse and rider appear in a kind of halo against the deep glowing sky of twilight and the dust of his cavalry in the distance. In two preparatory drawings Rubens seems to have used a substitute sitter, for the face is a different one. In the second drawing, as in the painting, he added an extra strip at the top with a palm branch arched over the rider. Like the Genoese portraits, the *Duke of Lerma* was imitated by other artists: Van Dyck used it for Charles I, and Rubens himself used it for Marie de' Medici, where the palm branch, a symbol of victory, is replaced by a personification (Plate 56).

In his portraits Rubens shows what is typical. Men of letters and affairs are represented as if in their studies (Plates 97, 98) although the portrait of the dietician Nonnius, of about 1627 (London, National Gallery) is framed by a niche and accompanied by a figure of Hippocrates just as, beside a column, Seneca overlooks his editor Lipsius (Plate 21). There must be overtones of state in the use of architecture in casual settings of Rubens's own family (Plates 5, 25) as well as in more formal ones (Plates 7, 24). In about 1625 (on the evidence of their apparent ages) he painted his sons Albert (1614–57) and Nicolas (1618–55). The elder boy holds books, the younger still plays with a live bird on a string. Despite their grand architectural setting they remain unmistakably children. A head study for Nicolas (Vienna, Albertina) and a copy of one for Albert show that the portraits were not painted direct.

The souvenir of his first wedding is too an icon, formal in the emblems of married trust on which the poses are based (Plate IX). In a lovers' bower in the evening, Rubens sits casually on a bench, his wife seated elegantly on her heels. Their dress has the brilliance and the fit of a fashion plate, and is painted in a degree of detail that belies the fresh-air ease of the poses. Light reflected from Isabella's collar makes her face almost shadowless. She wears a married woman's lace cap under her straw hat. Despite the picture's seeming casualness and momentary actuality, the figures were painted, each separately, indoors and locked into an oval composition of sweeping curves; the cutting of Rubens's hat by the frame seems to have been deliberate. The picture's meaning also combines the instantaneous and the eternal. Honeysuckle symbolizes fruitful love, and the outdoor setting of lovers clasping hands follows Alciati's emblem of marital fidelity. Unlike Rembrandt, Rubens never portrayed

[48]

26 The Family of Jan Brueghel the Elder *c.* 1612–13 Panel 124.5 × 94.6 *London, Courtauld Institute of Art*

himself as a painter; here he leans on the courtier's jewelled sword-hilt. As a wedding record the picture conveys likeness, status, happiness and vows in perpetuity.

Rubens's sensibility to posture, hands and eyes, the elements which most clearly inform the sight as words do the hearing, is apparent in his portrait of a colleague (Plate 26). Visiting Antwerp in 1614, Johann Wilhelm Neumayr von Ramssla found two principal painters, Rubens and Jan Brueghel (1568–1625), painter of flowers and small landscapes. We know Brueghel also from his letters to Cardinal Borromeo and his staff in Milan; written in atrocious Italian until Rubens became his amanuensis, they reveal a staid and modest man who with pride and enthusiasm puts forward his art but not himself. Rubens, who painted figures for some of Brueghel's pictures, depicted the Brueghel family as he did his own, headed not by a painter but by a burgher, a tender husband and father. Documents have recently confirmed the identification in this portrait of Jan, his second wife Katharina van Marienburg, and their eldest children, and also a date therefore of c. 1612–13. The Holy Family, the model for all Christians, is the basis of this family group portrait, but the focus is on hands, imbuing with personal warmth the symbolism of clasped hands (Plate IX), and eyes, linking the figures both to each other and to the beholder.

It has been claimed that Rubens exaggerated the size of his women's eyes (Plate 24). Indeed he understood the symbolic enlargement of eyes in primitive and Byzantine art, but such distortions of scale reduce the face to a character mask. Rubens emphasized the eyes and made them speak by the subtler means used by fashion models and camera stars, who know how to widen their eyes and use liner and shadow; in chalk drawings he often drew the pupils of the eyes in pen and ink. He could also coax a sympathetic sitter in an informal portrait, most notably in that of Susanna Lunden, *née* Fourment (1599–1643), traditionally but inappropriately – since the hat is of felt, not of straw – known as the *Chapeau de Paille* (Plate XVII). When she married Arnold Lunden in 1622 the young Susanna was already a widow. The portrait was very probably painted at this time, and the ring, although on the index finger, may thus be deliberately exhibited; perhaps also the dispersing grey clouds are intended to be symbolic of her changed status. The daughters of the silk merchant Daniel Fourment seem to have been exceptionally vivacious and pretty; Susanna was already related to Rubens through his first wife, and in 1630 her youngest sister, Helena, was to become his second wife (Plate 24). The informality of the portrait of Susanna is evident technically, in the manner in which it was enlarged at the right and lower edges during painting (p. 149), and in its emotional atmosphere. Her fashionable decolletage, with the new French square neckline, is emphasized by the support of her folded arms, and the picture's mood and expression imply some private relationship, coquettish and avuncular, and undoubtedly innocent. Nevertheless, although wrongly, the portrait was engraved in the eighteenth century with the title of *Rubens's Mistress*.

An interesting comparison may be made with one of the last portraits painted of his first wife Isabella Brant (Plate 27). A chalk drawing in the British Museum, London, although thinner in the face, is probably close in date. At thirty-four Isabella's features were softer and, more significantly, very familiar to Rubens, and this and similar portraits of her from

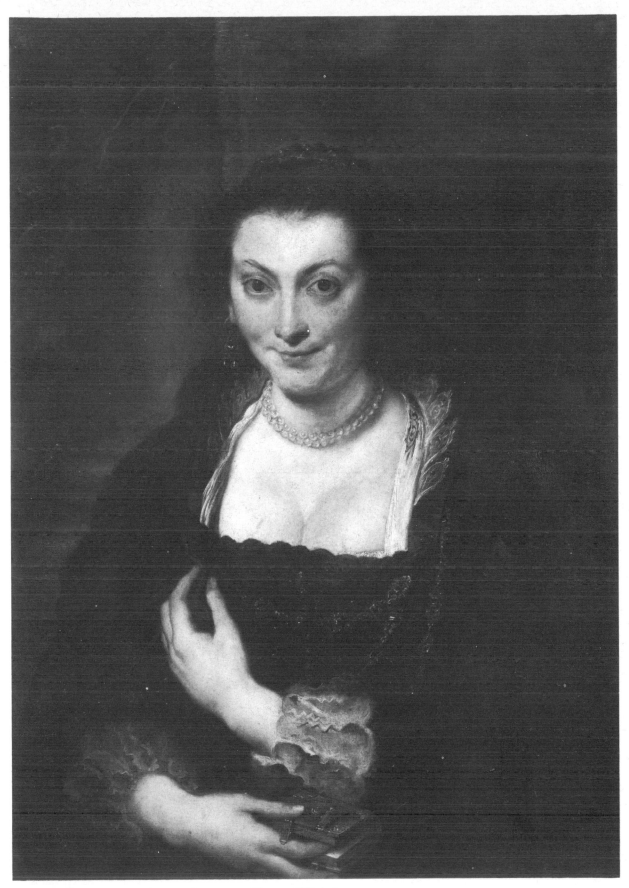

27 Isabella Brant *c.* 1625 Panel 86 × 62 *Florence, Uffizi*

the early 1620s embody sympathies more delicate and less equivocal than those in the portrait of Susanna.

Susanna Fourment was painted in the studio, and so were Rubens's landscapes although, just as he drew heads from life, he went out of doors to draw figures, animals and individual motives (Plate 31) and, in his last years, to record views in chalk or gouache. As a mode of painting he came to landscape late, and not merely because Renaissance theory undervalued it. His first master, Verhaecht, was a landscape specialist, and in 1603 Rubens declined to paint 'sylvan subjects' (p. 13); they would not earn an auspicious reputation for an aspiring history painter making his way in Italy. On the other hand he needed landscape settings (Plate 11) and his frequent delegation of backgrounds in the Antwerp studio to specialists like Jan Wildens (Plate 28) was good studio practice even if it shows that landscape interested him little. His interest seems to have grown as a hobby about 1616–17 with landscapes that are not only consciously constructed but also lacking a sense of actual locality. Moreover, while the development of seventeenth-century landscape was largely towards

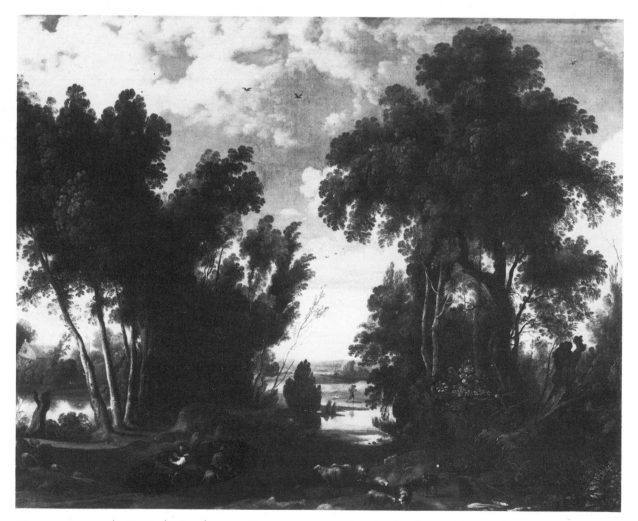

28 JAN WILDENS (1586–1653) **Landscape** Canvas 120 × 150 *Los Angeles, County Museum of Art*

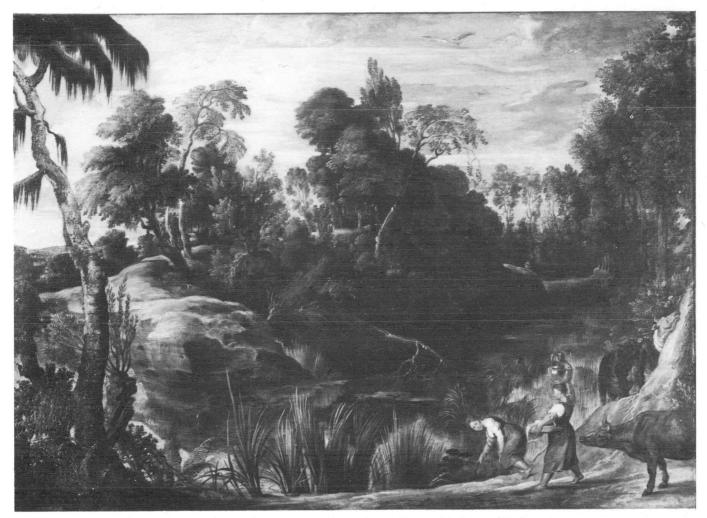

29 Landscape with a Hillock *c. 1616* Panel 76 × 107 *Schloss Vaduz, Collection of the Prince of Liechtenstein*

the creation of spaces, Rubens's concept of form led him naturally to depict objects. The *Landscape with a Hillock*, which is probably his earliest surviving landscape without narrative content (Plate 29), retains the stage-like formulas of a previous generation, with trees at left and right framing a central mass. On either side of the centre, more distant views are opened, and the eye is led into them more by tactile than by optical impressions: the twisting ridge of the hill on one side and the gulley on the other. Nevertheless, as in every other mode of his art, Rubens infused the formulas he adopted with new and abundant life: trees and plants seem to grow before our eyes, the earth itself seems to breathe, and even one of the cows winds like ivy round a tree-trunk on the right.

Similar terrain and trees appear in the *Landscape with a Boar-Hunt* (Plate 30), whose strong diagonals and rearing horses recall the life-size *Hunts* of *c.* 1615 (Plate 14). Between the converging forces of horsemen, hounds and peasants with pitchforks, the boar is trapped by a rotting fallen tree. Two drawings survive of an actual tree, made on the spot. One which

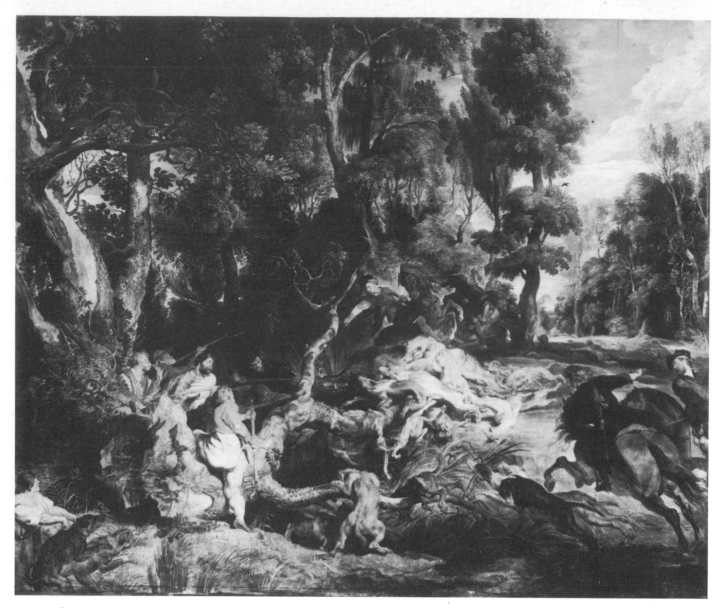

30 **Landscape with a Boar-Hunt** *c.* 1616 Panel 137 × 168.5 *Dresden, Staatliche Gemäldegalerie*

was used for the painting emphasizes the spiralling recession of the branches (Plate 31); the other (Chatsworth, Devonshire Collection) shows the tree from a position further to the right, spread across the picture plane. The tree on the far left of the painting is also dead and its trunk split. The violence of the action contrasts with the calm beauty of a landscape that encompasses both verdure and decay. Boar-hunting was known from Antiquity, and Rubens also painted a landscape with the Classical scene of Meleager and Atalanta hunting the Boar of Calydon (Madrid, Prado). When Jakob Burckhardt called the Dresden painting 'a "morality" of the inevitability of fate' he may have had in mind both the action of natural forces and the fatal ending of the Meleager story.

[54]

Landscape with a Fallen Tree
1616 Black chalk, pen
d ink 58.2 × 48.9
ris, Louvre

Soon, however, the landscapes begin to acquire a sense of place as strong as the sense of time engendered by the rural activities they encompass, the tending of flocks and crops, carting and hunting. A painting which belongs to this category, although it is not properly speaking a landscape, is the *Prodigal Son* of *c.* 1617 18 (Plate 32). This is one of the pictures which Rubens never sold and perhaps considered experimental. Certainly his treatment of the subject is individual. The parable of the Prodigal Son (Luke 15, 11–32) is unrivalled in graphic imagery. The Italians (and Rembrandt) favoured the themes of the prodigal's return and forgiveness; in the Netherlands his earlier indulgences were a popular subject which allowed both visual enjoyment and moralistic disapproval of scenes of loose living.

32 **The Prodigal Son** *c. 1618* Panel 107 × 155 *Antwerp, Koninklijk Museum voor Schone Kunsten*

The prodigal reached rock bottom in a far (that is, a Gentile) country, begging for the husks fed to swine, animals no Jew would keep. The wretched spendthrift receives equivocation from the pig-maid but deep suspicion from her companion. Gradually we take in the farmyard details: the evening light, the unloaded cart, the horses led to the pond, the piglets and an interested dog, the clutter of objects in the loft and on the ground the hay fork dangerously left prongs uppermost, the stalled cows, the sleek horses and three further figures tending them, two by candlelight. Behind all this lies the easy but relentless order of country life, of morning and evening, work and rest. But in the strong perspective and even stronger linear subdivision of the surface, the artist imposes an order of his own which invites comparison with the grandest of altarpieces or architectural scenes. A drawing for the cart was used in two other landscapes, and the model for the maid appears both in landscapes and in *Nativity* scenes at this date. The loft and its contents recur in an *Adoration*

33 **Autumn Landscape with a View of Het Steen** Detail of Plate XXVIII

34 **A Shepherd with his Flock in a Woody Landscape** *c.* 1618–20 Panel 64 × 94 *London, National Gallery*

of the Shepherds (Rouen, Musée des Beaux-Arts), and the left-hand horse is based on studies made in Florence from Giambologna's equestrian *Cosimo I.*

Two landscapes in the National Gallery, which are contemporary with the *Prodigal Son,* suggest the countryside near Antwerp and Malines, gentle and pastoral, full of streams and little woods, with many trees grown spindly and twisted from inadequate spacing (Plates 34, 35). By constructing such landscapes from features that are recognizably typical of a particular locality, Rubens achieved a more 'naturalistic' appearance than in the *Land-scape with a Hillock.* He also used the larger shapes of tree masses and contours, much as he used buildings in the *Prodigal Son* (Plate 32), to see and show the landscape as a whole rather than as a collection of interesting details.

These two pictures, which now hang side by side, literally grew in execution. The first, the *Shepherd and his Flock* (Plate 34), was originally limited to the perspective of trees along the bank of the stream, with the sun low down near the left edge. Rubens then nearly doubled the picture area, adding broad strips at both sides and narrow ones at the top, above the birds, and the bottom. He added the plank bridge on the right and made many small alterations. On the left he added the tree leaning outwards and elaborated the rest of the foreground clump to hide the original position of the sun, which he relocated near the new

35 The Watering Place *c.* 1618–20 Panel 99 × 135 *London, National Gallery*

left edge. In the mysterious wooded middle distance a huntsman and hounds course from left to right; the activity perhaps suggests a morning rather than an evening landscape.

The evolution of the *Watering Place* (Plate 35) was exceptionally complicated. Rubens began by painting a reduced version (a little over half-size) of the subject he had already completed. He then doubled the area by additions all round, putting in more foreground figures. Subsequent additions, mainly above and to the right, and in more than one stage, resulted in a panel made up of eleven members and six times the original area. Again he moved the sun further to the left; white clouds give a cooler light than the golden glow of the first picture. Much of the right half of the *Watering Place* is very thinly painted and brown in colour, but not necessarily unfinished. The whole sequence of both pictures probably took only a few months.

But even in the last golden decade, when his pursuit of fresh air was less energetic but perhaps more constant, Rubens's landscapes are pieced together and spatially not entirely coherent. This is true of the famous landscape in the National Gallery, London, with a

36 Landscape with a Distant Rainstorm *c.* 1638 Panel 90 × 134 *Birmingham, Barber Institute of Fine Arts*

view of *Het Steen*, painted in the autumn of 1636, although when the painting is hung with the base near eye-level, as Rubens would have hung it, the sequence from foreground to far distance is more logical. At a time when Dutch painters such as Van Goyen and Salomon Ruysdael were beginning to lower the horizon, to empty their landscapes of objects and to paint, as it were, the matrix formed by the sky and the clouds, Rubens still constructed his landscapes from objects – hedges, ditches, banks and trees – making a relief which the eye follows as if by touch (Plates 33, XXVIII). From the autumn flowers in the foreground and the fowler stalking partridges, through the hedges that cast blue shadows to the low yellow morning sun on the far right, we read the landscape by tangible objects; most of all by two great lines: from right to left along the stream leading to the house, and diagonally from the fowler through the branches to the line of trees corkscrewing into the distance.

Only rarely did he ever approach a more optical impression built from patches of colour and tone. Immediacy and fluidity of handling have given rise to suggestions that the small late sunset *Landscape with a Shepherd and his Flock* (Plates XXIX, XXX) was either painted from nature or conceived only as a sketch for another work. Such misreadings of Rubens's

economy are not supported by close inspection. The picture evolved gradually, with many alterations, and the right-hand quarter, on a second panel, was added with great deliberation. Rubens had discovered how to combine understatement in details like foliage with extreme precision in the drawing of branches, the steeple to the left of the sun, buildings and animals. His note on a drawing of trees at sunset (London, British Museum), 'The trees reflect in the water browner and more fully than the trees themselves', is relevant to the left foreground. This is the nearest he came to optical landscape: diagonals still feel their way over the ground, but everything is described by light from the flaring sun, which either illuminates or is interrupted by objects. Yet one light source was not enough for Rubens's ebullient plastic sense, and the sheep and shepherd in the foreground are lit from different directions.

 Rubens followed the Italians in often characterizing the time of day, especially morning and evening. In the 1630s Dutch landscapists began to observe and paint specifically wet and

37 **The Flight into Egypt** *c.* 1625 Panel 48 × 64 *Lisbon, Museu Calouste Gulbenkian*

38 Landscape by Moonlight *c.* 1637–40 Panel 63 × 89 *London, Courtauld Institute of Art*

windy types of weather, and it seems probably that Rubens was aware of, and even in-
fluenced by, this development. A larger very late painting (Plate 36) shows an abundance of
soft greens in the cool light of a windy day; in the right-hand distance is the purple-grey of
falling rain. The thinly painted foreground is predominantly brown and perhaps not finished;
in the belief that it was too empty several figures were added by another hand, mostly taken
from the *Watering Place* (Plate 35). When the painting was cleaned about 1940 the decision
was made to remove them.

Occasionally Rubens painted night landscapes, although the three that are known are,
as is the case with his precursor in this *genre*, Elsheimer, all connected with the *Flight into
Egypt*. A small finished painting of this subject (Kassel, Gemäldegalerie) is signed and dated
1614. Another *Flight into Egypt* of about ten years later (Plate 37) has the character of an oil
sketch, drawn with the brush; the transparent technique makes the moonlight scene more
luminous. The main group is similar to the Kassel picture, with Joseph turning to look for
pursuers and two angels leading the donkey. But there are many differences. The idealized
Madonna has become a peasant mother. The landscape setting is enlarged around the figure

[62]

and in the luminous transparency of Rubens's technique the two new angels not in the Kassel picture flying behind her seem as if they are part of the landscape. When he painted the Kassel picture Rubens admired, but could not yet re-create, Elsheimer's mysterious night scenes; a decade later he succeeded: mood and technique, figures and setting are totally integrated.

The *Landscape by Moonlight*, painted in Rubens's last years, is even more poetic (Plate 38). Here he originally painted a *Rest on the Flight* in the centre of the picture; subsequently he changed his mind and painted it out to make a pure landscape, leaving only the grazing animal in the foreground. Instead of the crescent moon of the earlier picture the moon is full in the midst of a starry sky.

IV GROUPS AND CYCLES

There is a parallel between Rubens's conception of space in landscape and his attitude to architecture. Many Renaissance artists turned seriously to architecture, and we should expect someone of his wide interests to have done so. Indeed his paintings show a consistent and very personal vocabulary of architectural detail so advanced for its time that on occasion it anticipates that of Borromini. Rubens also designed altar frames and statues, and parts of the decoration of the Antwerp Jesuit Church (p. 74) as well as the whole of his own house (Plate 4). But the chief architectural features of the Rubenshuis were the garden front, screen and pavilion, and while he was interested enough in the plans of Genoese *palazzi* to

Figure A. The original positions of the
three paintings in SS. Trinità, Mantua
From left to right:
Baptism, Trinity, Transfiguration

publish a collection of them in 1622, the architectural complexities of interior space seem not
to have engaged him. The apsidal top-lit sculpture gallery in his house is not really an ex-
ception to this, since he saw it as a setting for objects. His remarkable formal sense, which
would even turn figures round in his mind, made him a master of objects rather than of
spaces; space in his paintings exists between and because of objects and not independently
of them.

Paintings, however, are made of marks on surfaces. The special case of *trompe-l'oeil*
illusionism, as when painted figures seem to look out of painted windows or walk out of
walls, offers an apparent extension of our own world, as in a hall of mirrors. But all other
painting of the recognizable, from the early Renaissance to Cézanne, offers a real world
which exists within and by virtue of the picture, and which is equivalent to our world but
distinct from it. Rubens never used *trompe-l'oeil* except in tapestry where the woven texture
destroys the illusion (p. 90); significantly he came nearest to it in the youthful virtuosity of
certain early works (Plates IV, 39) whereas later he built up forms by dabs of colour and by
brush drawing in paint. Even the most surprising and immediate images like the *Deposition*
and the *Three Graces* (Plates XII, 17) present not illusory extensions but painted equivalents
whose reality invades *our* world. When Rubens came to paint groups or cycles of pictures
he adhered to the tradition of large-scale non-illusionist painting that runs from Giotto
through the Renaissance to the last years of the sixteenth century.

He met the tradition in post-Renaissance Italy, where walls were decorated with
frescoes or with large oil paintings, and it was in Italy that he made his first contribution to
the tradition. The Jesuit Church in Mantua, SS. Trinità, was inaugurated at Christmas 1596
although decoration continued afterwards. Jean Richardot, asking Vincenzo Gonzaga on
26 January 1602 to prolong Rubens's stay in Rome, wrote of 'grand and magnificent works'
begun in Mantua, and although the painted surfaces we now see date from 1604–5 it is not
impossible that the three pictures for the chancel of SS. Trinità, indeed the artist's master-
pieces for the Gonzaga, were started as early as 1601. After the French occupation of Mantua
in 1797 the church (now part of the Archivio di Stato) became a hayloft. Napoleon sent the
Transfiguration to France (Plate 41). The *Baptism* was extricated from the fodder in 1799 and

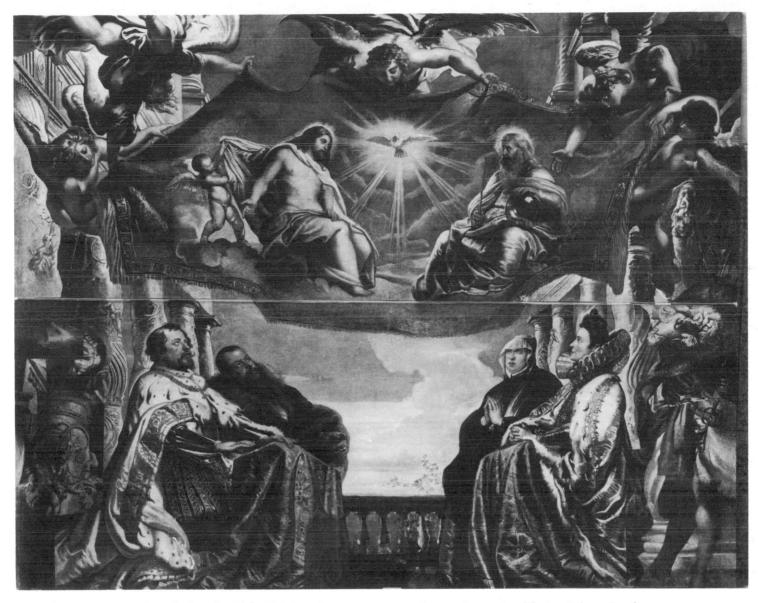

39 The Gonzaga Family Adoring the Holy Trinity *fragment* 1604–05 Canvas 384 × 481 *Mantua, Palazzo Ducale*

later sold (Plate 40). The central picture, the most damaged, was cut up in 1801; the patched middle, showing Duke Vincenzo, his wife and his parents, previous benefactors of the church, honouring an image of the Trinity remains in Mantua. Some separate pieces survive, cut from the outer areas of this canvas, of Vincenzo's three sons and two daughters and of halberdiers on either side; the right-hand halberdier's head, identified in the eighteenth century as a self-portrait, is lost (Plate 39).

Much has been written in attempts to decide finally whether the fragment in Vienna (Plate v) represents Vincenzo's eldest son Francesco IV (1586–1612), then aged eighteen and

40 The Baptism of Christ 1604–05 Canvas 411 × 675 *Antwerp, Koninklijk Museum voor Schone Kunsten*

youthfully obese, who died of smallpox soon after succeeding his father as Duke, or the youngest son, Vincenzo II (1594–1627), and this question is of more than academic import-ance. For the argument involves not merely comparisons with other portraits of Vincenzo's sons at different ages. X-rays show a differently posed head underneath the Vienna figure, which raises the question whether Rubens re-arranged the persons in the course of painting, perhaps over a period of three years. Moreover, the identification has a bearing on the way the painting was to be read. The light triangles in the top right corner of the Vienna frag-ment are part of the Maltese cross on the uniform worn by Ferdinando (1587–1626) in another detached portion (Private Collection, Wassenaar); in all attempts at reconstructing the missing areas of the picture Ferdinando is placed with the Vienna figure to the left on the surface and the other son, whose presence although not his identity is confirmed by early descriptions, to the right. If we read the portraits in order of precedence on the surface then the Vienna figure appears to be at the back, furthest from his father, and thus should be the youngest son. But if, in accordance with the strongly three-dimensional character of all the surviving parts, we read them in oblique perspective, then we see the Vienna figure as nearest to the picture plane, or in other words in front of his two brothers as befits the eldest son Francesco; this is surely what Rubens intended.

[66]

41 The Transfiguration 1604–05 Canvas 420 × 680 *Nancy, Musée des Beaux-Arts*

The over-lifesize portraits are effective from a great distance, and their technical brilliance and naturalistic viewpoint over the altar made them the nearest Rubens ever came to *trompe-l'oeil*. But the ambiguity of smaller heavenly figures, shown in front of a gold curtain, reinforces the identity of the canvas as painting, not illusion. The Salomonic columns have Doric capitals, like those used by Giulio Romano in the Cortile della Cavallerizza in Mantua, though their bands of vine relief derive from the *Healing of the Lame Man* in Raphael's tapestries, a set of which was in Mantua. The architectural setting of an open-ended court with a balustrade has precedents in Venetian painting, but Rubens also knew the marvellous open-ended space of the Piazzetta in Venice.

At first sight each of the huge canvases was symmetrical; however, while the *Trinity* was seen frontally, the *Baptism* on the spectator's left and *Transfiguration* on his right were seen from below and obliquely as one faced the altar (Figure A). Each picture had its autonomous space; the side ones are unmistakably surfaces as well as images of a three-dimensional world, and Rubens designed them so that, in an oblique reading, the figures nearest the spectator would seem to be in the foreground. Thus in the *Baptism* the main event takes

Figure B (*far left*)
The original relationship of
the three altarpieces in
S. Croce in Gerusalemme, Rome
Figure C (*left*)
The relationship of the three
panels in the Chiesa Nuova
(S. Maria in Vallicella), Rome

place towards the left in bright light; the figures on the right, shaded by trees, are the un-baptized in darkness (cf. Isaiah, 9.2). Each painting is divided into distinct groups and the foreground figures are over-lifesize. Each contains its own, heavenly, light source, and the three pictures are thus united by consistency of shadow rather than of light. The *Trinity* shines in golds, silvers and greys, with the black and white costumes offset by red furnishings, Christ's pink robe; it originally included (as a detached fragment shows) the deep turquoise of Eleonora Gonzaga's dress. In the *Baptism* different flesh tones work against a dark land-scape and a river degrading from turquoise to a bluish mother-of-pearl at the horizon which recalls faithfully the Venetian Lagoon. In the dark *Transfiguration* the figures, and the rare inclusion of the subsequent exorcism of the child in the right-hand group, depend on Raphael's famous treatment of the subject in the Vatican; the costumes are in greys and mutations of primary colours. Most of this picture, and the Leonardesque old men and Michelangelesque youths in the *Baptism*, imply experience in Florence and Rome, while the setting of the Gonzaga rulers behind draped prie-dieus suggests knowledge of Pompeo Leoni's bronze groups in the choir of the Escorial which Rubens saw in 1603.

When Rubens arrived in Rome, Annibale Carracci had recently (1597–1600) painted on the ceiling of the Farnese Gallery figures which eye one another across the corners of the real space of the gallery. In his first Roman commission (Figure B) Rubens painted three separate altarpieces, but St Helena (Plate 61) looked at a vision of the Cross on the chapel ceiling. He had perhaps already studied the chapel in Treviso Cathedral in which Porden-one's *God the Father* in the cupola, his drawing from which survives, was related spatially to Titian's *Annunciation* over the altar. A few years later, in the chancel of the Chiesa Nuova in Rome, Rubens went further than Annibale (Figure C).

On 25 September 1606 he had contracted to paint the principal altarpiece for the Oratorian church in Rome, which is dedicated to Our Lady but which replaced one dedicated to St Gregory. The relics of five early martyrs were brought to the new church in 1590–7; Rubens's altarpiece was to incorporate as an inset the miraculous Vallicella Madonna and show St Gregory and the martyrs venerating it. This altarpiece (Plate 42) was ready for retouching by June 1607 when Rubens was recalled to Mantua; at a trial hanging later in

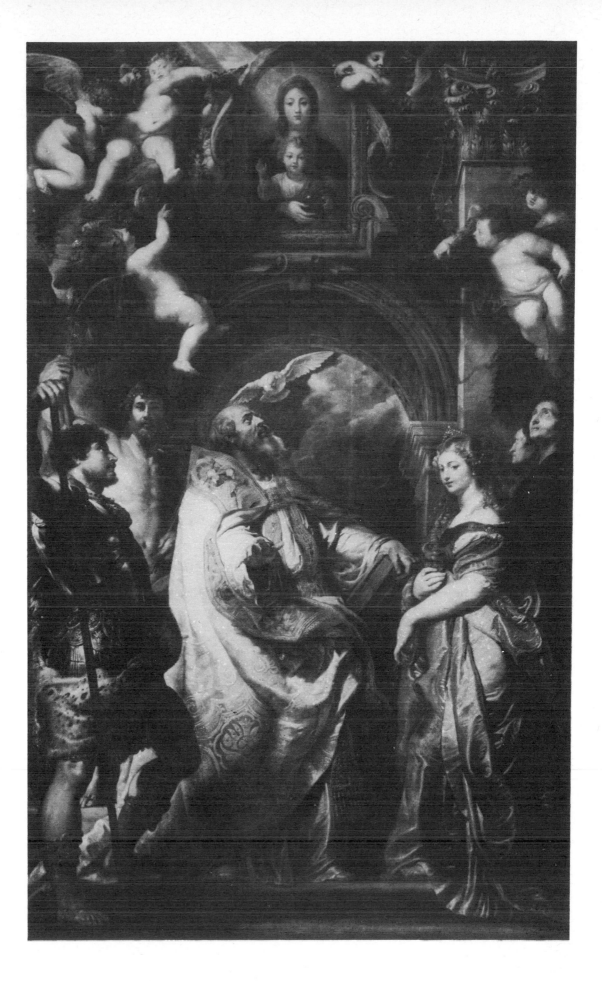

**42 St Gregory the Great
and Other Saints** 1607
Canvas 477 × 288
*Grenoble, Musée des
Beaux-Arts*

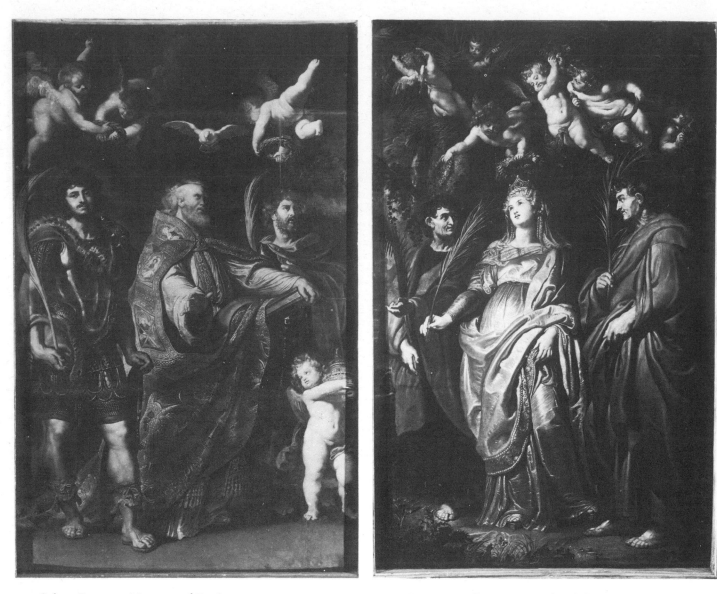

43 Saints Gregory, Maurus and Papianus 1608
Slate *c*. 413 × 262 *Rome, S. Maria in Vallicella*

44 Saints Domitilla, Nereus and Achilleus 1608
Slate *c*. 413 × 257 *Rome, S. Maria in Vallicella*

the year the clergy were not satisfied with the proposed setting for the Madonna. Rubens, however, found more serious objections; in particular the picture was so shiny that it was hardly legible. As the Duke of Mantua could not afford to buy it, Rubens kept the picture and in 1610 placed it by his mother's grave in St Michael's, Antwerp. The aperture for the miraculous image had never been cut, and the depiction of the Madonna and Child in its stead may only have been completed in Antwerp.

Between February and October 1608 Rubens painted not merely a new central composition *in situ* on slate panels (Plate 45) but also two further panels at the sides of the apse, into which he put the six saints (Plates 43, 44) looking towards the image of the Madonna over the altar. In the first version the saints stand before a ruined triumphal arch whose

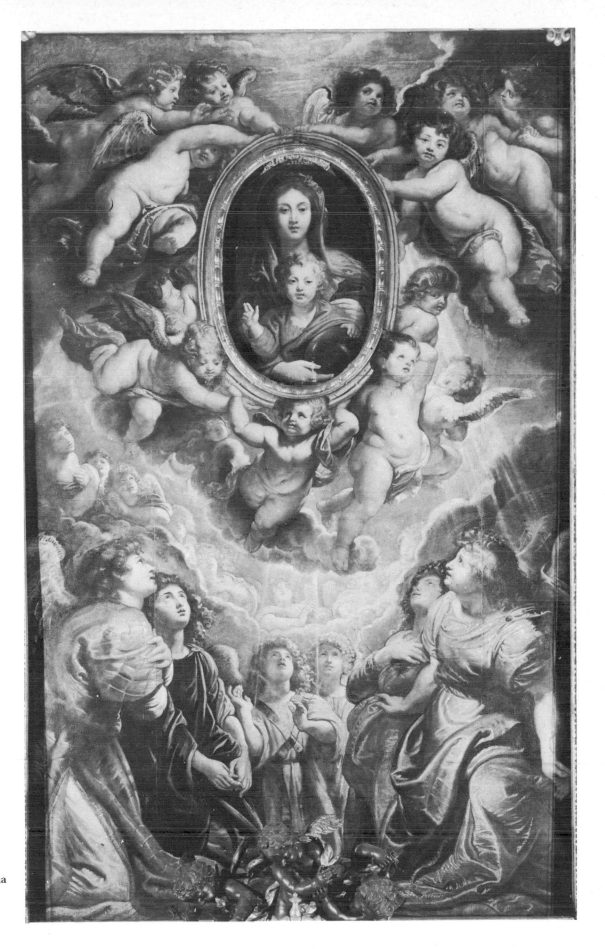

**45 The Image of the Madonna
Adored by Angels** 1608
Slate c. 485 × 268
Rome, S. Maria in Vallicella

Corinthian pilaster is a replica of those which articulate the church apse, as they appeared before the Baroque enrichment of the mid seventeenth century. In the second altarpiece the Madonna alone is honoured, and angels replace the architectural forms. The adoring saints now look across the real space of the apse, ranged like column figures in a medieval portal; moreover, they stand in echelon as if facing not diagonally out from the apse but towards the Madonna. The beholder's space is spanned by the continuity of the saints' gaze from the side pictures to the central one (Plate 44).

Back in Antwerp Rubens provided polyptychs for Gothic churches, but it is simplistic to see these as no more than a return to Gothic traditions of image making. Indeed in the first polyptych, the *Raising of the Cross*, the action in the main panel is again extended beyond its borders. In his earlier depiction of this event in Rome (Plate 62) Christ appears to look down at the beholder; in the Antwerp altar the divine gaze is so sharply turned upwards as to show most of the whites of the eyes (Plate 46). This was conceived as no mere expressive gesture, nor was the figure of God the Father, now lost, placed in the panel above (Figure H, p. 108) for decorative reasons. For it is to the Father in Heaven that Christ's gaze is turned, and both this gesture and the very raising of the cross are directly related to the actions of the priest saying mass at the altar below. The elevation of Christ on the Cross is not only an event but also the means of salvation according to Christ's own words, 'If I be lifted up I will draw all men to me' (John 12.32). Moreover this elevation is re-enacted at Mass when the priest raises the Host at the Elevation for all to see. And a moment earlier as the priest prepares to say the words of Consecration, he describes how at the Last Supper, 'Christ took bread . . . raising His eyes to Heaven to Thee, God His Father' – this detail is not in the Gospels – and the rubric directs him at the same time to look upwards.

Little is known about the original frame of the *Deposition* triptych (Plate 74), but it was certainly more elaborate than the present black wooden borders. In several later instances Rubens designed frames for his altarpieces, starting indeed with the unexecuted *Conversion of St Bavo* of 1610–11 (p. 108). In the altar for the new Jesuit Church he certainly designed both the architecture of the frame and its sculpture, including the Christ Child looking down from the focal point of the apse to bless the congregation, like the inset painted figure in the Chiesa Nuova altar. He must also have conceived the extension of the Roman proto-type by placing niches at the sides of the chancel, later to be occupied by statues of saints (Plate 47). In the Lady Chapel of the Jesuit Church he used painting, sculpture and real lighting, in a combination which became the prototype of many Baroque chapels; the effect has to be reconstructed (Figure D) because the altarpiece of the Assumption is now in the Kunsthistorisches Museum in Vienna. Real but concealed windows above and right of the altar shed light from the same direction as in the painted scene, while overhead a marble God surrounded by angels still reaches down to receive the ascending Mary. Rubens's original frame for the later Antwerp *Assumption* (Plate 89, Figure E) was crowned by carved figures of the Trinity as if the whole event were taking place in the Cathedral itself. In another altar, for the contemporary church of St Augustine, the Madonna's throne must have been designed to fit but also to soften the lines of the nave arcades that lead to it (p. 133).

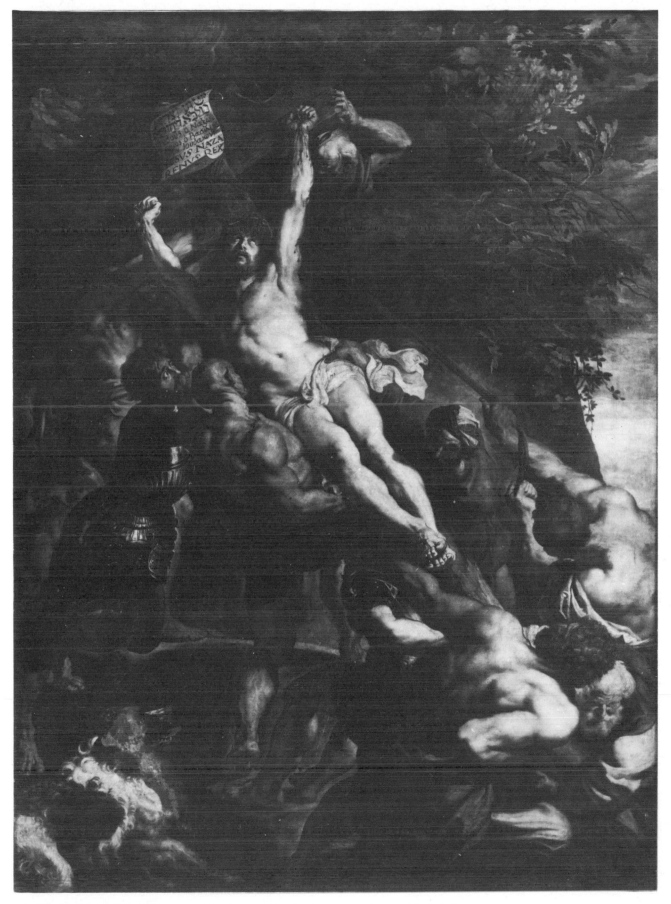

46 The Raising of the Cross *centre* 1610–11 Panel 462 × 341 *Antwerp, Cathedral*

Figure D (*left*). The original setting of the *Assumption* in the Lady Chapel of the Jesuit Church in Antwerp

Figure E (*right*). Father, Son and Holy Spirit in the original frame of the *Assumption* in Antwerp Cathedral

Rubens's major contributions to the decorative tradition, however, were in cycles of painting and tapestries. The *Decius Mus* tapestry designs were made for Genoa about 1617, but the decade from 1619 was especially concerned with series: in 1621 he wrote, 'I am by natural instinct better suited for very big works than small curiosities . . . no undertaking, be it limitless in quantity and variety, has overcome my courage'. A new palace was rumoured in London; his workshop had just supplied ceilings for the Antwerp Jesuit Church; he was designing tapestry, and would soon begin the paintings for the Luxembourg Gallery. In the early 1630s he would paint the Whitehall ceiling, and only the second Luxembourg Gallery would defeat him, through political, not artistic difficulties; the studio would supply, to his designs, massive decorations for the arrival in Antwerp of the Infante Ferdinand, and three-score large mythologies for the Torre de la Parada, Philip IV of Spain's hunting lodge near Madrid. Except for the last two, each of these commissions had an overall formal as well as an iconographical scheme appropriate to its context. All except the Whitehall ceiling now have in some measure to be reconstructed because the originals have been removed or even destroyed. Four commissions warrant special discussion.

The Antwerp Jesuit Church was begun in 1615 and dedicated in 1621 to St Ignatius Loyola, founder of the Society of Jesus, in anticipation of his canonization in 1622. It marks a transition from austerity to lavishness in Jesuit churches. The architects were the Jesuits Aguilon and Huyssens, but Rubens designed sculpture for the facade (there are drawings for the angels in the door spandrels (Plate 49) and the panel with the IHS monogram (Plate 48)), the marble high altar, and all the decoration of the Lady Chapel (1625). On 29 March 1620 he signed a contract to provide, in less than a year and with the help of assistants, thirty-nine large ceiling canvases for the two aisles and the two galleries over them. In 1718 lightning caused a fire which destroyed the ceilings; their steeply foreshortened compositions are recorded in prints and drawings and some of the autograph oil sketches and *modelli* which by contract Rubens was allowed to keep in exchange for the provision of the *Assumption* for the Lady Chapel. In the final paintings delivered in February 1621 the contribution of Van Dyck, named in the contract as principal assistant, may have been considerable, but Rubens designed and painted the *modelli*. He must also have conceived the underlying order

47 **Borromeuskerk, Antwerp** The Chancel

48 **Borromeuskerk, Antwerp** Detail of Façade

of the whole series, though since none of the paintings survived the fire the nature of that order is no longer self-evident.

The restored church is now parochial and dedicated to St Charles Borromeo. In the Rhineland the Jesuits were concerned to emphasize the continuity of the Roman Catholic Church by reviving for their buildings the late Gothic style. The Antwerp church was based in plan, more radically, on Early Christian aisled basilicas, and its paintings and marble inlays struck an early visitor as a 'paradise' (Plate 50). Each aisle and each gallery had a sequence of nine paintings, each about ten by twelve feet in size: three slightly smaller fields under the west gallery showed the patron saints of the Archdukes. In Byzantine churches the mosaics were disposed hierarchically and architecturally to form a symbolic model of the ranks of heaven. In the Antwerp aisles alternate bays from the corners contained the four Greek and four Latin Doctors, the great doctrinal pillars of the Church after the Evangelists and St Paul; in between them were female saints, mostly early martyrs, who are part of the Church's foundation. In the gallery ceilings this architectural principle of alternation did not operate: Old and New Testament scenes were paired as type and antitype, the Adoration of the Kings for example being prefigured in the Queen of Sheba's visit to Solomon. All the panels were placed to read as one faced the altar (east) and in a perspective of about 45

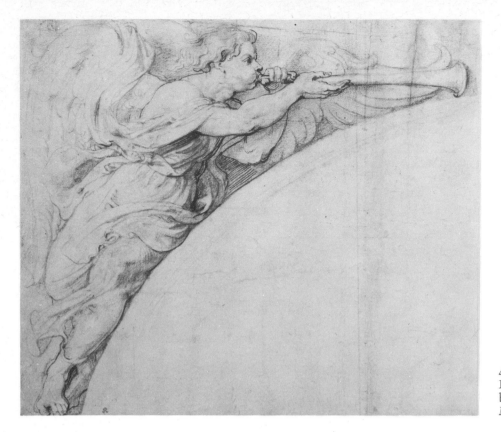

49 Trumpeting Angel *c.* 1617–20
Black and white chalk, pen and
brown ink 24.5 × 28.3
New York, Pierpont Morgan Library

degrees from below (Plate 51). The upper, biblical panels were lit by side gallery windows
and could be seen through the arcades from the church floor – though not all at once. Each
gallery ran in historical sequence from east to west as in Michelangelo's Sistine Ceiling; to
read each one the beholder would gradually raise his head or step backwards. The lower
panels were less brightly lit and could only be seen singly and from within the arcades; they
therefore had to be clearer and simpler with fewer figures.

Evidently Rubens did not impose an abstract linear pattern linking individual panels
because no overall view was possible. Instead he observed consistently three decorative
principles: variety, integrity of surfaces, and the elimination of weight. Between different
panels he varied the pattern of light and dark and the direction and tempo of compositional
movement; the direction of lighting also varied arbitrarily and not according to the light
from the windows. Moreover, these variations, and an overall dappling of tone and colour
in the upper ceilings when seen from the nave, preserved and asserted the integrity of the
canvases as surfaces rather than windows (the second principle). Thus, in spite of their steep
foreshortening, each individual painting offered an equivalent reality, not an illusory
extension, to the beholder's world; this distinction is the same as that already made in
considering pictures seen against a wall or in a vertical frame. At the same time, the upper
world of the ceiling paintings must have appeared to be one in which bodies, objects and
even buildings floated without weight (the third principle). This appearance in panel after
panel would have presented a kind of heaven above the beholder on the church floor. The

lower ceilings showed figures against skies rather than in interiors, although this was paradoxical since in reality they could be seen to be below the gallery spaces.

The high altar, which survived the fire, can be seen as a total exception to this scheme. It is a complex of painting and sculpture, visible from almost the whole church, and consistently lit not only by the side windows in the apse but also by a lantern in its semi-dome which corresponds to the divine light seen by the protagonists in all the four interchangeable altarpiece canvases, of which Rubens himself painted two (p. 123). This lantern also serves to light the carved Madonna and Child at the top of the altar frame (Plate 47).

The great ceiling in the Whitehall Banqueting House in London happily survives, recently restored to Rubens's original layout and as near as ageing of oil paint allows to its original tonality. After nearly three centuries in which the Banqueting House served first as a chapel and then as a museum it is now accessible and free of spatial obstructions; never-

50 SEBASTIAN VRANCX (1573–1647) **The Jesuit Church in Antwerp** *Vienna, Kunsthistorisches Museum*

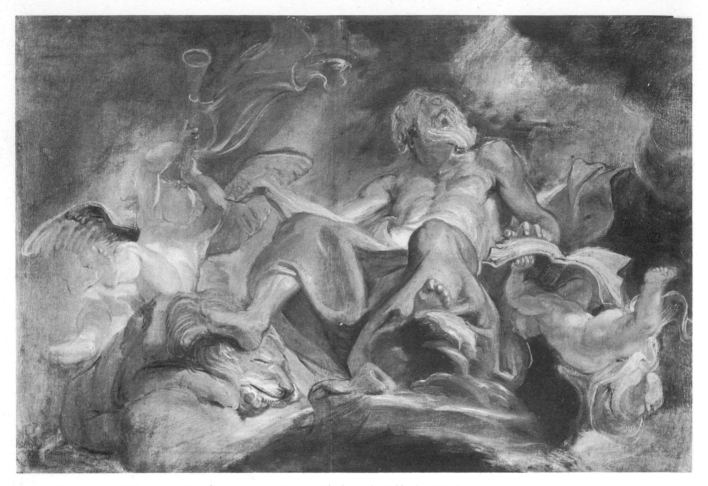

51 St Jerome *modello* 1620 Panel 30 × 45.5 *Vienna, Akademie der Bildenden Künste*

theless it is not sufficiently studied or illustrated. The tonal contrast between paintings and ceiling surrounds also makes photography difficult. The ceiling must be approached with three aspects in mind: architecture, decoration and propaganda. When the architect Inigo Jones built the Banqueting House in 1619–22 he chose a Venetian ceiling type, divided by beams and mouldings into various fields; he must have envisaged paintings in these fields, seeing the room as a sort of sandwich with zones of austere wall-articulation between the rich layers of ceiling, gallery (between storeys) and courtiers below.

As decoration Rubens followed the Venetian formula by which some compartments read correctly from each direction; those directly overhead are always upside down, those at an oblique angle are right way up, and the centre picture reads from the entrance (Figure F). Subsequently, probably in 1688, the panels were re-arranged, and their original orientation was not restored until 1973. Rubens knew by 1621 of the new buildings at Whitehall, but it is unlikely that he gave the projected ceiling serious thought or made any sketches before he returned to Antwerp in 1630 with the commission for it. In a single large sketch made soon after that, he worked out first the central *Apotheosis of James I* (Plate 52). He then

[78]

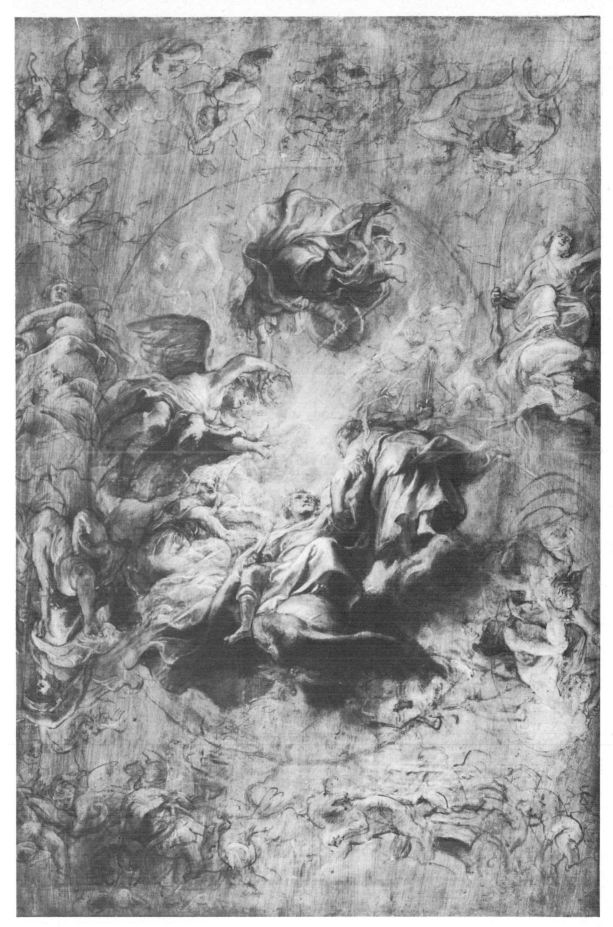

52 Sketch for the Whitehall Ceiling 1630 Panel 95 × 63.2 *Glynde Place, Viscount Hampden*

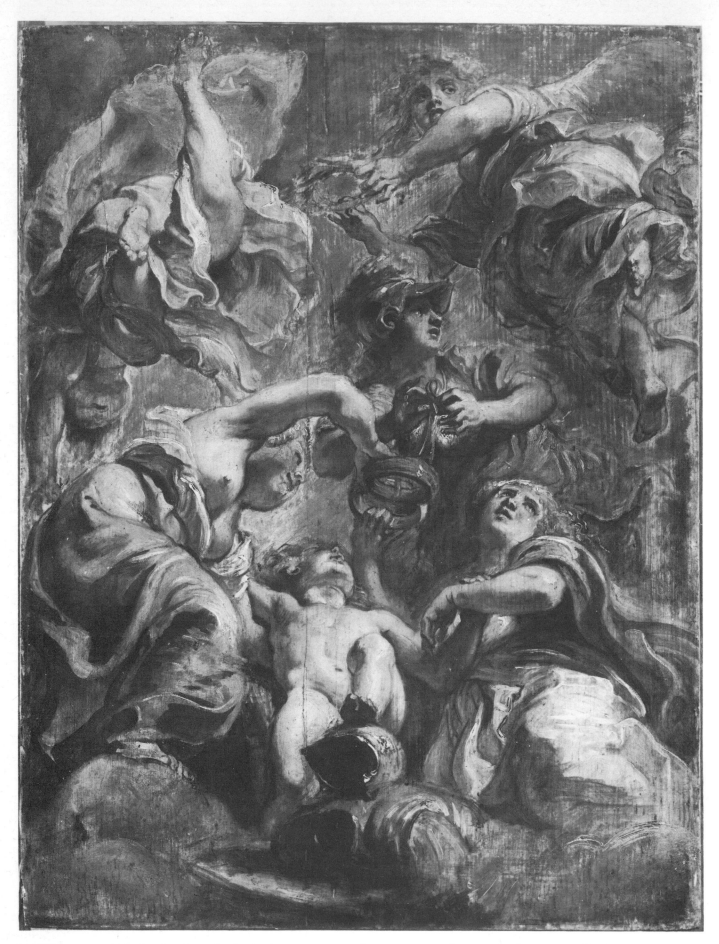

53 **The Union of England and Scotland** *sketch* 1630–31 Panel 64 × 49 *Rotterdam, Museum Boymans-van Beuningen*

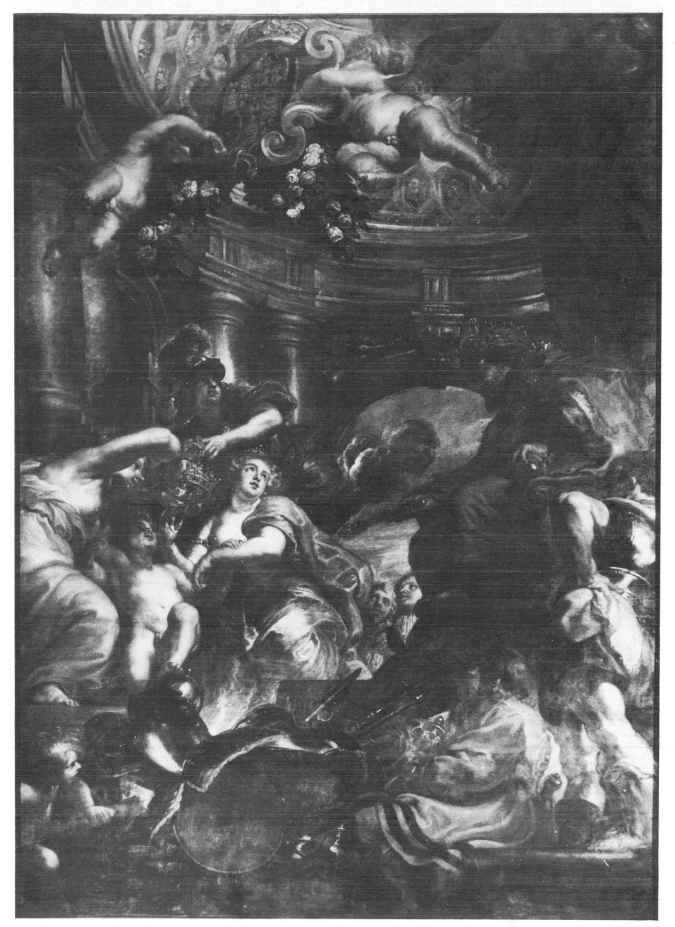

54 **The Union of England and Scotland** 1630–35 Canvas *c.* 716 × 503 *London, Whitehall Banqueting House*

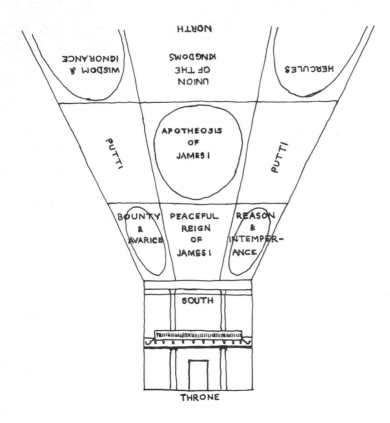

Figure F. The subjects of the Whitehall Ceiling, showing the directions in which they should be viewed

turned the panel through ninety degrees to sketch groups of *putti* symbolizing happiness. Finally in four ovals he sketched the corner groups, in which Reason conquers Intemperance, Bounty Avarice, Hercules Envy or Rebellion, and Wisdom Ignorance. In the sketch these are not yet in their proper places, and they overlap other groups, but they already face in the right directions. The sketch thus contains the germ of the whole ceiling (as well as the key to the re-location of its panels in 1973) except for the *Peaceful Reign of James I*, seen above the throne from the entrance, and the *Union of England and Scotland*, seen from the throne. Rubens then made a number of detail sketches before submitting *modelli* to King Charles I. He seems to have worked on several sketches at once. One of those for the panel at the north end, which shows James I enthroned witnessing the union of his two kingdoms (Plate 53), is close to the final painting (Plate 54), except for a shift of axis, and for the presence of two figures at the top which belong to the *Peaceful Reign* at the south end.

The canvases were finished by August 1634, but not paid for; a year later Rubens decided to retouch them in Antwerp rather than accompany them to London. Close inspection shows how far their legibility depends on the large strokes with which he transformed workshop products into his own. They were dispatched in December 1635. Their warm harmonious colours, red, pink, yellow, brown, grey and white, complement both the sand and cream colours of the architecture and the ceiling's optimistic themes.

As propaganda the paintings proclaimed the benefits of the wise and peaceful reign over a United Kingdom of the Stuart dynasty exemplified by its founder James I. In 1604 James VI of Scotland and I of England was proclaimed King of Great Britain. His concern for the union, which he called a marriage, between the two nations, was only second in his speeches and writings to the principle of the absolute God-given power of the Crown. The child over whom England and Scotland hold gold rings in the sketch, coronets in the final painting, is not an identifiable person, but undoubtedly symbolizes union between the two nations and love between king and people. As in many Baroque ensembles the programme was only completed when the living ruler, Charles I, sat enthroned below the image of his father in the ceiling. When the paintings were installed the English Civil War was only six years ahead and only King Charles and some of his court believed in their message; however, it was indeed addressed to them and to foreign embassies, that is, to those who could understand the ceiling's emblematic richness. The paintings still convey a more lasting message in the formal language of their art, but form and ideology are complementary. Rubens may have devised the iconography himself, but in discussion with the king; he was able to personify the major themes of Justice, Kingship, Peace and Concord without the element of illustrative journalism that dominates the earlier Medici cycle.

In 1622 Rubens had contracted with Marie de' Medici, widow of Henri IV of France, for pictures for two galleries in her new Luxembourg Palace in Paris. It was here that he came closest to the wall decoration of Italy, with which both artist and patron were familiar; this may have influenced Marie's choice of painter, although she knew of Rubens through her sister Eleonora, Duchess of Mantua, as well as from independent reports reaching the French court. Moreover the tapestries (Plate 55) Rubens was designing for her son Louis XIII set a standard for royal decoration which could otherwise only be matched, in the absence of local talent, by an Italian artist.

By 1620 Louis XIII, brought up under his mother's regency, had established himself as ruler of an officially Catholic France. Parallels were traceable between the achievements of Louis and his father Henri IV and the imposition of civil and religious order in the Roman Empire by Constantine, the first Christian Emperor, and in 1620–1 Louis commissioned from Rubens designs for twelve tapestries of Constantine's life. In the *Marriage of Constantine* (Plate 55) Rubens combined in one scene the weddings of Constantine and his sister although actually seven years separated the two events; the allusion is to the double marriage in 1615 of Louis and the future Philip IV of Spain with each other's sisters. Since Constantine's chief adversaries had been his brothers-in-law a cautionary comment is implied. Rubens relied heavily on Raphael's *Acts of the Apostles* cartoons as well as on Antique sculpture. In 1622–3 cartoons painted by assistants reached Paris. By 1625 Marie, defeated in life, had upstaged her son in art with the opening of the Luxembourg gallery, and Louis gave the seven hangings then woven to the Papal Envoy. The tapestries, now in Philadelphia, are exceptionally well preserved, and their saturated colours balanced by the shimmer of gold and silver threads compare well, as Ludwig Burchard observed, with the gold-ground mosaics of late Antiquity.

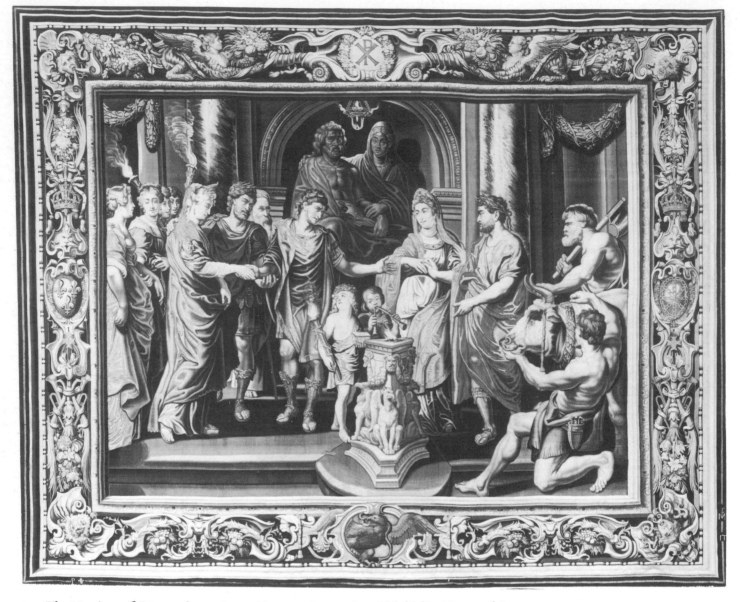

55 **The Marriage of Constantine** 1621–5 Tapestry 485.5 × 609 *Philadelphia, Museum of Art*

The best painter of women since Titian was an obvious choice for an ensemble of twenty-one histories of what the contract calls the Queen Mother's 'heroic deeds'. They were installed in the west gallery of the Luxembourg in 1625; Rubens spent several weeks re-touching the canvases, in which he had relied considerably on assistants. The second series, for the east gallery and devoted to the life of Henri IV, was abandoned in 1630 after Marie's exile. In 1802 the Queen's Gallery was made into a staircase, and the paintings are now in the Louvre. The key to the series is the separate portrait of Marie, rather comically bare-breasted in the guise of Minerva. As an educated Florentine princess, married at twenty-seven, crowned and widowed at thirty-seven (May 1610), made Regent but subsequently estranged

56 The Capture of Jülich 1622–5 Canvas 394 × 295 *Paris, Louvre*

Figure G. The overall pattern of scenes 5 to 9 of the Luxembourg Gallery as seen from the entrance

from her son Louis XIII, her career was under-supplied with the stuff of history painting. Rubens admired and befriended the reserved, intelligent queen dowager, and his pictorial tribute was whole-hearted, though even he did not find it easy to bring her to life. But, on the threshold of the age of the Absolute Monarch, he did create a triumphal sequence, read clockwise round the long narrow room, of allegories in which he drew on his accumulated experience of secular and religious history painting. As earlier in the altar of the *Miracles of St Francis Xavier* (Plate 87) celestial groups parallel the earthly, and he found formal analogies, and perhaps intended symbolic ones, with the life-story of a greater mother named Mary. Thus, like the Blessed Virgin learning from St Anne, Marie appears at Minerva's knee (Plate XVIII); the Castalian Spring behind them was sacred to Apollo (here playing a viol) and the Muses. Marie is welcomed at Marseilles on 3 November 1600 (Plate XIX) by France (in fleurs-de-lys) and the City (with a crown of towers). The capture of Jülich in the Rhineland on 1 September 1610, planned by Henri IV before his assassination, was the Regency's only military act: Marie herself stayed in Paris, and her presence with Victory, Fame and Strength in its depiction (Plate 56, adapted from the *Duke of Lerma*, Plate IV) is thus purely symbolic. The view of Jülich is based on prints of the Spanish recovery of the citadel in 1621.

Rubens provided for the gallery a series of canvases to fill the ends and the spaces between the side windows, and apart from a dado and stucco frames and infilling the paintings constituted the wall-architecture. Marie's plan was for a sequence of subjects alternating from one wall to the other, but Rubens managed to change this to a clockwise reading starting with the left long wall. From the end of the gallery direct daylight would be obscured by the thickness of the walls. The visitor entering in the right-hand corner thus saw first two of the three very big paintings at the far end: Marie's coronation as Queen of France and the symmetrical hinge-picture on the end wall between her life as a girl and wife and that as regent and dowager. The visitor would then take in the left-hand wall in general before starting at the near end with the first history. On this wall Rubens followed the tradition of the great Italian decorators in grouping pictures together to form larger overall patterns. The first three scenes form a triptych around the *Education of Marie* (Plate XVIII). The next five pictures also form a symmetrical group, in which the three middle compositions

are linked tonally by a large shallow V which runs through them, while each of the two outer ones, depicting the *Proxy Wedding of Marie* and *Henri making Marie Regent*, is a symmetrical composition framed by architecture (p. 155, Figure G). The right-hand wall, however, could only be seen from the entrance in extreme foreshortening, and Rubens therefore composed no larger pattern but designed all the pictures on it as individual compositions. On longer inspection other formal symmetries appear: one aquatic scene opposite the other, a dark purple in two opposite canvases. The dominant colours of the series are scarlet, turquoise, yellow ochre, grey, gold, blue-green and flesh, but the first panels, depicting Marie's childhood are more restricted in palette and the last six, relating the queen's quarrels with her son, the young king, are darker than the rest. Rehanging in a gallery of the right shape would undoubtedly restore other formal virtues of Rubens's largest surviving cycle.

The decorations for the arrival of the Cardinal-Infante Ferdinand (a cardinal at ten but never a priest) in Antwerp on 17 April 1635 were unusual in both the gravity of their message and the artistic stature of their designer. State entries represented a contract between ruler and people of renewed benefits in exchange for loyalty; Antwerp was now fighting not for military but for economic survival. In 1628 Rubens described the city as living on its savings, without trade, for quite apart from the continued Dutch blockade of the Scheldt (p. 15) Spain had deprived Antwerp of the right to trade with the Spanish Indies; this was the most obvious concession to be sought through the new Governor, the King of Spain's younger brother. The decorations were designed by Rubens, Caspar Gevaerts and Nicolas Rockox as both a loyal welcome and a desperate plea for the dying city's economy. Rubens drew on earlier *Entries* of which there were records, and much of the imagery was traditional and local and well known to Antwerp citizens. The decorations consisted of nine huge scenic structures of wood and cloth, with cut-out figures, real mouldings and banners, and large canvases of portraits and allegories. Ferdinand was greeted by a stage 75 feet, nearly 23 metres, high showing his own progress and arrival as the victor, jointly with his cousin Ferdinand, King of Hungary, over the Swedes at Nördlingen on 6 September 1634 (Plates 57, 58). In the *Meeting at Nördlingen* the cousins shake hands (a symbol of concord) before their armies, below eagles with laurel crowns and Jupiter's lightning; the Hapsburg two-headed eagle appears below on the shield of Germania, in mourning black. The Danube river-god's urn pours water and blood. Rubens's pacifist handling of a martial subject is typical of his last decade. This golden painting, broadly composed and handled, was largely executed by Rubens himself when the *Stage of Welcome* was enlarged at the last moment. Since it was for the right side the composition, dominated by the central red of King Ferdinand's cape, is firmly closed to the right. It was of course designed to be seen from below, as its base stood twelve feet above ground.

Many of the iconographical intricacies and the Latin inscriptions accompanying them were recognized by a minority; their intended audience was the Governor, though much must have gone unexplained that spring afternoon. The City Council commissioned Caspar Gevaerts to publish a full account, which appeared in 1642 with engravings, made from

57 The Stage of Welcome 1635 *Engraving by Theodor van Thulden*

Rubens's original sketches, by Theodor van Thulden. The *Pompa Introitus Ferdinandi* is one of the handsomest products of the Antwerp presses, but when it appeared both Governor and artist were dead. The final seal on Antwerp's decline was set by the Treaty of Münster in 1648 which formalized the political situation and the closure of the port. The successors to Rubens's decorations were ironically to be in Holland. His style and imagery underlie the decoration of the Oranjezaal of the Huis ten Bosch executed in 1649–52 by pupils and followers in memory of the Stadholder Frederick Henry, Prince of Orange. And the sculptural and emblematic language of the new Town Hall of Amsterdam, founded in the year of Münster and upon the trade that had once been Antwerp's, would have been impossible without Rubens's example.

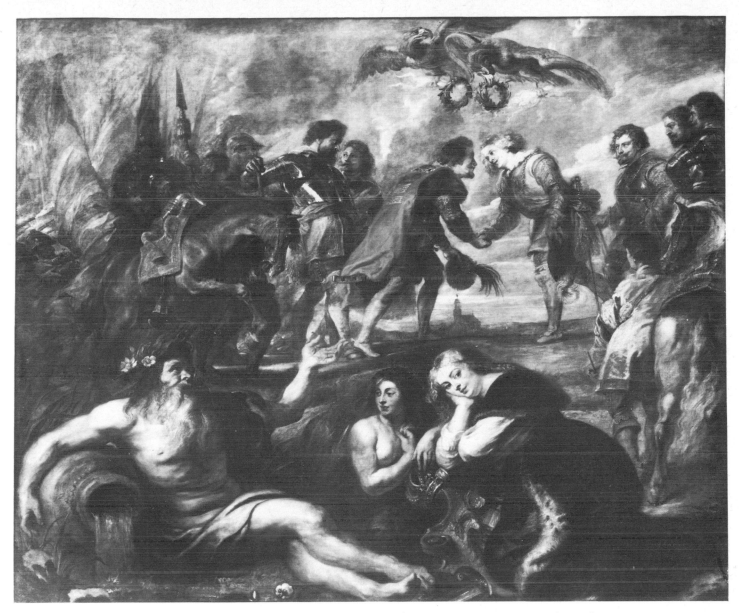

58 The Meeting of the Two Ferdinands at Nördlingen 1635 Canvas 328 × 388 *Vienna, Kunsthistorisches Museum*

Producing the decorations for the Entry of Ferdinand was very much like building a stage set: a hasty operation, to make an impermanent display, in which the work of individual executants is subordinated to techniques of over-emphasis in the service of clarity. Tapestries on the other hand take a long time to weave and, although movable, are meant to last for ever – or at least until sunlight and organisms destroy their dyes and fibres – but again a common style is imposed by the technique. Moreover, whatever the designer paints will be transformed not only by the nature of the weaving process but also by the function of tapestries in lining walls: the wall of a room is both a surface limiting its extent and a part of the structure which makes it safe to occupy, and unless the designer wishes deliberately to exploit impressions of ambiguity or instability the hangings should not contradict the

nature of the wall. Already in the *Decius Mus* and *Constantine* sets Rubens showed an understanding of this relationship between decoration, surface and structure, as clear as Raphael's in the *Acts of the Apostles*; narrative scenes are treated as high reliefs and the figures are large in proportion to the framed area (Plate 55). Because of its texture, the eye cannot read the *Marriage of Constantine* as a view through a window in the way it is tempted to do in the painted *Capture of Jülich* designed in the same period.

In the *Decius* and *Constantine* tapestries Rubens designed only the histories, but in the *Eucharist* and the *Achilles* series which followed them the borders were essential to his overall design. As a girl, Infanta Isabella had spent some months in the Madrid convent of the Descalzas Reales (who incidentally were Poor Clares, discalced Franciscans, not Carmelites as is often stated); soon after the death of her husband Archduke Albert she adopted the Clares' habit as her dress and became a member of the Third Order of St Francis. In 1625 she ordered from Rubens designs for sixteen Brussels tapestries of the *Triumph of the Eucharist* to be woven as a gift to the chapel of the Descalzas. Although the original hangings, delivered in 1628, are still in the convent, they are not in their original situation and their arrangement has to be reconstructed. A meticulous sketch for the whole altar wall (Plate 59) shows five hangings representing the Hapsburgs, with music-making angels (left-handed for reversal in weaving) adoring the Sacrament. In the centre is part of the chapel wall, on which Rubens painted from imagination features that are not to be found in the actual building: above the altar is a relief with a garland, loaves and a chalice, and above this a nun looks through the customary grille placed to give a view of the altar from within the convent enclosure. This sketch is the key to the series: the eleven side wall hangings, showing the defeat of heresies, the witness of evangelists and saints, and the three Eucharistic prefigurations of Melchisedek's offering to Abraham, the Manna and the feeding of Elijah, are framed by Salomonic columns above and Doric ones below, conceived as from a single viewpoint. In this architectural scheme Rubens recalled both his Mantua altar (Plate 39) and the description in Exodus 26 of the Holy of Holies, in which the presence of God prefigured that of Christ in the Eucharist (p. 102). It is difficult to relate Rubens's scheme literally to the details in the Book of Exodus, but it is notable that the description there led him to complicate his decoration: the architectural borders represent the structure of the Holy of Holies, and within them there appear to be other tapestries, representing the hangings with which it was adorned.

The eight oil sketches and the cartoons, and probably the intermediate *modelli* for the *Life of Achilles* tapestries, designed in the early 1630s, all belonged to Rubens's second father-in-law, the silk and tapestry dealer Daniel Fourment and a reasonable conclusion is that the stories were commissioned by Fourment for his business. The histories were popular, but few of the sets woven were made with Rubens's uniquely witty borders, in which stone-coloured herms observe and react to the histories. Rubens took this device, which he had already used in title-pages, from Annibale Carracci's fictive commenting sculptures on the ceiling of the Farnese Gallery in Rome (p. 68). Rubens may have devised the programme for the *Achilles* series himself, drawing not only on Homer's *Iliad* but also on Renaissance encyclopedias and commentaries and on other Classical authors. The story of Briseis (Plate

59 The Adoration of the Eucharist *sketch* 1625–6 Panel 31.8 × 31.8 *Chicago, Art Institute*

60 Briseis Restored to Achilles *sketch c. 1631–4 Panel 45 × 67.2 Detroit, Institute of Arts*

60) seems not to have been represented before. She had been captured by Achilles on his way to Troy, but was taken from him by Agamemnon; in anger Achilles then withdrew from battle. When his friend Patroclus was killed Achilles resumed his arms and other sequestered spoils. The whole incident involved not merely human rivalries but also the chain of celestial dissensions that forms a counter-theme to the *Iliad*. Rubens replaced the medieval morality of Achilles as the victim of the passions by the Classical themes of the influence of the gods on men and the dominance of love.

Briseis Restored to Achilles shows the dead Patroclus in his tent, and Achilles running to greet Briseis who is presented by Nestor under the direction of Ulysses, while attendants bring up horses and other booty. The joyful animation extends even to the framing herms of Mercury and Concord and the wriggling cornucopias in the lower border.

The series seems to have been produced on speculation and not with a particular site in mind, but when they are placed in order it can be seen that Rubens intended the tapestries to be read, individually and in sequence, from left to right with a full stop at the fatal arrow in Achilles's heel; the sketches are thus mirror-images in both forms and actions.

V THE HEROIC STYLE

Earthly life is a progress from birth to death. Every traveller on the road sees in the lives of others reflections of his own past and future; conversely, when we read a biography we trace the events of an individual life in relation to our own experience. This holds true whether the person portrayed was a great moral example, good or bad, a fighter or a competitor, a performer or a creative genius. We expect him or her not only to grow up and grow old, but to develop, to mature, to improve, and we count as most successful those lives whose close neither falls short of achieved aims nor follows decline and protraction. So there is a general expectation, not only that any study of an artist's work will include discussion of his stylistic development, but also more naively that development is in some way synonymous with improvement. There is also a supposition, more often made than substantiated, that discussing an artist's style is the key to appreciating him.

From the artist's point of view his latest work ought to be his best; otherwise he is going backwards. On the other hand he judges the work of any other artist no less objectively than do the historian and the curator of art, who measure quality in a work by the acceptability of the artist's aims and the degree to which he fulfilled them, not according to whether it is a late work or not. Creativity may lie dormant, blossom, wither prematurely or flourish without diminution, but it does not in itself 'get better'. Improvement takes place in other faculties: dexterity and co-ordination, observation, self-criticism, avoidance of mistakes, breadth of range, and the wisdom of years and experience. In Rubens's earlier works we are often conscious of the effort involved in their creation (Plate II) whereas the fluency and assurance of the later ones may deceive us into thinking them easily done (Plate 93).

Very few of Rubens's pictures are dated by inscriptions; in many cases documents can tell us when a work was commissioned or paid for, although in any given case unless they tell us both it is impossible to say how long the picture took to complete. But the greater part of Rubens's *oeuvre* can be dated only by indirect evidence, either by its historical, literary or topographical associations, or by stylistic comparison with dated or datable works. In the case of associations it is important to remember that, for example, a number of the works now in Italian collections were painted long after Rubens left Italy; in the case of style it is important to take account of the range of types and sizes of picture he produced, and to compare like with like. He was well aware that the purpose and location and even

the subject of a picture affect its composition, that the scale on which it is conceived and the distance from which it is to be viewed affect the size and sort of brush the artist uses, and even that a work produced by assistants may need to be painted in a different manner from an autograph one. And if for the artist style and function are interdependent, so for the art-historian are style and date; the degree of delegation to helpers can now only approximately be determined, and the range of approximation will depend on the experience and even the preconceptions of different scholars.

Moreover, the term 'style' embraces several different qualities, in particular *composition*, the way a picture is arranged of objects, shapes, colours, and lines of movement both on its surface and in the feigned third dimension; *form*, the way lines and tones and colours are used to convince the eye of what is depicted; *expression*, the way composition and form are used to convey a meaning; and *content*, the message which is conveyed. These qualities vary in importance between one work and the next and from one phase of the artist's career to another. We can often say with certainty what pigments Rubens used, what literary source he followed, what persons he represented. The characteristics of his style, on the other hand, are not absolute, and discussion of them ought to offer signposts to perception and inquiry rather than a substitute for what the pictures have to say.

When Rubens left Antwerp for Italy in May 1600 his knowledge of Antique and Renaissance art, derived though it was from prints and other easily transportable objects, was considerable (Plate 1), and his enthusiasm was fired both by his own study of Classical authors and by the attitude and example of his colleague and former teacher Otto Vaenius. He was nevertheless still entirely a Netherlandish painter. The works of art he saw in Italy gave him a new vision both of Italy and of his native country; it also exposed him to an almost overwhelming variety of influences. Certainly the paintings of his Italian years are stylistically less consistent than those after 1608; the period was one of experiment in which each undertaking posed new problems of both design and visual vocabulary.

Rubens's first commission in Rome shows his ability not only to absorb influences but to produce a personal, rather than a merely eclectic, amalgam full of new ideas (Plates 61–3). In June 1601 Archduke Albert determined to complete his modernization of the crypt chapel of St Helena in S. Croce in Gerusalemme, Rome, of which he had been titular cardinal as a young man. His representative in Rome Jean Richardot (p. 11) approached Rubens with the commission for three altarpieces on wooden panels for the chapel. Besides the major part of the True Cross, the church preserved the Title from it and part of the Crown of Thorns: all three appear in the main altarpiece of *St Helena*, the mother of Constantine and the finder of the Cross. This was finished by January 1602 and Rubens was allowed further leave from Mantua to finish the slightly smaller side altars, *Christ Mocked* on the left and the *Raising of the Cross* on the right (Plate 62). The latter was very soon badly damaged by water and was replaced by a copy on canvas in 1614. The pictures were removed from the church about 1750 and are now the property of the Municipal Hospital in Grasse.

St Helena's attendant *putti* (Plate 61) look back to those in Vaenius's *Martyrdom of St*

61 **St Helena** 1601–02 Panel 252 × 189 *Grasse, Cathedral*

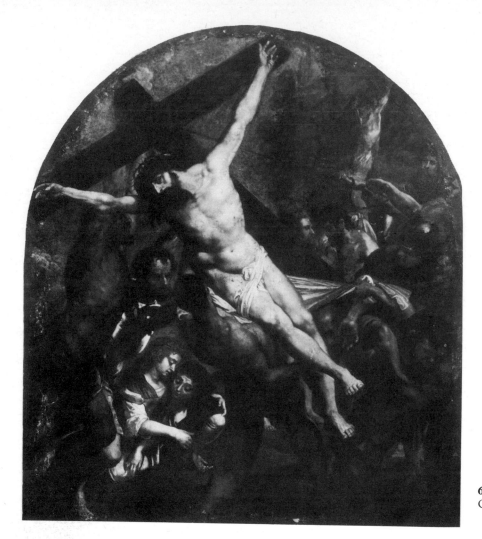

62 COPY AFTER RUBENS **The Raising of the Cross**
Canvas 224 × 180 *Grasse, Cathedral*

Andrew (Plate 2) but they are also clearly the precursors of Rubens's own later angels. The saint derives from a particular Roman sculpture of a matron and from Raphael's *St Cecilia* in Bologna, but she is also the seventeenth-century ecstatic type later celebrated in sculpture by Bernini. The triumphal arch and the purple curtain behind her are imperial symbols; the Salomonic columns recall those in St Peter's, then believed to have come from the Temple in Jerusalem, and thus represent ambiguously both the original and the established centres of the religion of the Cross. In *Christ Mocked* (Plate 63) Rubens showed Pilate on his palace balcony, in accordance with the latest biblical research of the time. The figure of Christ recalls both Titian and the Antique (p. 144); the strong and artificial colouring recalls the *Judgement of Paris* which is probably a little earlier (Plate 11) while the exploitation of the night scene implicit in the Gospel account and the violent gestures suggest the work of Rubens's near contemporary Caravaggio. In the *Raising of the Cross* (Plate 62) Rubens emphasized, as Caravaggio had just done in his *Crucifixion of St Peter* in S. Maria del Popolo, the ungainliness and the strain of lifting a heavy beam; the operation is the more painful and precarious because Christ's feet are not yet secured to the cross.

In all three altarpieces, while the principal figures are near the picture plane, strong diagonals constantly tempt the eye into the background; the figures, although under life-size,

[96]

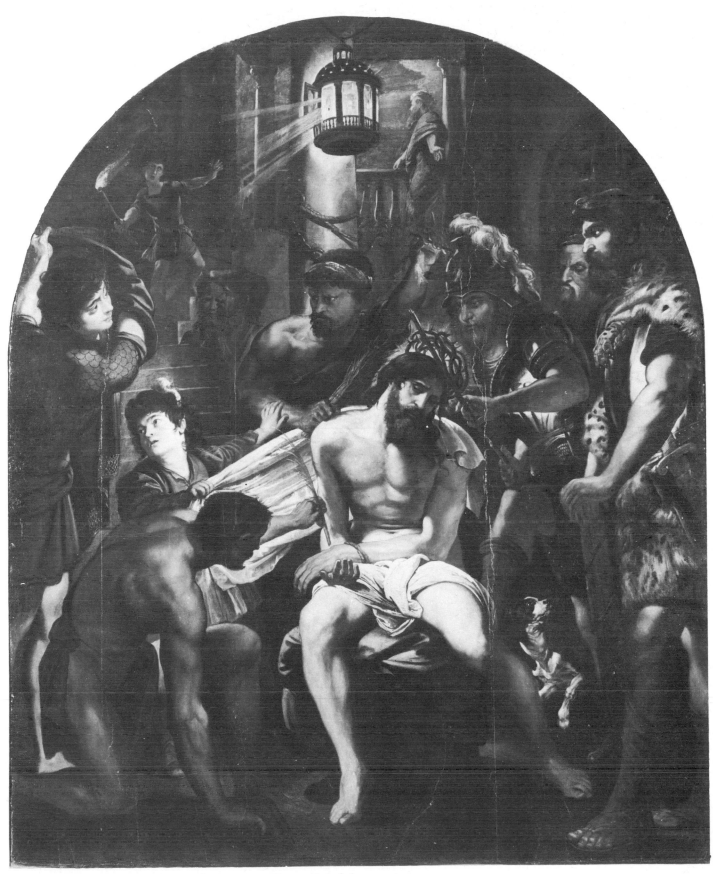

63 Christ Mocked 1601–02 Panel 224 × 180 *Grasse, Cathedral*

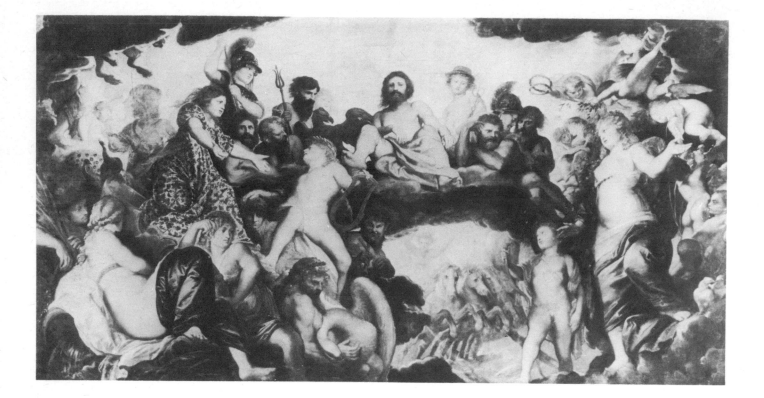

64 The Assembly of the Go[ds]
1602 Canvas 204 × 379
Prague, Hradcany Castle

are large in scale for the pictures. In the two Passion scenes they crowd the space in such a way that their location in depth is only readable from a viewpoint closer than the width of the picture. At this range, which many early seventeenth-century paintings require and which the beholder would easily adopt in a chapel only three times as wide as the pictures, the strong contrasts in scale between foreground and background figures become spatially coherent, and the dog in *Christ Mocked* takes its proper place behind a forest of legs.

The muscular male figures and the well-built princess show Rubens, for all his eagerness to rehearse the new lessons of the Antique and emulate the painters of Central Italy, still bound to Vaenius's conception of flesh. The smooth surfaces of these bodies are like neither polished marble nor living skin, but resemble rather a coating of wax or rubber. In the attempt to make them expressive of emotion, some of the faces verge on caricature; this is true also of some early drawings (Plate 94) but in these paintings the young foreigner in Rome undoubtedly used every means he could to impress.

Different problems faced the painter when on his return to Mantua he executed a large *Assembly of the Gods* (Plates 64–5). The dark clouds filling up the corners and the steep perspective suggest that this picture was painted for a ceiling, and such a destination would not conflict with Rubens's complaint in 1608 that no works of his hung in the Gonzaga picture gallery. Little is known about the history of the picture, which has been in Prague since the later seventeenth century and was only rediscovered in the 1960s; however, the arrangement of the celestial figures symbolizes a horoscope for 1602 and dates the painting to that year.

65 Venus Detail of Plate 64

The conflict between Juno and Venus (representing married and illicit love) was not the most tactful comment to be made on the fidelity of Vincenzo Gonzaga. In the centre sits Jupiter, with eagle, flanked by Neptune and Mercury. On the left Juno, in brocade with her peacock, arraigns Venus, standing on the right. Juno is seconded by the helmeted Minerva but confronted by Apollo holding a lyre and striding a sphinx. Mount Olympus symbolizes Mantua, to which the swan and river deities in the foreground also refer. Venus, surrounded by doves and *putti* with flowers, is accompanied by Cupid; behind her Ceres and Bacchus embrace. The bright patch in the lower centre, with the horses of the sun, is a common device in ceiling painting, but Rubens later returned to the bridge *motif* in a different context (Plate 16). The horses derive from Roman reliefs, and Venus and Mars recall figures found both in paintings and carved on a sarcophagus still in Mantua. Rubens's amazing imagination allowed him to visualize them fully in the round, then in the picture to rotate and reverse them left and right.

The S. Croce altars and the Mantuan allegory mark Rubens's graduation, from the ranks of the Northern portrait and landscape specialists to the status of history painter. It was from this higher rank, implying equality with the most arrogant of Italian artists, that he now approached portraiture in such brilliant performances as the *Duke of Lerma* of 1603 (Plate IV, p. 48) and *Marchesa Brigida Spinola Doria* of 1605–6 (Plate VIII, p. 46). The daring foreshortening of the horse in one and of the architectural setting in the other were not only technical achievements but also introduced into portrait painting new associations of majesty and new energy in the organization of pictorial space. If his skill with the sheen of silks and the glint of armour is perhaps most obviously seen in one of the separated fragments from the *Gonzaga Family Adoring the Trinity* of 1604–5 (Plate V), it should be remembered that the fragment can be inspected closely whereas the picture, like its two huge companions (Plates 39–41), was originally meant to be seen from some distance and from below; Rubens therefore exaggerated the tonal contrasts.

Yet the same strong modelling and colouring occur in other works such as *St George Killing the Dragon* of *c.* 1606 (Plate 66). According to the *Golden Legend* St George rescued the Princess of Silene, a story which already before Rubens's time had figured as an allegory of triumph over evil. The picture may therefore have been intended as an altarpiece, but if so it was never delivered, remaining in the artist's possession; the figure of horse and rider recurs in other pictures (Plates 14, 15). As a preparatory drawing (Paris, Louvre) confirms, Rubens added a broad strip on the right, as well as narrow ones at the top and on the left; he probably did this several years later at a time when he preferred to give his figure groups an ampler spatial setting.

The last Italian works show no diminution in the range of Rubens's sources; on the other hand his control of forms and the spaces they occupy has gained greatly in assurance and complexity. Both versions of the high altar for the Chiesa Nuova (Plates 42–5) are spatially entirely credible, and the pictorial necessity of making satisfactory painted surfaces is finely balanced with the narrative requirements of creating a spatial world, analogous to that of the beholder, into which the picture frame appears to be a window. Moreover,

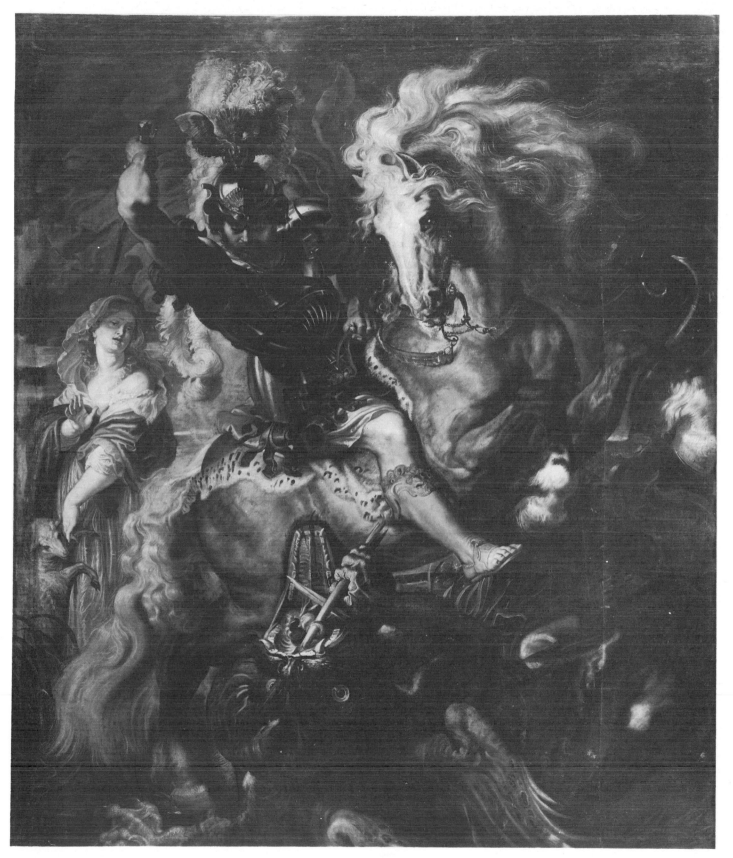

66 St George Killing the Dragon *c.* 1606 Canvas 304 × 256 *Madrid, Prado*

Rubens has begun to absorb the lessons of Antique and Renaissance art about the human figure: his martyrs in the Chiesa Nuova may resemble Roman marble statues, but they no longer have the smooth moulded aspect of the figures in the S. Croce altars. And, at least in the depiction of their blue or silver robes and of their faces and headdress, the two versions of St Domitilla have a new sensuousness which seems to derive, through Rubens's own Genoese portraits (Plate VIII), from the finely clad women of Raphael, Titian and the Italian Mannerists.

Rubens had absorbed too what Italy could tell him about colour. The *Holy Family with a Dove and Saints John Baptist and Elizabeth* (Plate 67) is the precursor of a long sequence of intimate religious pictures painted to foster the private piety of Antwerp patrons; perhaps the scarcity of assistance in Rome explains the fact of a smaller version of the Los Angeles *Holy Family*, also autograph, in the Metropolitan Museum in New York. Against a dark background the figures are robustly modelled with white highlights and rose and Venetian red flesh contours and shadows. Mary's robe is rose pink, her mantle ultramarine. St Elizabeth wears light brown, St Joseph dark grey and brown. The billowing forms which fill and seem almost to project in front of the picture frame indicate Rubens's sensitivity to Roman pictorial ideas of the early 1600s, although physiognomically the figures look back to Raphael and, in Mary's long neck, to Parmigianino; there is even a hint of Michelangelo's *Bruges Madonna*. The varied textures recall Caravaggesque painting: ruffled feathers, curly hair, St John's woolly garment, the coarse and fine cloths of the adults' robes and the blanket and cover of the cradle. But far from being a catalogue of sources and borrowings the final result bears the unmistakable stamp of one personality.

There was no sharp break in style between the Italian works and those immediately following Rubens's return to Antwerp, such as the *Adoration of the Kings* of 1609 in its original form (p. 15) or the *Real Presence in the Blessed Sacrament* painted in 1609 or 1610 for the right transept, facing the nave aisle, of St Paul's, formerly the Dominican Church, in Antwerp (Plate 68). In an unfinished apse, representing the Church on earth, learned saints confer like ancient sages: in the foreground are the four Latin Doctors of the Church, including St Gregory in brocade and St Jerome in crimson hat and robe. Among the other figures are St Thomas Aquinas and St Paul. On the altar, placed against a cerulean sky with the same studied asymmetry as Rubens had employed in the *Gonzaga Family* (Plate 39), is the Host in the monstrance representing the second person of the Trinity; the two others, Father and Holy Spirit, are above, surrounded in glory by grey clouds and *putti* holding the Consecration texts from the Last Supper. The long lines of the principal figures and the strongly differentiated lights and shadows are close to those in the Chiesa Nuova paintings. As in Raphael's Vatican *Disputà* fresco, of exactly a century earlier, the subject is a concord, rather than a disputation, of saints on the doctrine of Transubstantiation, which in respect of doctrine (as distinct from authority) was the crux of both the Protestant Reformation in Raphael's time and the Catholic Counter-Reformation in Rubens's day. In 1658 the painting was enlarged and reframed to pair with Caravaggio's *Madonna of the Rosary* which had been acquired about 1620 for the corresponding left-hand altar. The reproduction is trimmed

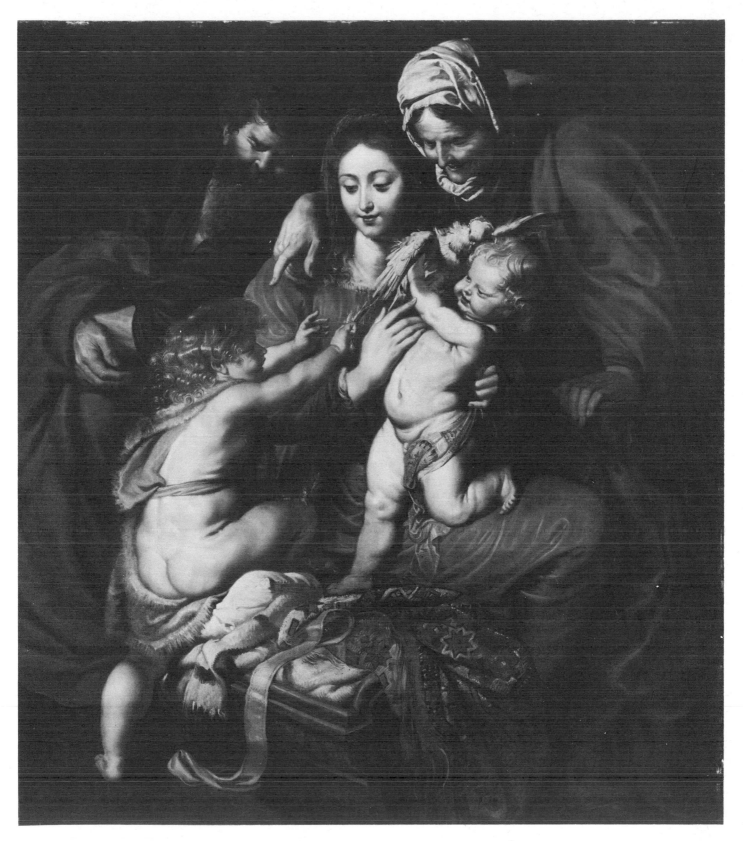

67 The Holy Family with a Dove *c.* 1608 Panel 138.5 × 121 *Los Angeles, County Museum of Art*

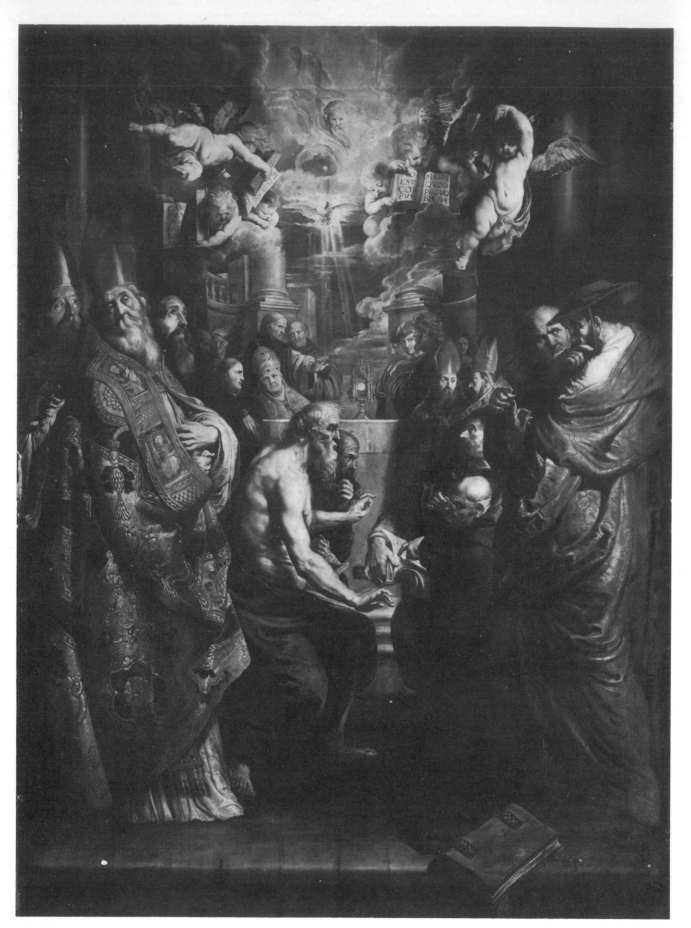

68 The Real Presence in the Blessed Sacrament *c.* 1609–10 Panel 309 × 241.5 *Antwerp, St Pauluskerk*

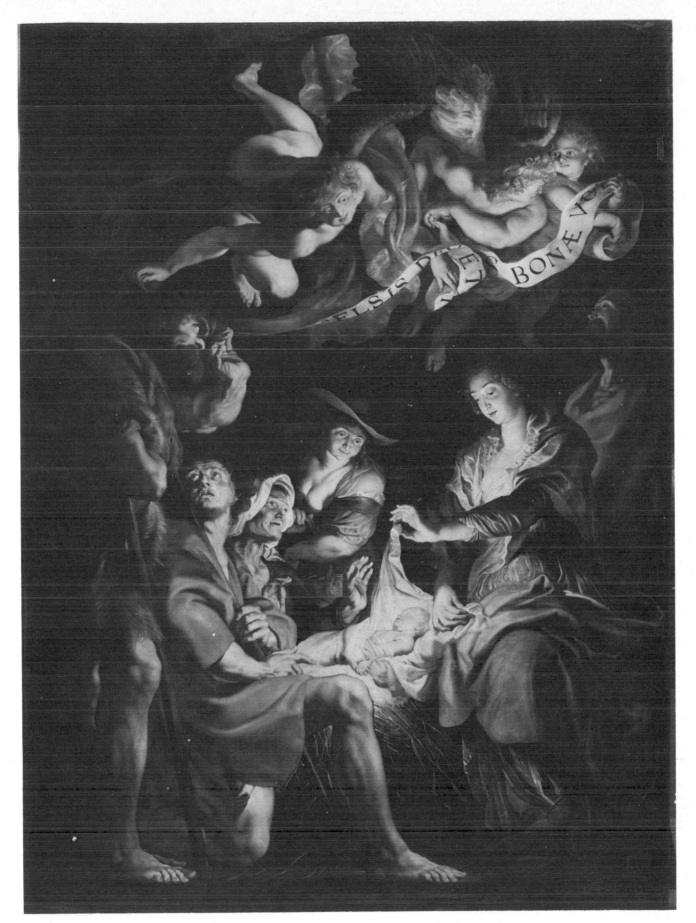

69 **The Adoration of the Shepherds** *c.* 1610 Canvas 401 × 294.5 *Antwerp, St Pauluskerk*

at top and bottom according to Snyers's engraving of 1643 showing the picture's original state; the book in the foreground does not appear in the engraving and may have been added at the time of the enlargement.

An over-lifesize *Adoration of the Shepherds* has hung in the same church, St Paul's, for over 200 years, though its original destination is unknown (Plate 69). This is even more closely related to the Italian period, for in it Rubens re-posed the figures from his altarpiece of 1608 of the same subject painted for the Oratory Church at Fermo in the Marches. The shepherdess in the Antwerp picture relates to the rise of pastoral literature and perhaps to old Netherlandish traditions of including midwives in the Nativity. The night setting was also popular in the North, although Rubens's closest inspiration here was Correggio. Local colours, cherry red, blue, grey, lilac and yellow ochre, are subordinated to variations in tone in relation to light sources – although the light is supernatural – within the picture.

In style, then, the year 1609 was of no special significance. The immediate new departures were in Rubens's status, his practice and his subject matter. Before the end of the year he was bound as portrait painter to the Regents (p. 41) and whatever his opinion of the super-iority of history painting to portraiture his talents for the latter could not escape notice (Plate IX); but as the finest painter in Antwerp since the death of Pieter Bruegel the Elder he was quickly in demand for every kind of picture. This affected his practice, obliging him to set up and manage a studio with assistants and specialists, and in considering any of his subsequent works scholars have to observe the distinctions Rubens himself made, in writing to Sir Dudley Carleton (p. 148), between autograph works, those painted by assistants and retouched by himself, and those entirely by the studio.

Rubens's own enthusiasm for Classical studies, as well as that of his Antwerp burgher patrons, led him to devise new subjects as well as to re-interpret familiar ones. Some, like the *Virtuous Hero* (Plate 13), are now less fully understood than for example the *Death of Seneca* (Plate 70). The famous philosopher was a paragon of Stoic courage. Nero condemned him to death; his veins being opened, he stood in hot water to increase the bleeding, while friends noted down his last sayings. Rubens closely followed two Antique sculptures then wrongly identified with the philosopher: a head of which he owned a version (probably the one now in the Ashmolean Museum, Oxford) and the body and arms of the *African Fisher-man* now in the Louvre but then in Rome, of which he had made several drawings. His attempted reconstruction of the event from Tacitus's *Annals* is gruesomely realistic; the body even seems to be shrinking. But the symmetry of the relief-like composition (with the forces of law personified in the background) turns reportage into a solemn, deeply moving image with – even though the Neo-Stoic Lipsius specifically condemned suicide – the sacramental character of a Christian martyrdom.

It is no accident that the secular compositions of the early 1610s resemble high reliefs. Both Ancient and Medieval artists had exploited the high relief as a means of clearly presenting, as in a sort of living diagram with the minimum use of perspective, relationships between personifications of abstract ideas. Moreover Rubens was especially preoccupied with sculpture in this period; Justus Müller Hofstede has suggested that the memorandum

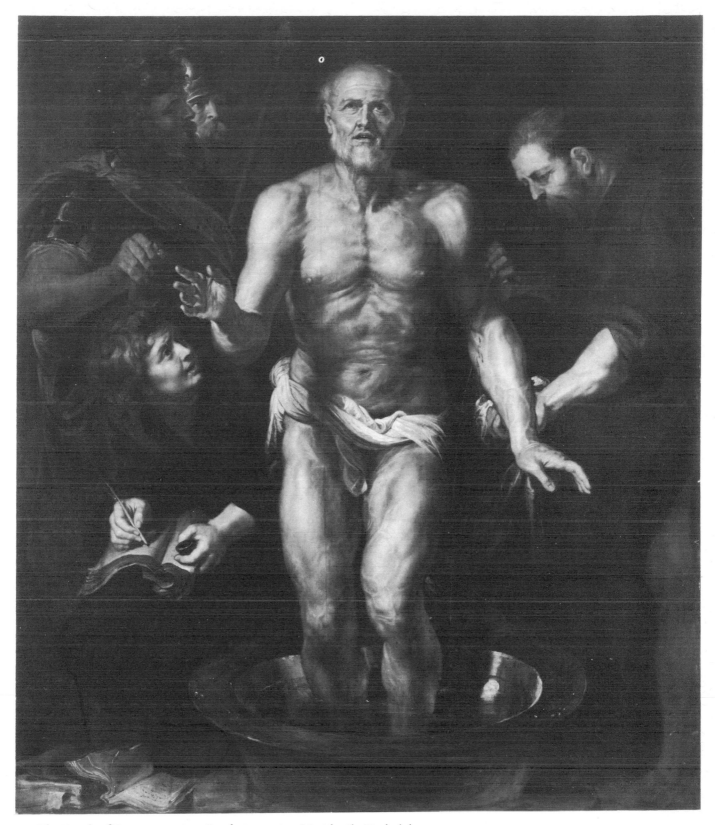

70 **The Death of Seneca** *c.* 1611 Panel 181 × 152 *Munich, Alte Pinakothek*

Figure H. The original setting of the *Raising of the Cross* in St Walburga's, Antwerp

On the Imitation of Statues (p. 143) was written about 1610, pointing to the *Death of Seneca* as a successful example of the translation of stone, by way of the fiction of painting, into flesh. By 1618 Rubens had completed his sculpture museum with the acquisition of the Carleton marbles (p. 30); on the other hand his decision in 1627 to sell his statues to the Duke of Buckingham was due less to personal reasons – grief at his wife's death or prolonged absence from home on diplomatic business – than to artistic ones, the beginning of a more painterly late style for which he no longer needed the presence of the marbles.

Although the 1609 *Adoration of the Kings* was painted as a huge oblong overmantel, a triptych-like division was implied in the composition. Within a year, projects for triptychs for Gothic churches in Antwerp involved Rubens with the principles, rather than the details, of traditional altarpieces in which painting was combined with sculpture. The commission for the *Conversion of St Bavo* for Ghent Cathedral was actually countermanded by the new Bishop of Ghent in 1612 in favour of a sculptured altarpiece, much to Rubens's displeasure; by a double irony the succeeding Bishop commissioned Rubens in 1623 to paint a single canvas as a centrepiece for this altar. Rubens's original *modello* or 'dissegno colorito' (coloured design) as he called it, of *c.* 1610, in the National Gallery, London, shows that he had envisaged a single continuous space behind the frames of the main panel and the two wings. Perhaps this setting, reminiscent of the great pageants of figures of Veronese in Venice, was too 'modern' for the Bishop; certainly Rubens himself did not offer this kind of continuity either in 1610 in the *Raising of the Cross* for St Walburga's Church, or in later triptychs.

When he signed the contract for the high altar of St Walburga in June 1610 (Plates 71–2) the oil sketches for it must already have been approved. The centre panel at least was painted *in situ* and with the wings, which are not spatially continuous with it, was finished in August 1611; the final payment was made two years later. In 1815, shortly before the church was demolished, the main panels were moved to Antwerp Cathedral where they are today. Above them were two cut-out angels flanking, and a carved gilded pelican above, the apex panel representing God the Father; these, and the predella panels of the Crucifix and stories of Saints Catherine and Walburga, were separated and mostly lost, though the *Miracle of St Walburga* from the predella is in Leipzig. The main panels, themselves fifteen

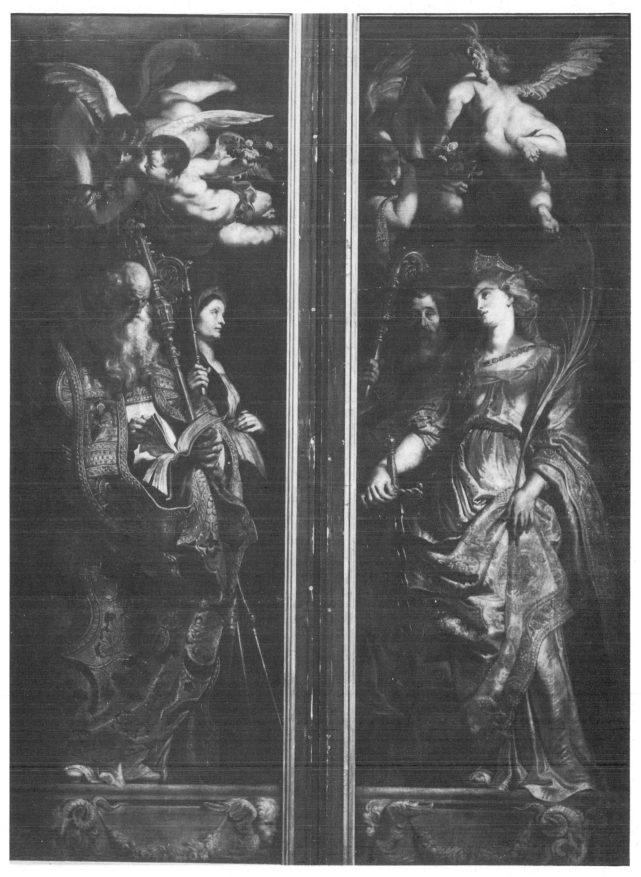

71 Saints Amandus, Walburga, Eligius and Catherine 1610–13 Panels each 462 × 150 *Antwerp, Cathedral*

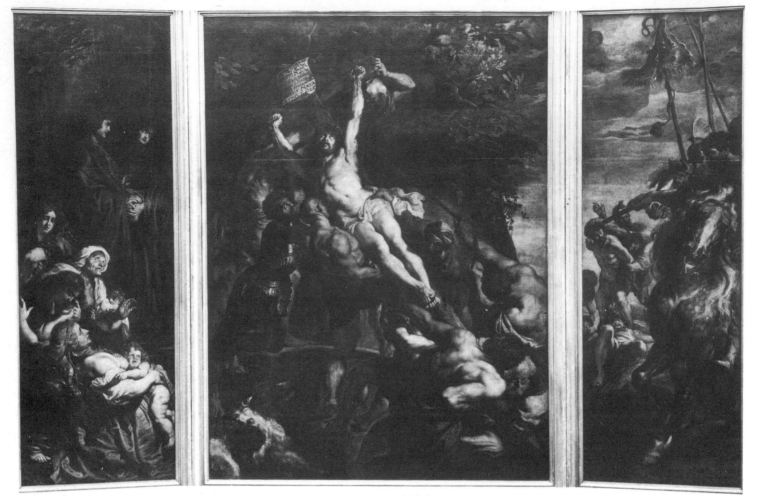

72 The Raising of the Cross 1610–13 Panels 462 × 641 *Antwerp, Cathedral*

feet tall, originally stood fifteen feet above the chancel floor; as this part of the church was
built out over the street it was raised the same amount again above the nave (Figure H).
The shape and subjects of the altarpiece were probably prescribed for Rubens, but in depict-
ing Christ lifted up (Plate 46) he made perpetual a single unstable instant. In depth and on the
surface the brutal raising of the Crucified is the archetypal Baroque image, for ever *about to
reach* verticality and symmetry above the whole church (p. 36); the emotional impact of
Rubens's realism must have been even more violent when the picture was placed high above
the beholder. Among many details there is a poignant formal parallel between the central
bald man pushing up the cross and the nursing mother at the bottom of the left-hand panel.
The outsides of the wings of Northern triptychs traditionally showed fictive sculptured
figures, usually in monochrome. The saints on the outside of Rubens's wings (Amandus,
Walburga, Eligius and Catherine, all popular in Antwerp) are, as the cut-out angels above
them were, painted in colours; they are still reminiscent of the martyrs in the Chiesa Nuova
(Plates 43, 44) but their exceptional attenuation was perhaps conditioned by their tall Gothic
surroundings (Plate 71).

A sheet of studies of *Heads and Hands* (Plate 73) shows the continuity of images in Rubens's mind, for while the female head relates to studies for St Domitilla (Plate 42) the two hand studies are for the Virgin Mary on the left of the St Walburga altar and the male head is probably a portrait of Cornelis van der Geest, merchant, art collector and church-warden in charge of that commission.

The second great triptych was ordered by Rubens's friend, Burgomaster Nicolas Rockox, as president of the Antwerp Arquebusiers' Guild. The altar, for the guild's chapel in the south transept of Antwerp Cathedral, was commissioned in September 1611. The centre panel was delivered a year later, the wings not until March 1614 though the accounts show that they were part of the original commission. While in the earlier triptych the relation of wings to centre is ambiguous, here the wings are spatially entirely distinct from the centre (Plate 74). On the outside, however, the painting of *St Christopher and the Hermit* shows a single space across the two panels (Plate 75). Just as Hercules once carried the heavens for the giant Atlas, so here the giant ferryman, the Christian Hercules, carried across a storm-swollen torrent his divine master the Christ-child, weighted with all the sins of the world.

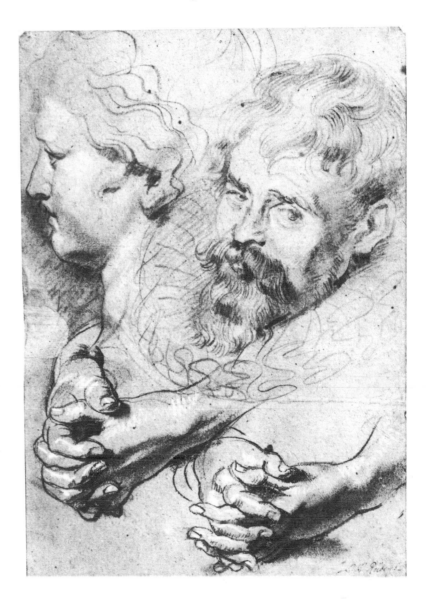

73 Studies of Heads and Hands *c.* 1606–10
Black and white chalk 38.9 × 26.9
Vienna, Albertina

74 The Visitation; The Deposition; The Presentation in the Temple 1611–14 Panels 420 × 610 *Antwerp, Cathedral*

His twelve-foot figure is lit by the lantern of the hermit who converted him. St Christopher was the patron of the Arquebusiers' Guild, and the theme of the Christ-Bearer (*Christophoros*) unites all the panels. On the interior wings, in which Rubens received studio help, the body of Christ is carried in Mary's womb in the *Visitation* and by Simeon in the *Presentation in the Temple*. Between these bright and joyous events the *Deposition* prefigures the same body's sacramental presence on the altar below: the blood in the dish beneath the ladder has the colour and transparency of altar wine. Thus on the inside a theme fundamental in itself serves also as an emblem of the picturesque patron saint on the outside to whom the altar was dedicated. The Cathedral Chapter criticized Christopher's nakedness, whereas that of Christ was acceptable as expressive of the tangible reality of the *Corpus Christi*. The sacred body is held more by compositional means than by the participants, whose hands hardly touch it. Only Mary Magdalen, in a gesture strengthened by alteration in the course of painting, grasps the foot which on an earlier occasion in the Gospel she had bathed in her tears, an archetypal penitent. Moreover, all the faithful who receive Communion at Mass are also, like the Magdalen, bearers of Christ's body; in Rubens's time, as in the Early

75 **St Christopher and the Hermit** 1611–14 Panels each 420 × 150 *Antwerp, Cathedral*

Christian era (and again since Pius X), it was the norm for all to do so.

Some elements are traditional: the two ladders, the man holding the sheet in his teeth. On the other hand Rubens's Christ and Nicodemus on the ladder are quotations from the Laocoön group, the paragon of Ancient pathos. The modelling is so strong as to make the group appear three-dimensional even when it is seen in foreshortening from the side; this exercise of Rubens's virtuosity must have been intended to recall medieval carved altarpieces. But the realism is not a mere feigning of sculpture; it serves to unite all the elements in one group, at one moment, and in one diagonal sweep: Aristotle's three unities of place, time and action. To this end, Rubens rejected the traditional counter-theme of the swooning Mary: she too shares in the main event. But human emotion is not lacking: at the base of the diagonal and nearer the beholder, the clear, radiant and indeed sensuously beautiful face of Mary Cleophas touches the heart through its very contrast with the gruesome scene above (Plate XII).

Except in the matter of decorum there was no sharp division in Rubens's mind between religious and secular art. In the *Deposition* the figure of Christ alone is naked, for narrative, not artistic reasons; yet the sensuous treatment of surfaces, of skin and fabrics, hair and faces, is no less apparent here in the service of a Christian message than it is in the nude figures of paintings close in date such as *Venus Mourning the Dead Adonis* (Duits Ltd., London) or *Venus, Cupid, Bacchus and Ceres* (Plate XI). Terence's line, 'Sine Cerere et Libero friget Venus' (Venus freezes without Ceres and Bacchus) could be interpreted both negatively (Rubens painted a *Shivering Venus*) and positively, as in this allegory of the aphrodisiac properties of food and wine. Monochrome reproductions of this relief-like composition emphasize the strong modelling of the figures and the carefully contrived lines their limbs are made to follow, but fail to convey the painting's sensuous qualities – vibrant nacreous and soft pink flesh, quite unlike marble, and offset by the other colours, pale sea-green foreground, blue-grey sky, cobalt, crimson and white drapery, and Venus's ash-blonde hair. By about 1615, in *Ixion Deceived by Juno* for example (Plate XIV), the female figures themselves have begun to change, becoming softer in contour and less demonstratively athletic. It might be fashionable, but it would be no less foolish, to attribute this change to a greater awareness of femininity, either physical or emotional, in the early years of Rubens's married life, since it can be adequately accounted for in terms of his experience in painting. Nevertheless the figure of Hilaeira in the *Daughters of Leucippus* (Plate XIII) belongs to a different species from that of her mother-in-law in *Leda* fifteen years earlier (Plate VI). At the same time Rubens became more adventurous in composition. With a low horizon, the abduction of Hilaeira and Phoebe stands out against the sky; so do the hunting scenes of the same date (Plate 14) in which he explores a composition of figures radiating from the centre. His friend Dr van Thulden (Plate 97) imposes his presence as if there were no picture surface. His single heroes of this period are set in open landscape (Plates 76, 78) or in one case enclosed in a cavern that is constructed as much from the forms of prowling lions as from masses of rock (Plate xv).

These three heroes seem to have been painted without any commission, and were all retained in Rubens's studio 'for my own pleasure' until 1618 when he bartered them with

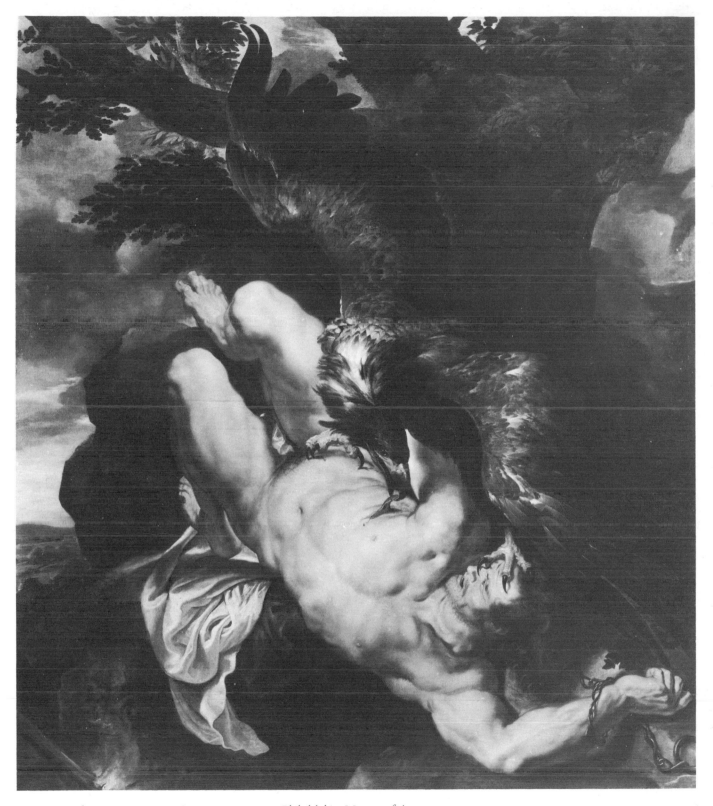

76 Prometheus *c.* 1611–18 Canvas 243 × 209 *Philadelphia, Museum of Art*

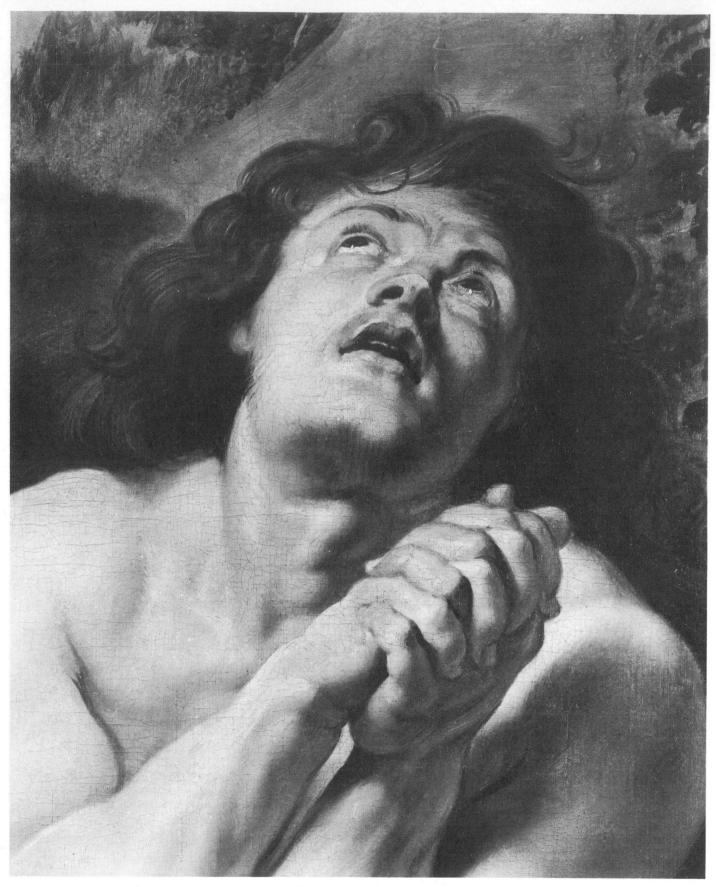

77 **Daniel** Detail of Plate XV

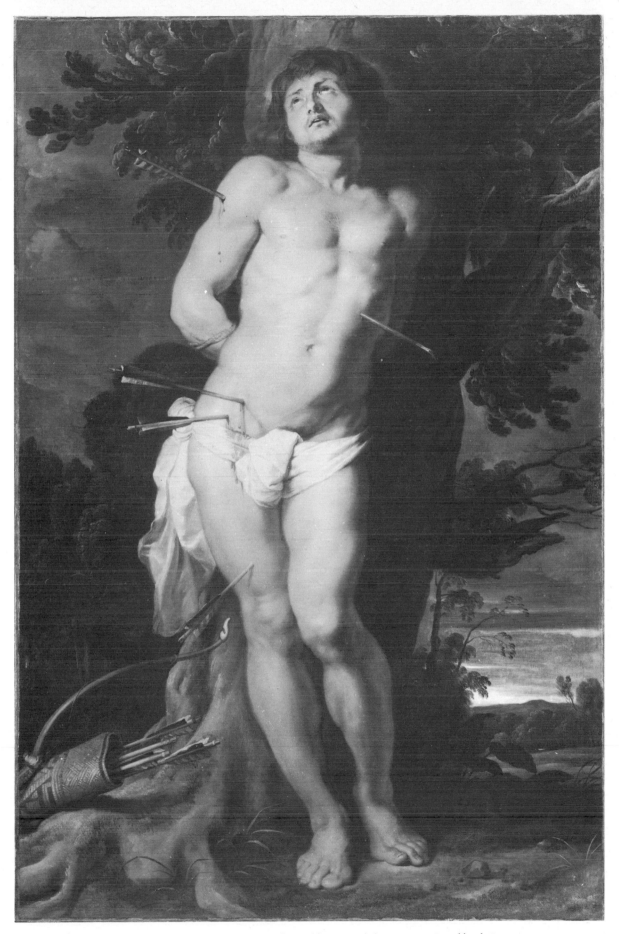

78 St Sebastian *c.* 1615 Canvas 200 × 128 *Berlin-Dahlem, Staatliche Museen, Gemäldegalerie*

other works to Sir Dudley Carleton in exchange for Antique statues. *Prometheus* (Plate 76) was described in a poem by Dominic Baudius in 1612, but when Rubens offered it to Carleton he retouched it. He described it then as 'by my hand, and the eagle done by Snyders'. Prometheus was chained by Jupiter on Mount Caucasus where an eagle daily fed on his liver which always regenerated itself each night. Snyders's preparatory drawing for the eagle survives (Plate 79). Prometheus, the creator of men and the first artist, symbolizes the agony of creation, and Rubens may therefore have intended the picture to be an aesthetic as well as a formal statement. It was designed to hang above eye-level, and is the more terrifying because nothing except the implied diagonal of the composition anchors the visually unstable heroic figure in the field of the picture.

From Carleton's collection *Daniel in the Lions' Den* (Plates xv, 77) passed to Charles I and then to the First Duke of Hamilton. After being twice sold from Hamilton Palace, in 1882 and 1919, it disappeared until 1963. Several full-size copies are known, and misunderstandings about the primacy of the original frustrated more than once its purchase for Great Britain. In Rubens's list of pictures on offer to Carleton in April 1618 *Daniel* is referred to as entirely autograph, and while Rubens often employed specialists to paint animals and other *genres* there is no adequate reason to suppose that he misled Carleton in this case. The firm, smooth and unsensuous flesh modelling is unattractive in comparison with the *Daughters of Leucippus*, but it is characteristic for a live male nude of its date, *c.* 1615–16; autograph drawings that may be compared in handling with the painting survive both for the figure and for some of the lions. At the end of the Book of Daniel the Babylonian king was forced by popular outcry to throw the prophet, who had destroyed the local gods, to the lions. After seven days Daniel was found alive and untouched and the astonished king released him. From the den floor Rubens shows both the fervent prayer of the holy man and the uneasy behaviour of big cats faced with events and forces beyond their understanding. Although Rubens had opportunities to see menagerie animals and his psychological insight extended to them, one lioness (Plate 80) was based on a Renaissance bronze.

A Hellenistic sculpture of the type known as the *Dying Alexander* probably inspired the tilted head and upward gaze of both Daniel and *St Sebastian* (Plate 78), which cleaning has recently revealed to be as cool in tonality as *Prometheus*. St Sebastian was popular as a protector against the plague long before the manner of his martyrdom made the subject a pretext in the Renaissance for nude painting. Rubens's figure is an almost exact mirror image of Mantegna's much smaller *St Sebastian* in the Kunsthistorisches Museum, Vienna, which Rubens may have known, although its location before 1659 is not established. Nevertheless, whatever Rubens may have borrowed from Mantegna he has re-interpreted totally in his own language. His life-size saint writhes transfixed before our eyes, and the roots and branches of the tree to which he is bound writhe with him. The strong and fluid modelling and the low viewpoint bring us close to the figure, which is at the front of a space that extends back to the light sky at the horizon. The figure is complete in itself, but the space in which it stands is open at the sides as well as in the distance. Thus the convexity of a Classic high relief is combined with a spatial infinity which has rightly been called Baroque.

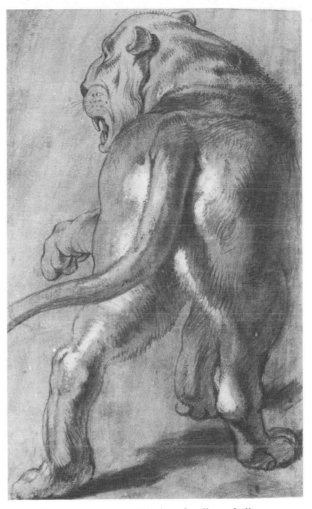

79 FRANS SNYDERS (1579–1657) **An Eagle** *c.* 1611
Pen and brown ink and wash 28.1 × 20.3
London, British Museum

80 A Lioness *c.* 1615 Black and yellow chalk,
grey wash and white body colour 39.6 × 23.5
London, British Museum

VI THE MATURE AND LATE STYLES

Rubens's works of the 1610s are indeed so various and now so scattered around the world
that no writer has done them justice and no attempts to produce a reasoned progression
from one to the next have succeeded. The sacramental meaning of the *Deposition* altar was
clear and the subject was popular; with the aid of his studio Rubens produced several re-
vised versions of the same theme before 1620, and it is perhaps significant that they conform

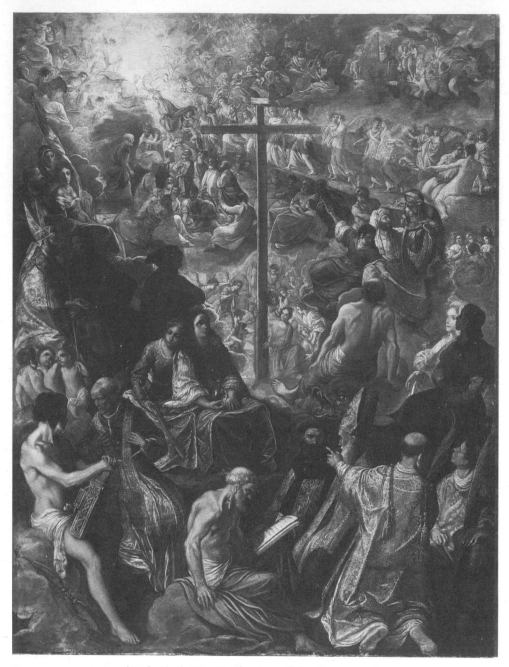

81 ADAM ELSHEIMER (1578–1610) **The Exaltation of the Cross** *c.* 1603–05
Copper 48.5 × 35 *Frankfurt, Städelsches Kunstinstitut*

to the newer type of altarpiece, a single upright painting without wings placed in a carved or architectural frame. Rubens's altarpieces on new themes after the Antwerp *Deposition* also belong to this type, and individual or local taste alone can account for the survival of the triptych form in examples such as the *Fishmongers' Altar* he painted in 1618–19 for Notre-Dame-au-delà-de-la-Dyle in Malines (Plate 83). Indeed in this case we do know that the Fishmongers' Guild had bought the unpainted panels earlier, in 1613. Five years later they sent them to Antwerp for Rubens to paint on them the *Fish with the Tribute Money* (Matthew 17.26) in the left wing, the *Miraculous Draught of Fishes* (Luke 5.1–11) in the centre, to which

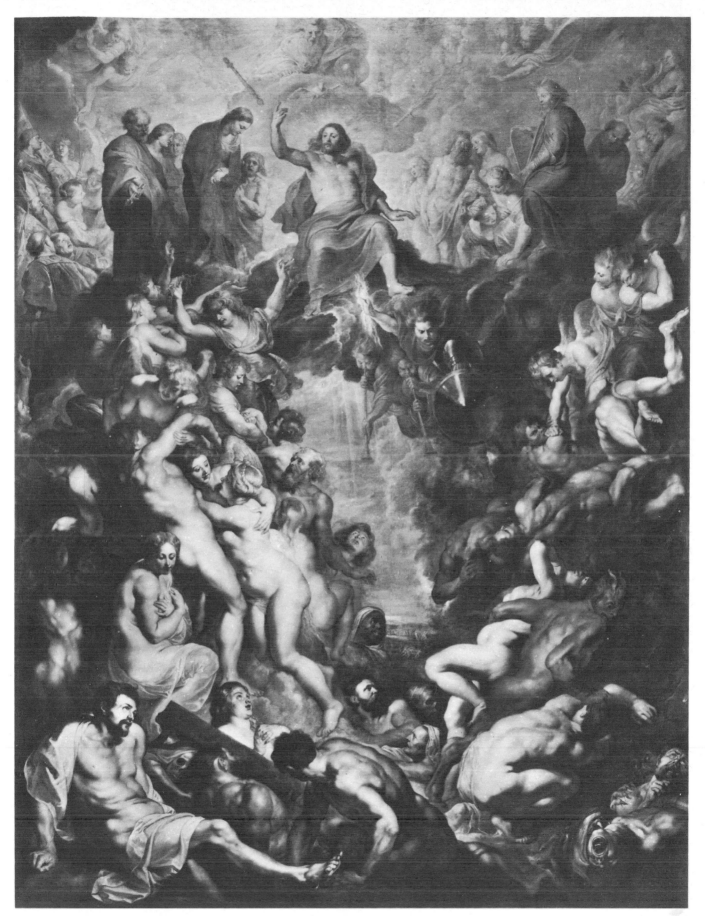

82 The 'Great' Last Judgement *c.* 1615–17 Canvas 605 × 474 *Munich, Alte Pinakothek*

Rubens personally devoted most attention, and *Tobias Opening the Fish* (Tobias 6.5) in the right wing. On the exterior he provided *St Peter and St Andrew*, and in the predella a Crucifix flanked by *Jonah* and *Christ Walking on the Water*. The Crucifix is now lost, but the other two predella panels are in the Musée des Beaux-Arts in Nancy; the main panels are still in the right transept of the church. The three inside scenes are, as in the Antwerp *Deposition*, spatially and temporally separate, but in this case they are compositionally united: there are many links or parallels on the surface between forms which extend independently into depth, and the green water is the same in each panel. There is a counter-play of three dominant reds in the hat of the apostle on the extreme left, the cloak of the hauling figure in the centre foreground, and Christ's robe. Rubens's rough heroes, too large for their boats, owe as much to Raphael's *Acts of the Apostles* cartoons as to observation. When seen from a distance they extend into depth so vividly that the impression of pictorial unity gives way to that of a real scene enacted before the beholder.

The '*Great*' *Last Judgement* (it is twenty feet high) was painted about 1615–17 for Wolfgang Wilhelm, Duke of Neuburg on the Danube, an enthusiastic Catholic convert, who built the Jesuit Church at Neuburg and commissioned the painting from Rubens for the high altar (Plate 82). The painting was removed to Düsseldorf in 1692, and later to Munich, where the Rubens room of the Alte Pinakothek was built round it. Michelangelo's great fresco in the Vatican, which Rubens knew, conveys doom (the Old English word for the Last Day) and the soul-searching of early Counter-Reformation Rome. In accordance with the later, evangelizing, phase of the Counter-Reformation, Rubens's canvas concentrates on the salvation of the Blessed: they rise joyously on the left, at Christ's right hand, towards Heaven, which forms the top third of the picture. The painting is light in tone and the recurrent colours are rose (including Christ's robe, for it is the colour of salvation), yellow ochre, lemon, pale green, dove grey and flesh tone. The use of figures to form a solid structure without architectural supports owes less to Rubens's memories of Michelangelo than to those of the small but monumentally conceived scenes of Adam Elsheimer, such as the *Exaltation of the Cross* (Plate 81) which, at one thirteenth of the height and width of the '*Last Judgement*, is large for that artist, and was painted *c.* 1603–5 as the centrepiece of a small polyptych for private devotion. Rubens probably learned more from Elsheimer than anywhere else about controlling crowds; he wrote of the German artist that he 'in my opinion . . . had no equal in small figures'. Much of the *Last Judgement* was painted by assistants, but Rubens kept very firm control of the work at every stage from outline drawing on the canvas to the final touches before the canvas was rolled up for transport to Neuburg.

The two altarpieces for the new Jesuit Church in Antwerp (Plates 85, 87), movable alternatives with two by other artists, show a similar structural use of figures although they also contain architectural settings. They were certainly finished by 1619 and were commissioned by 1617 or even in 1615. They are now in Vienna together with the *modelli* for them; having escaped the fire (p. 74) they were bought by Maria Theresa of Austria shortly after the expulsion of the Jesuits in 1773. They represent miracles performed by Ignatius Loyola, founder of the Society of Jesus, and Francis Xavier, his friend and disciple who is

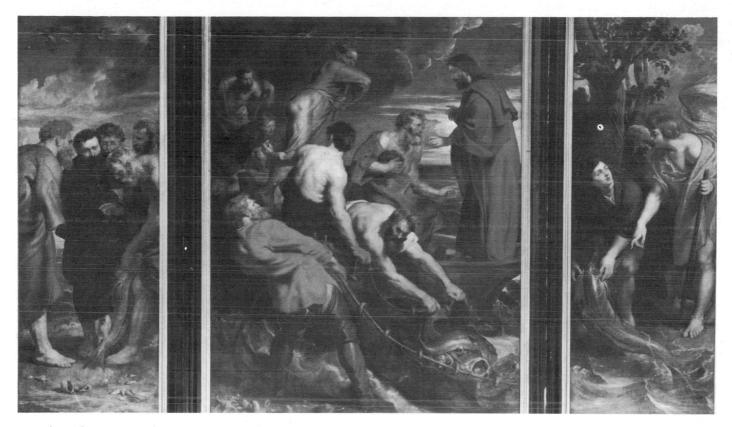

83 The Fishmongers' Altar 1618–19 Panels 301 × 447 *Malines, Notre-Dame-au-delà-de-la-Dyle*

known as the Apostle of India. Since they were not canonized saints until 1622 but only *Beati* ('Blessed') the provision of altarpieces in their honour is, like the lavishness of their church, an indication of the missionary zeal of the Antwerp community of the Society.

Each altarpiece depicts an amalgam of several events, as a kind of public meditation on the works of the saint. In the *Miracles of St Ignatius* (Plate 85) the saint stands at the altar of a church reminiscent of St Peter's in Rome (the apse was radically altered in the evolution of the *modello*) with his nine original companions. In the foreground are persons helped by his intervention according to the earliest biography of Ignatius: mothers whose confinements were miraculously eased, and on the far right a suicide who was revived long enough to receive the sacraments; on the left in the background devils are cast out from the possessed. In the *Miracles of St Francis Xavier* (Plate 87) Rubens again used an early biography, as well as books about oriental life. On the left a mother holds her drowned baby which the saint revived. The dead rise from the grave; one figure in the foreground, for which there is a life

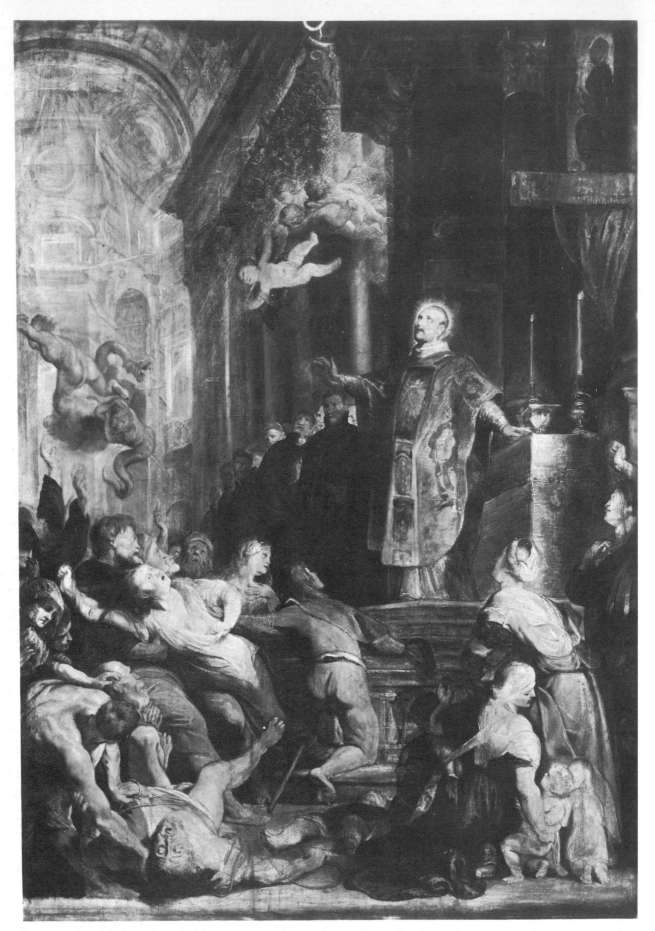

84 Miracles of St Ignatius *modello c. 1615* Panel 105.5 × 74 *Vienna, Kunsthistorisches Museum*

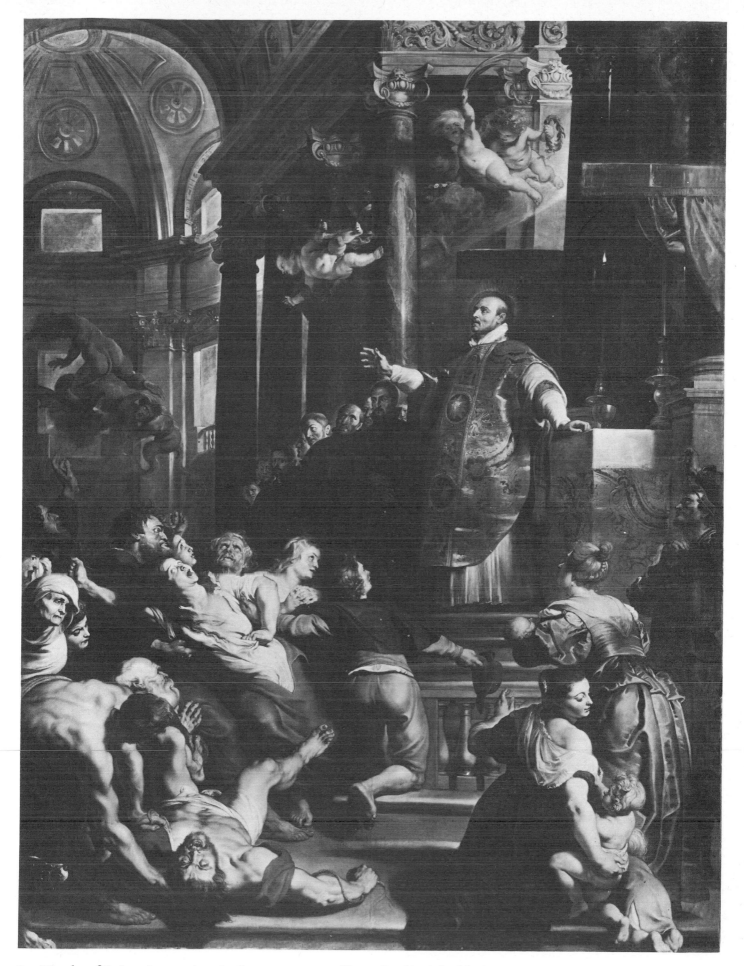

85 Miracles of St Ignatius *c.* 1615–18 Canvas 535 × 395 *Vienna, Kunsthistorisches Museum*

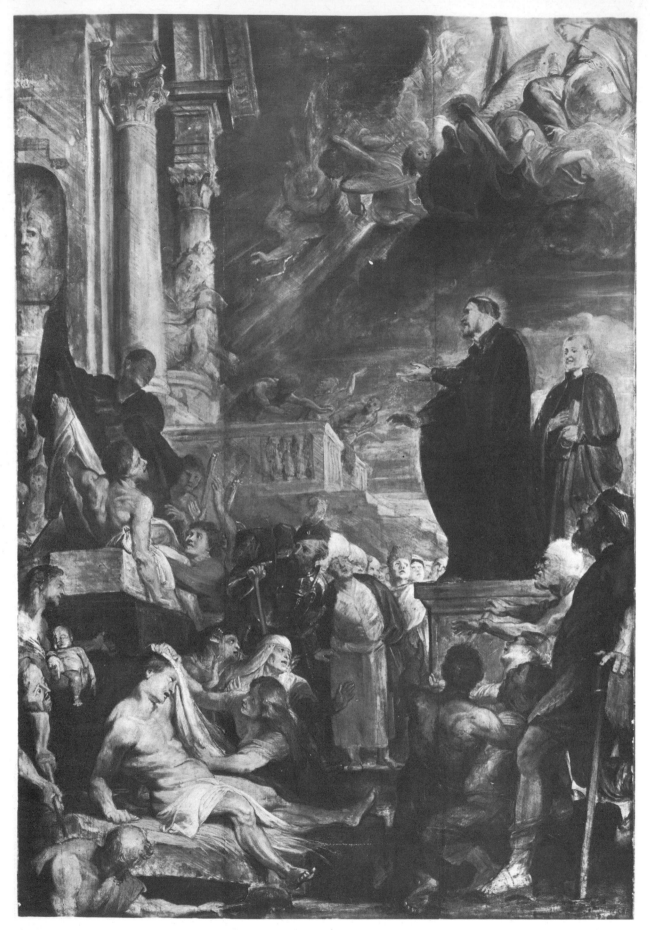

86 Miracles of St Francis Xavier *modello c. 1615 Panel 104.5 × 72.5 Vienna, Kunsthistorisches Museum*

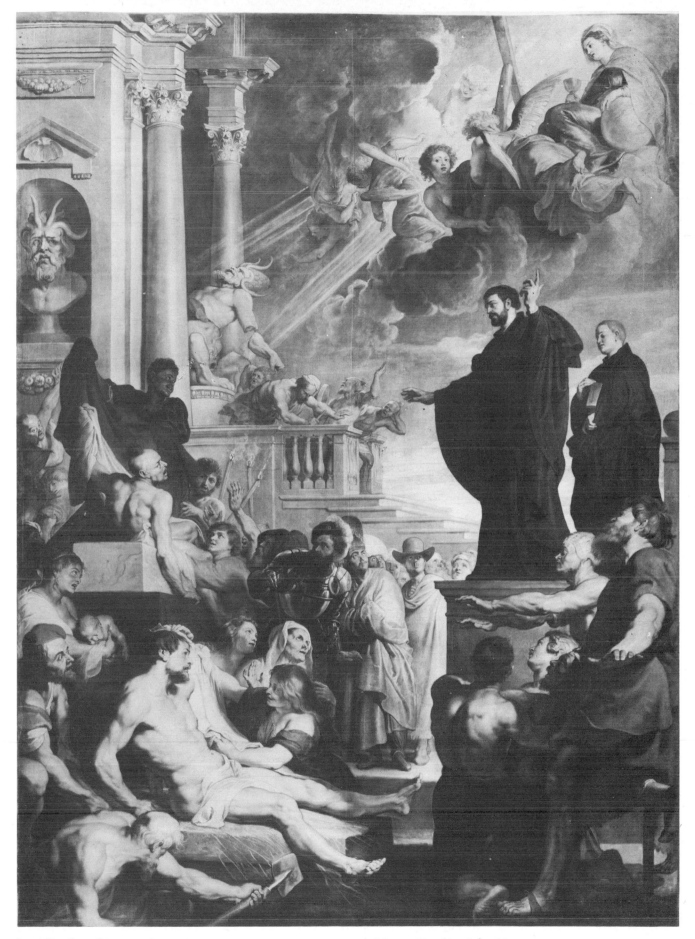

87 Miracles of St Francis Xavier *c.* 1615–18 Canvas 535 × 395 *Vienna, Kunsthistorisches Museum*

study (London, Victoria and Albert Museum) is from the same model as the similar awakening man in the *Last Judgement*. On the right a blind man with outstretched arms derives from Raphael's *Blinding of Elymas*; behind him is a group of pagan priests. The earthly wonders have heavenly counterparts above the figure of the saint, and by heavenly power the temple idols are cast down.

Between *modelli* (Plates 84, 86) and pictures Rubens made many life studies, reworking in detail each composition, and it can be seen by comparison how consistently he made space, forms and gestures more readable, for example the outline of St Francis and the gesture of the distraught mother. He also softened the architectural perspective when he realized how the painting would look when seen far down the church. A study of preparatory drawings shows that in the case of *St Francis* (whose gestures denote both preaching and healing) Rubens saw parallels with both Christ (in Plate 83 for instance) and the *adlocutio*, the address of an ancient Roman general to his troops (as for example on the Arch of Constantine).

Both altarpieces emphasize the missionary preaching of the Jesuits in conjunction with the miracles that were the evidence both of divine aid in their lives and of their sanctity in the posthumous canonization process. Miracles and – although both these saints died from natural causes – the ultimate testimony of martyrdom (the Greek *martyr* means witness) were the mainstays of Counter-Reformation didactic art, and Rubens was indebted to a whole range of earlier Italian altarpieces rather than to any single specific example. Moreover the memory of Raphael's Vatican frescoes and tapestry cartoons was of considerable importance for Rubens in the organization of many figures in an architectural setting.

An altarpiece such as *St Ives of Tréguier* (Plate 88) was also designed to be seen from a distance and painted with a corresponding breadth; one reason for its simplicity may have been economic, for the price of a commission depended not only on the degree of the master's autograph contribution but also on the number of figures included. St Ives (d. 1303) was a lawyer much venerated in the early seventeenth century as a defender of widows and orphans and a patron of lawyers and clerics. Rubens visited Louvain in 1617 and the altarpiece, which was later in St Michael's church there, may have been painted about that time for the chapel of the Louvain Law Faculty in St Peter's church. The colouring is simple. The details of the office, the landscape, the greys of the widow's clothes and the ochre and olive of her son's, all are dominated by the saint's scarlet gown which enfolds in large loops his gesture of assistance.

The year 1617–18 certainly marked changes in both Rubens's practice and his style. The painting of the *Decius Mus* tapestry designs in 1617 opens the period of great cycles of works dependent on the studio. In that year also Van Dyck came to work in his studio, and while the brilliant youth's contribution to the Jesuit Church ceilings perished in flames his influence on the older master, if not his hand, may be seen in the symphonic colour, softness of texture and awareness of the picture surface of the *Countess of Arundel* of 1620 (Plate XVI, p. 42). But Rubens's style changed in other ways. Though it seems paradoxical, he began to think more distinctly of both wall surfaces and exterior spaces (p. 53). The clarity of organization

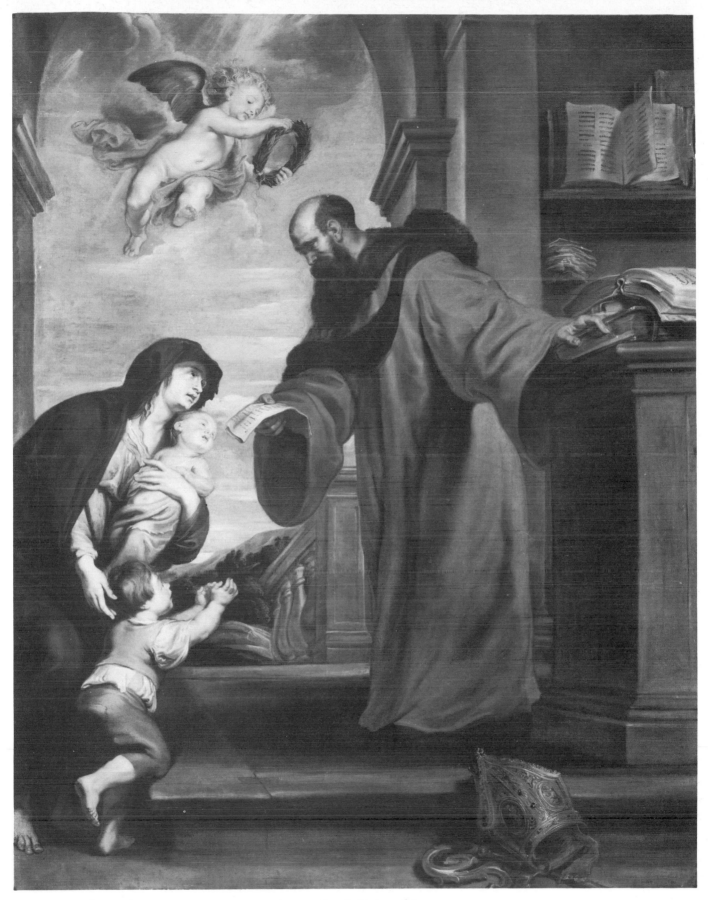

88 St Ives of Tréguier *c.* 1617–18 Canvas 295 × 216 *Detroit, Institute of Arts*

of many figures, both in space and on the surface, in the *St Ignatius* and *Xavier* altars shows one side of this development, and at the same time its effect can be seen working through the small intricate and intimate construction of the *Prodigal Son*, to the landscapes of about 1618 (p. 58). In turn, it is doubtful whether the vast spaces of the Medici cycle could have been conceived and organized before Rubens had contemplated and tried to recreate for himself the order of natural landscape.

From now on he tends to introduce the structures and furniture of the stable into his *Nativity* altars, and he even combines wooden props and marble columns in the setting of the over-lifesize *Adoration of the Kings* of 1624 (Plate XXI). Although this was painted, for St Michael's, Antwerp, while Rubens was very busy with the Medici cycle, it is entirely autograph. Its rapidity and assurance almost equal those of the *modello* (London, Wallace Collection, Plate XX), and are the product of his many years' experience with his materials and the limited time available to him. There is nothing sketchy or indeterminate about the altarpiece, but it is painted in scarcely more than two layers of paint: undermodelling and finishing. Both small and large forms are defined by optical means, shapes and juxtaposed patches of colour which help the eye to read the forms. Thus there are touches of blue in the scarlet cloak and white tunic of the left-hand king. This scarlet and the olive green of the turbanned central standing figure are changes from the limited colour range of the *modello*, as are Our Lady's red robe and dark blue-green cloak. Rubens also added the Corinthian column and rotated the Madonna and the left-hand king to face the beholder. The frontal central king appears in an earlier *Adoration* (Lyon, Musée des Beaux-arts) and Rubens used the pose again later for the portrait of Nicolas Respaign in Kassel. The overlooking camels are but one of his devices to adjust a naturally horizontal subject to fit a vertical format. The original architectural frame, made to the painter's design with lifesize carved figures of Our Lady and Saints Michael and Norbert, is now in the Catholic church at Zundert near Breda.

Although Rubens's original frame for the *Assumption of Our Lady* over the high altar of Antwerp Cathedral no longer exists, the picture is still in its place (Plate 89). Its history is complicated. In 1611 Rubens had submitted alternative *modelli*, now in the Hermitage, Leningrad, and Buckingham Palace, London, for a *Coronation* and *Assumption* respectively, for the high altar; the altarpiece he painted, now in Vienna, is based on a combination of these. For some reason it was not delivered; it was later placed in the Lady Chapel of the Jesuit Church according to Rubens's 1620 contract, in exchange for the oil sketches for the ceilings there (p. 74). Meanwhile in 1618 Rubens submitted new sketches for an altarpiece to the Cathedral Chapter. In 1619 the Dean, Jan del Rio, took over the project as his own memorial, and contracted with Rubens for a new panel. Rubens's marble frame was installed in the summer of 1624, the probable date of the last and definitive *modello* (The Hague, Mauritshuis). Rubens was away from Antwerp for most of 1625; in May 1626 the still unfinished panel was installed in the marble framework, which it had to be widened to fit; the choir was closed for the painter to work *in situ* and the picture was finished by March 1627. In this bright and joyous painting the dominant impression is of clear pale primary colours and their mutations, with neither strong highlights nor deep shadows. Mary, in

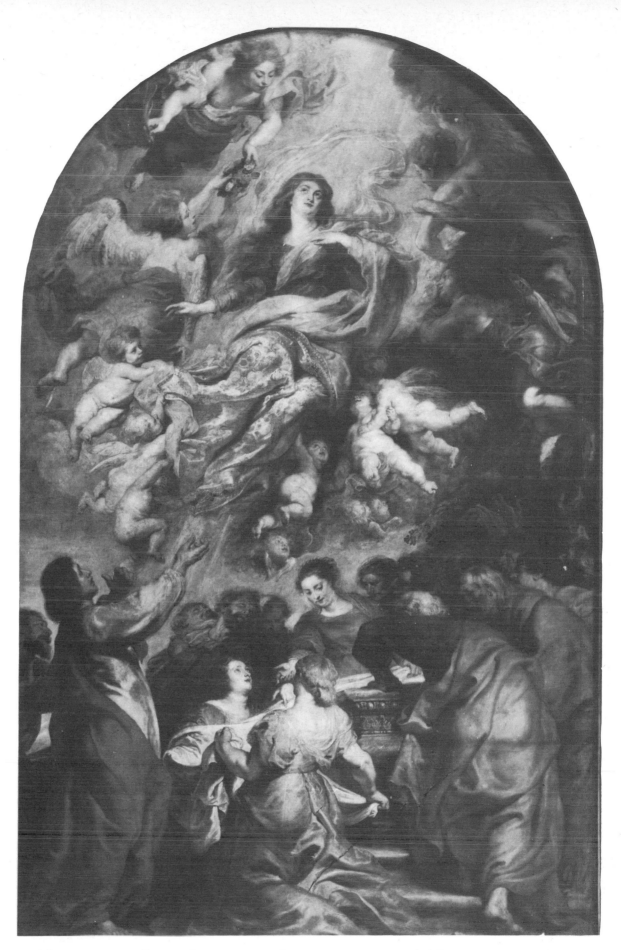

89 The Assumption of Our Lady 1624–7 Panel 490 × 325 *Antwerp, Cathedral*

blue, lilac and white, rises in a sky of pale blue, gold and smokey grey. The left foreground apostle, the woman behind the sarcophagus in the centre and the right-hand flying angel provide three points of red. The spiral and diagonal upward sweep of the earlier Vienna *Assumption* is here stabilized and contained in a circle of figures whose imagery recalls that of Titian's great *Assunta* in the church of the Frari in Venice.

When Rubens wrote prematurely in 1621 expressing a readiness to decorate the new building at Whitehall (p. 78) the experience of designing the ceilings for the Jesuit Church was fresh in his mind, and while his knowledge of the as yet unfinished Banqueting House can only have been vague he may have heard that it had a large ceiling compartmented in the Italian manner. By 1625 he had studied the ceilings of Primaticcio at Fontainebleau and had even acquired or copied some of the Italian artist's original drawings for them. By that date too he would have received accurate descriptions of the Banqueting House and would have been the more eager for a commission. The ceiling canvas he painted for York House, the Duke of Buckingham's London mansion, may thus be considered as a trial piece for the larger and later undertaking, and the left-hand of the Three Graces in the Buckingham picture (Plate XXII) recurs in one of the Whitehall sketches (Plate 53). The canvas probably reached York House late in 1627 together with an equestrian portrait of Buckingham victorious on land and sea; both pictures were destroyed by fire in 1949. For the equestrian portrait the original head drawing (Vienna, Albertina) and the oil *modello* (Fort Worth, Kimbell Art Museum) survive. For the *Glorification of the Duke*, circular with lifesize figures, the chief surviving document is a brilliant oil sketch which, although in a full range of colours, is not the final *modello* (Plate XXII).

George Villiers, First Duke of Buckingham, was Charles I's favourite and his rival in art collecting. Rubens first met him in Paris in 1625; between then and 1627 he bought several paintings by Rubens and the ancient sculptures the artist had acquired from Sir Dudley Carleton. Buckingham was an impetuous diplomat, mistrusted abroad and increasingly unpopular at home, and was assassinated in 1628. Rubens, who saw clearly his faults, nevertheless honoured his virtues in the two large pictures commissioned from him. In the ceiling Minerva and Mercury, patrons of the arts and diplomacy, raise the hero to a temple of Virtue, while Envy and Anger, represented by a lion, try to drag him down. The Three Graces on the left are cousins of those in Raphael's Farnesina frescoes in Rome, but in 1625 the foremost images in Rubens's mind were the pearly nudes, sophisticated colour relationships and daring foreshortenings of Primaticcio.

Yet the constant undercurrents of Rubens's vision were, besides Antique sculpture, Raphael, Mantegna and Titian. He had acquired an admiration and understanding of Mantegna at the court of Mantua, to which the great Paduan master had been attached more than a century before him. There he saw Mantegna's *Roman Triumph* cartoons for the only time, for although they were bought by Charles I and are now at Hampton Court they did not reach England until after his visit. In about 1630 however, in a small oblong canvas (London, National Gallery), he produced from memory or from drawings a colourful re-orchestration of two of the scenes. Raphael, the master of both form and narrative, was

Figure I. The setting of the *Mystic Marriage of St Catherine* in St Augustine's, Antwerp

never far from his mind. His references to Titian, though they were less constant, were not restricted to his years in Italy and the period after his visit to Madrid in 1628. For the saturated and harmonious colours and free brushwork of the *Mystic Marriage of St Catherine* (Plate XXIII), finished in 1628 before he left Antwerp for Spain, anticipate the style of the 1630s. The handling of this masterpiece can only be explained by Rubens's contact with Titian originals and copies which Van Dyck had then recently brought back from Italy.

Rubens conceived his high altarpiece for the Augustinian Servite Church in Antwerp, built by Wenzel Cobergher in 1615–18, as complementary to its arcaded interior (Figure I) both in the symmetry of the stepped platform and in the easy asymmetry of the figures, at which he arrived through a series of sketches. The *Golden Legend* tells of the Alexandrian St Catherine's visionary betrothal to Christ, who gave her a ring. The subject was popular both symbolically, of the religious life (so too nuns are given gold rings, and the Church is called the Bride of Christ) and pictorially, as a means of enlivening pictures of the Madonna and Saints. The Augustinian Church was dedicated to Our Lady and All Saints; the other figures in the altarpiece (patrons of side altars) are: top left, Peter and Paul; top right, John the Baptist; below St Peter the Augustinian abbess Clare of Montefalco and Mary Magdalen; below them Agnes and Apollonia, protectress against toothache; foreground, George, Sebastian, William of Sellone Duke of Aquitaine (with his back turned in the centre), Augustine, Laurence, and Nicholas of Tolentino.

It would be over-simple to describe Rubens's last period as dominated by the influence of Titian, even though the paintings he saw and copied in Madrid in 1628–9 affected him profoundly and permanently. For Rubens is one of those painters who had a genuine late style which, like those of Rembrandt, Frans Hals and Titian himself, owes more to length of experience in the handling of paint than to external influences. In fact Titian is generally credited with the invention of 'optical' painting; Vasari in Titian's lifetime described his late pictures as painted 'with dabs, coarsely and with blobs so that they cannot be seen from nearby but from a distance appear finished'; what for later painters became a matter of technique was for the Venetian master a new discovery, a kind of wisdom in the relation between object, eye, hand and materials. When Rubens attained the same sort of wisdom

the process was reinforced by his observation of its operation in Titian's work. For Rubens, brushwork was never a display of virtuosity, nor did he offer the beholder, as Frans Hals did, a visual game of determining how much could be understood from a particular distance. In any case he had for long been used to varying his technique according to the scale of the picture. Instead, in the late works, colouring and drawing become inseparable and indistinguishable.

The wisdom of years is also evident in his imagery. His repertory of figures of all kinds, both as formal arrangements of members and as the vehicles for particular meanings, was cumulative, both in his portfolios of drawings and in his visual memory. Sometimes therefore it is no more possible to separate out the strands of meaning and the correspondences of form than it is to separate out the painted marks on the surface that make up the images.

Rubens understood, too, as Titian did, that richness of colours depends less on their number than on their choice and co-ordination. This is nowhere better seen than in the altar of the Brotherhood of St Ildephonsus which he painted in 1630–2 for the Lady Chapel of St Jacques sur Coudenberg in Brussels (Plate 90). The Brotherhood was founded by Archduke Albert as a lay association for Hapsburg courtiers, and its altar in St Jacques was the gift of his widow in his memory. The Brotherhood was dissolved in 1657 and the painting was ultimately bought by Maria Theresa of Austria in 1777. St Ildephonsus was Archbishop of Toledo in the seventh century and the author of, among other works, *De Virginitate S. Mariae*. According to legend The Blessed Virgin rewarded her champion by giving him a mass vestment. Spanish artists depicted her in the act of descending into the cathedral to give him the chasuble; Rubens's commission required a less dramatic treatment but allowed him to exercise his capacity for abstracting from a story the typical and the symbolic. The triptych form continued to be used in the Netherlands for epitaphs, and Rubens here adapted to it the courtly formula of his Mantuan altar. The Regents, clad in gold and ermine, with red kneelers and drapes, are presented by their patron saints Albert of Louvain and Elizabeth of Hungary, while Ildephonsus kisses the garment presented by the enthroned Virgin (Plate XXIV).

Studies survive for three of the heads, including that of the Madonna (Plate 3). Since the commission came from Rubens's official employer it is not surprising that he painted the entire work himself; it is a perfect example of his control of colour, texture, light and composition at the beginning of his last decade. The golden niche behind the throne and the flowing and diaphanous draperies received as much care as the heads and the *putti*. At the same time the picture contains nothing superfluous; Rubens eliminated the elaborate architectural background shown in the preparatory oil sketch (Leningrad, Hermitage) in favour of an indeterminate setting which does not distract attention from the figures. On the outside of the wings he painted the *Holy Family under the Apple Tree* with Saints John Baptist, Elizabeth and Zacharias (Plate XXV); the two halves have been separated from the inner panels and joined together for display. This subject was appropriate to the Lady Chapel; moreover in the Song of Solomon (2.3) the King is compared to the apple tree under whose shade the beloved sits.

[134]

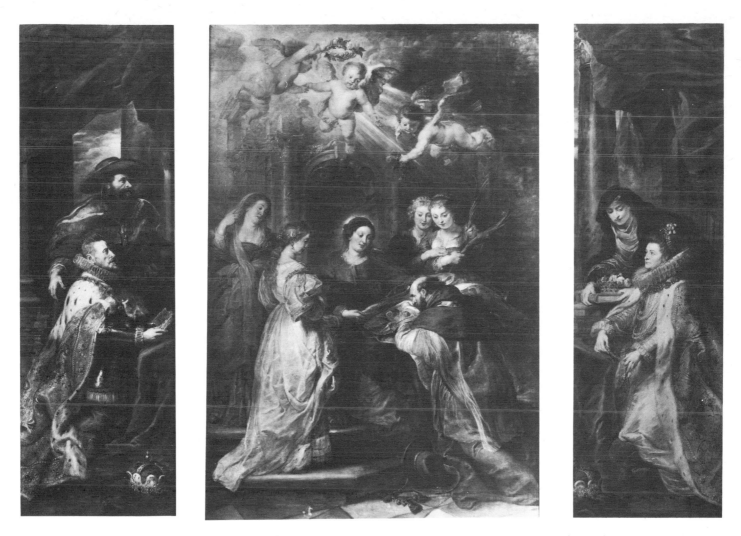

90 The Altar of the Brotherhood of St Ildephonsus 1630–32 Panels 352 × 454 *Vienna, Kunst historisches Museum*

Similar qualities are found in the picture of the same period usually called the 'Garden of Love' but known in Rubens's own household as 'Conversation à la Mode'; a better title which takes account of the equivocation between these two is the *Garden Party* (Plate 91). Rubens seldom if ever painted figure compositions without a precise meaning in mind. Although no literary key has been found, this picture stands between medieval courtly love-garden allegories and Watteau's *Fêtes Galantes*. There are indications that he intended an allegory not of promiscuous love, as in Titian's *Worship of Venus* (Plate XXVI), but of conjugal love, represented by a walking and a seated couple on the left and another pair entering from the right. The single lady to their left, in dark blue, is welcomed by three seated figures who probably represent kinds or degrees of love between heavenly and earthly. Within the shade of the grotto are several less courtly figures of both sexes. The colours are varied: scarlet, black, lilac, gold, blue-green, dark blue, tomato red, silver, crimson and lemon. The

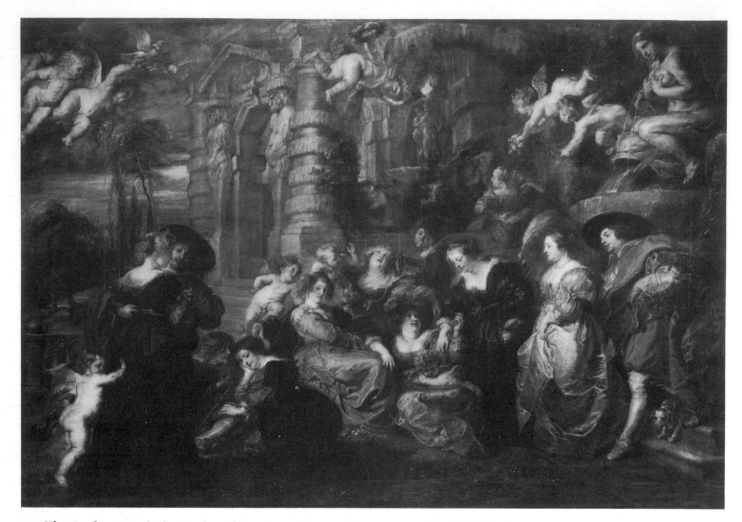

91 **The Garden Party ('The Garden of Love')** *c.* 1630–32 Canvas 198 × 283 *Madrid, Prado*

fountain statue on the right represents both Venus, goddess of love, and Juno, goddess of marriage and motherhood, as the latter's emblem the peacock makes clear. The cupid with the couple on the left carries a yoke, while another one flying in the centre holds a torch and a floral crown; these are all marriage emblems. Rubens, who gave emotions even to statues (Plate 60), imbued allegory with the casual poses and behaviour of real life. Courtly figures here move in a homogeneous space. It is unwise to identify portraits rather than idealized types; the architecture also is so loosely related to that of the painter's Antwerp house (Plate 4) that the garden should not be seen as representing his own.

The *Garden Party* was popular and much copied; Rubens himself made a double-sheet drawing based on the lower half for a woodcut by Christoffel Jegher. In a variant composition in the Rothschild Collection at Waddesdon some of the faces obviously *are* portraits, but this painting cannot be from Rubens's hand. The original in Madrid, for which there are several large figure studies, is a big picture with figures half lifesize; they are idealized and

with their setting they are the equivalent in painting of high relief. The Waddesdon picture on the other hand is a mixture of *genre* and portraiture in which the figures are placed in a landscape of exaggerated perspective.

In the same period as these two pictures Rubens made his last versions of paintings by Titian – they are not direct copies, but were made through an intermediate source (p. 155, Plate XXVI). The same rich palette can be seen in the *Holy Family with Saints* (*Rest on the Flight into Egypt*) of about 1635 (Plate 92). On the right St Joseph sleeps against a tree while his donkey grazes under a low evening sun which a little waterfall reflects. Both the female saint in the foreground, in black, gold and white, and the Madonna, the pink, rose, yellow and blue of whose garments are reflected in the sky, are adapted with little alteration from figures in the *Garden Party*.

More than three decades separate the late *Judgement of Paris* from the early painting of the same subject that hangs next to it in the National Gallery (Plates II, 93). Rubens's later composition appears to be more casual and his lighting is more natural. The marble figures of

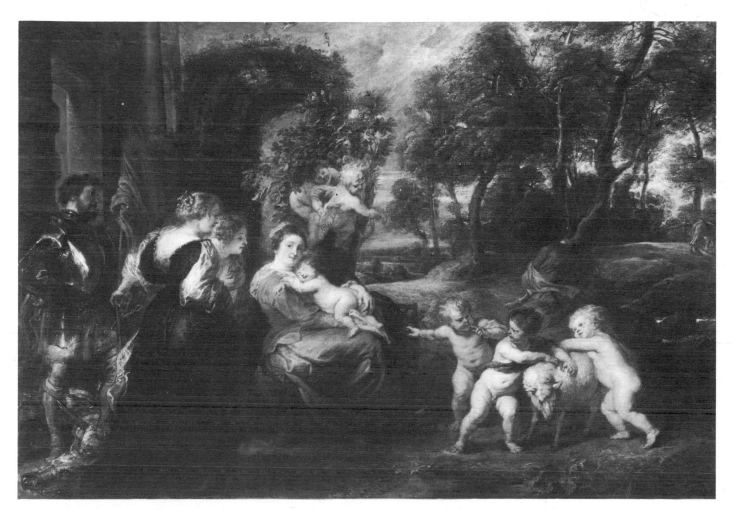

92 The Holy Family in a Landscape (Rest on the Flight into Egypt) *c.* 1635 Panel 87 × 125 *Madrid, Prado*

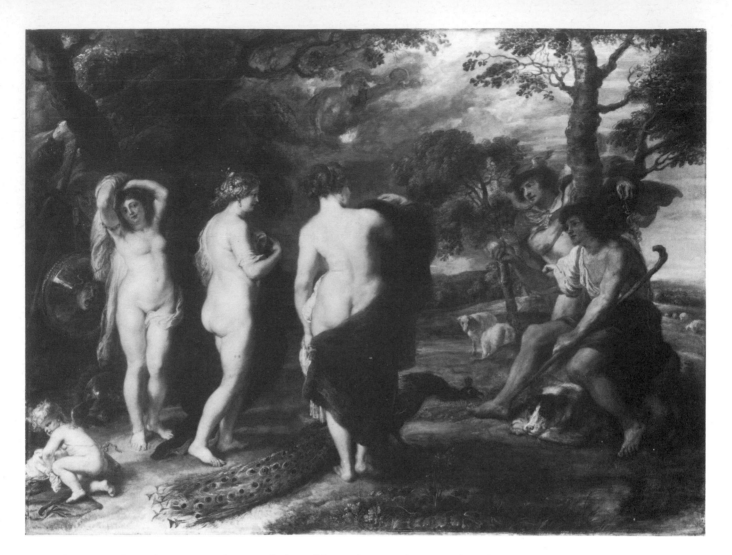

the early picture have become opalescent flesh and his palette under Titian's influence is rich and warm. Cupid plays with a garment blue like the sky and hills; the darker blue of the peacock echoes that of Venus's cloak in the centre of the group of goddesses. The purple of Juno's fur-trimmed cloak, on the right, is mixed from this blue and the pink used for the draperies of Mercury and Minerva. In the sky the war-Fury Alecto (cf. Plate 8) rides through the golden light and the dark clouds to signify the consequences of Paris's verdict.

In preparing for the earlier painting Rubens had considered the scene in which Paris orders the goddesses to undress; examination of the later picture shows that here again he first depicted that incident, with *putti* disrobing Minerva and Venus, Paris undecided and a group of satyrs looking on at the top left. He then simplified the composition, painting out the *putti* and satyrs, and established the agreement, through gaze and gestures, between Paris and Venus, who unlike the exhibitionist Minerva on the left has a traditionally 'modest' pose. Juno's peacock expresses a loser's anger by threatening Paris's dog; this confrontation takes up all the emotional tension of the event, so that the principal figures, viewers and viewed alike, seem relaxed. Compositionally, however, the painting is still tightly knit together: it is pivoted round the figure of Juno, whose right heel is exactly in the middle of the panel, and while the same easy brushwork flows over all the forms Rubens uses the pivotal figure,

93 The Judgement of Paris
c. 1633–5 Panel 145 × 194
London, National Gallery

[138]

as he had often done before, to distinguish a closed relief-like portion, on the left, from an open one with distant vistas between the figures, on the right.

For all that has been said, it would be wrong to characterize Rubens's late style as all sweetness and light: his observation and his narrative skills lost none of their bite, as can be seen in the *Crucifixion of St Peter* commissioned in 1637 by the Cologne banking family of Jabach and installed by them after the artist's death in St Peter's church in Cologne, the church in which Jan Rubens was buried fifty years earlier (Plate XXXI). In its original position over the high altar the terrible event stood out, freely painted and bathed in light, like a living scene. In the silence of the little side chapel that now houses it, this is a noisy picture: the four executioners are fiercely absorbed in their tasks, which are co-ordinated but nevertheless hasty and violent. Only the saint, humiliated and dizzy, exchanges glances with the beholder and thus brings him also into the reality of the event.

VII THEORY AND PRACTICE

How Rubens made his pictures is a question not only of importance for an understanding of his art but also of interest in itself: we all like to see an expert at work. Yet there are today many erroneous assumptions about Rubens's practice. Some are based on what is known – or supposed – about painters' studios in the last hundred years; it is easy enough to believe that methods had changed little since the seventeenth century and that in a period nearer to our own – Rubens was still a hero for Renoir – we should find answers to our questions. Such questions are stimulated by Rubens's skill in presenting the contrived as if it were natural (Plates IX, XXVII, 34, 91); but they are frustrated by the brilliance of his results and the paucity of evidence – except to the specialist – of his practice. In fact the *Honeysuckle* portrait (Plate IX) like all the landscapes was painted indoors over many hours; the *Garden Party* is allegory, not *genre*, and Rubens perhaps never *painted* a nude from life although a life *drawing* is one of the ingredients of his apparently casual but actually carefully ordered pin-up Venus (p. 162).

There seem to be only two contemporary accounts of Rubens at work. Sir William Sanderson, who watched him drawing in London, recorded that he 'would (with his Arms a cross) sit musing upon his work for some time; and in an instant in the livelinesse of spirit, with a nimble hand would force out, his overcharged brain into description, as not to be contained in the Compass of ordinary practice, but by a violent driving on of the passion'. This must not be misinterpreted as a pantomime of furious inspiration: the *nimble hand* implies control of energy along with speed. Urgency comes, as writers and composers as

well as artists know, from the human brain's terrible facility in losing the newly formulated idea in the very act of committing it to paper, and one of the fundamentals of technique is the ability to cope with this problem. The general point which Sanderson uses Rubens to exemplify is that thought and visualization precede the exercise of skill in recording the mental image. For evidence of Rubens's skill we have only to look at his works.

A different aspect is shown in Otto Sperling's account of 1621 already quoted (p. 10). After talking while painting and dictating, Rubens 'passed us to one of his servants to be taken all round his noble palace and shown his antiquities and Greek and Roman statues, of which he has a great number. We also saw there a big room which had no windows but was lit from a big opening in the middle of the ceiling. In this room many young painters sat, all painting different pieces which had been sketched out by Mr Rubens with chalk and a touch of paint here and there. The young fellows had to work up these pictures fully in oils, until finally Mr Rubens himself would put the finishing touches with his own brushes. All this is considered as Rubens's work; thus he has gained a large fortune, and kings and princes have heaped gifts and jewels on him. For the new Jesuit Church then being built in Antwerp he has carried out almost countless pictures'.

It is more usual to question Rubens's mental juggling act (which Henry Peacham's *Compleat Gentleman* confirms) than to ask exactly what Sperling saw. If he went before 13 February when they were delivered he would have seen the canvases for the Jesuit Church nearing completion. Otherwise he would have seen only a miscellany of large and small works, the assistants being more concerned in the large ones. The room where they worked cannot now be identified. The 'great studio' in the *reconstructed* Rubenshuis occupies two floors on the south side; it has the traditional studio north light with some windows on the east, but there is another room above it. Harrewyn's engravings of the house were made half a century after Rubens's death and are of limited value for the interior. It seems unlikely that Sperling was mistaken in what he saw and described, or that he confused the workshop with the domed sculpture gallery (p. 64). More important are his grasp of Rubens's method at its face value and his ignorance of what lay behind it.

Sperling saw the artist, learned as well as skilled, with an empty in-tray, a full bank account, and a technique and indeed a style for mass-producing Rubens originals. Since the Middle Ages workshops had depended on the matching of tasks to abilities and the master's skill and watchfulness. Rubens's helpers, who included, in 1620, Van Dyck, were master craftsmen like himself; his own skill and organization were nevertheless exceptional. Very early he had learned how to draw on paper as precisely with the point of a small brush as with a pen; he applied the same technique in oil sketches on wood panels, and in tightening up outlines, clarifying modelling and adding life and sparkle to the work of assistants, from the '*Great*' *Last Judgement* of *c.* 1615–17 (Plate 82) to the Whitehall Ceiling two decades later (cf. Plates 53–4). His price varied with the degree of his own work, and a large and autograph original – a miracle of execution as well as invention – was expensive. His overheads were considerable; his business ability was no doubt inherited.

But Sperling did not see the the preparatory work in the form of drawings and oil

sketches; nor did it occur to him that the many works of art in the house had practical use as well as atmosphere. Besides Antique figures and reliefs those works included copies, small bronzes, casts, paintings by older and contemporary artists, and many drawings both by sixteenth-century masters and by Rubens himself. Such works were necessary to him both for instruction and for inspiration. There was no formalized instruction in art; a pupil was apprenticed usually for four years to a master of the local guild and he learned by watching, listening and doing. From sweeping the studio, stretching canvases and grinding colours he progressed to making copies or reductions for sale by the master. Thus he learned both craftsmanship and style, the master's style; his own would emerge later after he had had experience in painting parts of originals for the master. When Rubens became a master in the Antwerp guild at the age of twenty-one he had had seven or eight years under three teachers; Otto Vaenius added to his example an understanding of Renaissance ideals in art and scholarship, and his influence was still strong in Rubens's early work (Plate 1). The succeeding eight years in Italy could be seen as an extended post-graduate course in which Rubens worked for himself and studied without supervision. He developed late, but for him the traditional *wanderjahre*, the Northern artist's period of travel, brought less consolidation than change and development, and what in a lesser genius would have been eclecticism amounted eventually to a rich and homogeneous style.

Many years later Rubens told the German painter and historian Sandrart that as a youngster he had copied Holbein's *Dance of Death*; the album with most of these little pen and brush copies of Holbein's woodcuts has recently come to light (Private Collection, Netherlands). In his teens he also copied works by Dürer, Stimmer, Amman, Goltzius and other Northern printmakers as a means of study. He acquired a life-long admiration for the elder Pieter Bruegel, like himself a scholarly artist who managed not to be swamped by the influence of Italy. Rubens's *Costume Book* (London, British Museum) appears to have been compiled after his Italian period as a reference collection of late medieval costume and headdress drawn from other (and often older) images. Some scholars have seen in the thin precise lines and somewhat archaic air of these drawings evidence of an earlier date during Rubens's apprentice years, but this misreading illustrates a general characteristic of his drawings from other works of art, which vary in style according to the nature of the original. In the *Costume Book* the primitive quality is in the originals, but even so Rubens seems to develop space around the originally two-dimensional images as he transfers them to the page.

While still in Vaenius's studio Rubens was also familiar with prints from Renaissance Italy and probably also from the School of Fontainebleau; Marcantonio's engravings after Raphael underlie some early paintings (Plates 1, 11). Aspects of the Renaissance and the Antique were also familiar to him, as they were in several Netherlandish studios, from another source: plaster casts and small bronze replicas of famous sculptures. The importance of these bronzes, made by both Italian and Northern artists, is difficult to overestimate: their manufacture needed special aptitudes in the reduction of scale, and since they could be moved about and handled they communicated more easily through the touch than their

large and far-off prototypes could do. As for the specific world of Classical Antiquity, Rubens was also predisposed to it by his education and by the steady discovery of all kinds of Antique everyday objects, which fascinated scholars then as much as archaeology today attracts a far wider public.

In some works of *c.* 1600 the range of references is already wide. A drawing of a *Battle of Greeks and Amazons* (Plate 94) depicts not the battle with Theseus (p. 35) but the ninth Labour of Hercules, capturing the girdle of the Amazon queen Hippolyte; in the middle distance the queen faces Hercules on the left. He wears the lion's mask on his head, much as the hero in the early *Judgement of Paris* (Plate 11) wears a leopard-skin. In drawing a composition of figures which explode both across the surface and out of the paper, Rubens seems to have exceeded the descriptive and expressive capacity of his medium. The equine types, which recur in mature works (Plates 15, 16), can be found in Antique art. The hard regular hatching in the shadows suggests direct imitation of engravings of battle scenes, and Rubens appears also to have known a painting by Vaenius of the *Amazons* of *c.* 1598 (Potsdam, Schloss Sanssouci). But the numerous alterations and hesitations, and the reduction in detail towards the edges, show that he was here more interested in inventing a new composition than in copying an existing one. The element of caricature, especially in some of the heads, is also personal to him and appears in several other pen drawings of this period.

But if in the North Antiquity had to be reconstructed, it seemed to live again in Mantua. The adopted birthplace of Virgil had been a Roman settlement and the extensive Gonzaga collections contained local finds; moreover Mantegna in the late fifteenth century in painting, and Giulio Romano in the second quarter of the sixteenth also in architecture, had so transformed the courtly city that Vasari, who visited it in 1541, called Mantua a new Rome. Figures like the blonde Venus of Rubens's Mantuan allegory (Plate 65) owe as much to Mantegna as to Veronese. That painting also contains borrowings from Giulio, some of whose drawings Rubens acquired or copied; from them he learned above all the translation into painting of a particular style of late Roman relief in which movement is conveyed not only through individual poses – which seem to us like those of nineteenth-century classical ballet – but also in larger loops and swirls that run from one figure to another, the 'large flowing line' in Hogarth's words, 'which runs through all his works' (Plate 8). In Rome Rubens saw and drew the most famous statues known and then gathered in the gardens of the Vatican and in the Borghese, Ludovisi, Farnese, Medici, Giustiniani and other collections; in Venice good Greek originals were available to him. During his eight years in Italy he travelled with an energy and dedication that would be the envy and perhaps the despair of a modern scholar, copying those drawings he could not acquire, copying also sculptures and – sometimes in the original medium – paintings. As he had learned from the woodcuts of Holbein and from his own teachers, he now learned from Titian, Tintoretto, Veronese, Pordenone, Leonardo, Raphael, Andrea del Sarto, Michelangelo, Correggio, Parmigianino, Primaticcio, Polidoro, and nearer his own time from Muziano, Giuseppe Salviati, Cigoli, Barocci, the Zuccaro, the Carracci, Caravaggio, Elsheimer, Giambologna and others. From them he made new discoveries about light, colour, modelling, composition, narrative,

94 A Battle of Greeks and Amazons
c. 1599–1601
Pen and ink over pencil
25.2 × 43
London, British Museum

gesture, the techniques of brush, pen and chalk, and about the human figure. Sandrart linked Rubens's works of the 1610s with Caravaggio, but while he certainly studied Caravaggio and could even have met him in Rome, Rubens saw in his work there the influence – which he felt in his own painting – of the narrative and gestural genius of Raphael. He did, however, persuade the Duke of Mantua to buy Caravaggio's *Death of the Virgin* and later led the subscription to buy his *Madonna of the Rosary* for the Dominican Church in Antwerp.

Soon after his arrival in Rome Rubens drew copies of most of Michelangelo's Sistine *Prophets* and *Sybils*; a drawing also survives of one of the *ignudi* in the zone below them, between Jonah and the Libyan Sybil (Plate 95). He removed the background, enlivened the angle and expression of the head, and consistently strengthened and masculinized the rather feminine musculature of the original to give an impression closer to heroic free-standing sculpture, or even to the more energetic figures in Michelangelo's own later red chalk 'Presentation Drawings' of the 1530s, which Rubens might also have seen in Rome. The change was not so much a reaction against the sexlessness of Michelangelo's heroic youth as a criticism of form. The importance of sculpture for Rubens's art has already been stressed (p. 36); moreover one of the few portions of his theory known to us concerns sculpture in relation to painting. Roger de Piles owned a notebook by the artist, which later belonged to the cabinet-maker Boulle, in whose studio it perished in a fire in 1720: today we have a few original leaves, partial manuscript copies still unpublished, and some printed fragments. One, *On the Imitation of Statues*, was printed verbatim in 1708 by de Piles with a free French translation. It is usually described as a treatise, but it consists of 400 words of difficult Neo-

stoic Latin and must record two or three pages of the notebook probably written soon after Rubens's return from Italy. 'To reach the highest perfection', he wrote, 'it is necessary to understand [statues], indeed rather to drink them in; but they must be used with judgement and care taken that painting does not take on the quality of stone. For many inexperienced and even experienced artists do not distinguish the material from the form, the stone from the figure, or the requirements of the marble from those of art. But while the best statues are very useful, poor ones are useless – in fact ruinous. For when beginners absorb their rough, stiff, hard and laboured anatomy they think they are learning, but it is to the disgrace of Nature when instead of flesh they only represent marble with colours'.

Rubens had not avoided this danger. Not only are specific poses taken from statues – for example the *Belvedere Torso* in *Christ Mocked* and the *Judgement of Paris* (Plates 63, II); the figures in general in early paintings of this kind are nearer marble than flesh and blood. But the figures in later paintings and drawings, even when based on statues, are far from them in constitution. Karel van Mander's *Schilderboek* (1604) uses 'life' to mean both living and sculptural models for drawing. Rubens based the features of Henri IV and Marie de' Medici in the Luxembourg Gallery on small busts sent to him for the purpose; by 1620 he could translate the most formalized of statues into skin and muscle. A large chalk drawing of that date of *Hercules Victorious over Discord* (Plate 96) seems at first sight to be an imagined figure, because of the multiplicity of arms and legs the artist essayed. But the viewpoint, at the level of Hercules's head, implies either that the figure was intended for an unusual (and unknown) location or, more probably, that Rubens worked from a small replica of the *Farnese Hercules*. The most remarkable transformation in a drawing from sculpture is that of three Caryatids after Primaticcio (Plate 18), although Rubens's genius for making statues live is nowhere better seen than in a splendid study for a lioness (Plate 80) in *Daniel* (Plate xv), which derives from a known Paduan bronze. Some of the other lions in the picture seem (because no models have been traced) to be taken from drawings of living animals, but this brings us to an important distinction between drawings done for immediate use and those done less for practice than for stock. In the workshop tradition drawings were an artist's most valuable asset, as a stock of reference material and patterns. Rubens's will directed most of the pictures and oil sketches in his house and studio to be sold, but his drawings were to be kept until his children had grown up, in case there was a potential artist among them.

While compositions took shape in his mind as occasion required, Rubens gradually built up a repertory of figures, many of which had specific meanings either in gesture or in association. The departure from Venus has been mentioned (p. 23). The *Death of Seneca* (Plate 70) is based by way of drawings on the Antique '*African Fisherman*' which was then thought to represent Seneca (p. 106). Rubens drew from several aspects the Laocoön group in the Vatican garden, which from Pliny's time has been recognized as one of the most expressive of Hellenistic sculptures; he also drew the figures individually. His quotations from this group include Laocoön's figure of heroic pathos in *Christ Mocked* (Plate 63) for the legs; in reverse in the *Deposition* (Plate XII) for the arms and torso, and (paraphrased) in *Prometheus* (Plate 76). Laocoön's sons are used for St John and Nicodemus in the *Deposition*;

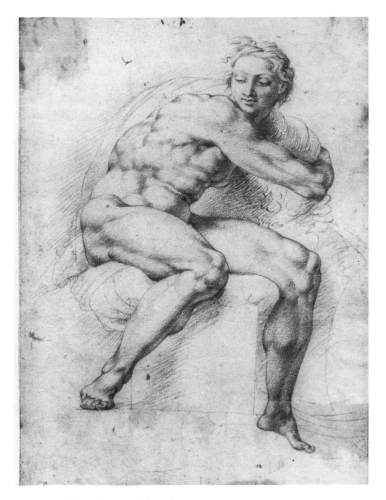

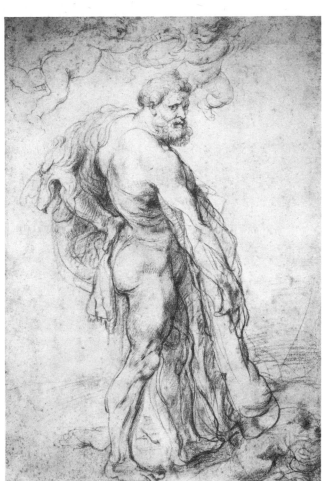

95 Ignudo *after Michelangelo c.* 1601
Red chalk 38.9 × 27.8 *London, British Museum*

96 Hercules Victorious over Discord *c.* 1618–20
Red chalk, corrected in black 47.5 × 32
London, British Museum

more usually they inspire figures caught up by superior forces. One or other appears thus as *Ganymede* (Vienna, Schwarzenberg Collection, and in the later, different composition in the Prado), as a female *Truth Triumphant* concluding the Medici cycle and, again as a female, rotated and reversed mirrorwise, as Phoebe in the *Daughters of Leucippus* (Plate XIII). The *Leda* he quoted there in Hilaeira is ultimately an Antique figure, while an Antique standing *Leda* inspired the princess of *St George*, the sinuous figure on the left of the *Circumcision*, and the figure of St Domitilla in the first Chiesa Nuova altarpiece (Plates 66, 12, 42). In the Chiesa Nuova pictures the Antique was historically apt for Roman martyrs, and the outer figures of the side panels are adapted from identifiable statues (Plates 43–4), although Rubens's patterns for armour were consistently a hybrid between ancient and modern. But while St Domitilla is an Antique version of Brigida Spinola Doria and her companions have Roman heads and togas, both the right-hand and the middle panels relate to paintings of the same subjects in SS. Nereo e Achilleo, Rome, made in the 1590s by Cristofano Roncalli and Durante Alberti.

The repertory thus was not limited to the Antique. There are drawings from sculpture by Michelangelo and Giambologna; a fountain figure by the latter is the model for the one in the *Garden Party* (Plate 91). The *putti* above St Helena (Plate 61) are only cousins of those in Elsheimer's *Baptism* (London, National Gallery) but thirty years later those in both the St Ildephonsus altar and the *Garden Party* (Plates XXIV, 91) are derived from *putti* by Rosso at Fontainebleau. Other repertory figures reappear, as is obvious from a comparison of the *Garden Party* and a *Holy Family* (p. 137); the broad oriental in the 1624 *Adoration of the Kings* also recurs (p. 130). Considering the size and range of Rubens's work his re-use of figures and motives must be seen as a sign of consistency rather than of a lack of invention or even of a desire for economy, and this consistency extends to details. Many of his goddesses seem to have employed the same hairdresser as those of Titian (Plates 17, 93) and it was probably from Titian that Rubens adopted a type of Roman jewelled upper-arm bracelet which is standard wear for his Classical nudes and the biblical Susanna (Plates XI, XIII, XVIII, 93).

Rubens's drawings were of course of many kinds. Some of the most revealing though not the prettiest are those in which the hand has moved 'naturally', guided not by instruction or concepts of style but by personality, habit and the patterns of thought and vision of his time. Such drawings are private notes for the artist's own use in recording and even in forming ideas, thoughts on paper; an elaborate early example (Plate 94) shows well how much ideas changed in the course of being set down, and how schematically or symbolically many of the forms are shown. Speed in drawing is hard to measure, but concentration is evident in every line (p. 139). In a very beautiful later example, couples intended for a peasant *kermesse* dance their way from his imagination over both sides of a large sheet of paper (London, British Museum). The next stage, when the composition was settled provisionally, might be a more finished drawing or, often, an oil sketch on a prepared panel. Sometimes, for instance in the ceilings for the Jesuit Church, the first stage was also in oil on little panels in monochrome; most of the Whitehall Ceiling was conceived on a single larger panel (Plate 52). Usually the more developed sketches were in three or four colours (Plate XX), often white, red or pink and yellow ochre (which could be mixed for flesh colour) and grey or black. But there are also oil sketches, often at a later stage, in which the colours of draperies and sky were important, and which employ a full palette but with lighter, less saturated colours than in the final painting. Oil sketches also had various functions: some were to show the giver of the commission an advance idea of the picture or even to form the basis of a contract, others were true *modelli*, blue-prints as it were for Rubens or his workshop to follow. The young painters Sperling saw (p. 140) would have worked from such *modelli*, the information in them being amplified or amended by the colour indications he noticed on the final canvases in progress.

The oil sketches are today often esteemed at the expense of finished works for several reasons. They are easy to transport and thus a mainstay of loan exhibitions. There are also proportionately more of the sketches still in private collections, and therefore marketable commodities, than of the big pictures. Further, if they are autograph and not by others following his invention or his method, they reveal his 'handwriting' and thus appeal par-

ticularly to the modern aesthetic of the sketch. There were already many sketches, as there were also many copies after Rubens, in seventeenth-century Antwerp collections, and the sketches were already valued as authentic works of the master which with care or luck might be easier and cheaper to acquire than finished pictures. Rubens's contract with the Antwerp Jesuits obliged him to surrender the *modelli* for the two altarpieces (Plates 84, 86) and to redeem the ceiling sketches by presenting instead an altarpiece for the Lady Chapel. The Abbé de Maugis, intermediary between Rubens and Marie de' Medici, managed to acquire from the artist the sketches for the Luxembourg cycle.

Assistants were more important to Rubens's workshop than pupils; that is to say, his principal aim was to employ their talents, not to develop them. Teaching was not for him, as it was for Rembrandt, either a necessary part of his personal artistic activity or a means of assuring an income. Moreover, his freedom from guild rules as Court painter meant that his pupils did not have to be registered. The closest Rubens came to compulsive teaching was probably in his last years with Lucas Fayd'herbe (p. 18). Fayd'herbe became a sculptor and the nearest equivalent in his country and period to a sculptural Rubens; his relation to the master was almost filial, and to some extent compensated for the failure of Rubens's sons to follow in his footsteps. In a letter of August 1638 Rubens instructed 'my dear and beloved Lucas' to make sure, in closing the studio for the summer, that no originals or sketches were left accessible: he was worried less about burglars than about the assistants, 'for as long as you are there you cannot close it to the others'. The high degree of 'interpretation' (a term used in tapestry weaving) on which he depended from his workshop meant that replicas or pastiches could be produced in his absence without his authority, and this undoubtedly happened on occasion, especially in the last decade. Significantly in designs for tapestries he left much less to interpret; for the *Achilles* series the small coloured *modelli* (about one-ninth size) were followed by full-size cartoons. Cartoons, usually the work of assistants or specialists, might be on either canvas or paper. Those which survive on canvas for the *Eucharist* series may have been retouched by Rubens; on the other hand four autograph cartoons on paper for an unexecuted *Aeneas* series have recently come to light (Cardiff, National Museum of Wales).

Tapestries are woven from behind, and the designs are thus reversed in the process; the *Achilles* tapestries were certainly designed to read consecutively from left to right, and Rubens compensated for this by reversing the *modelli* (Plate 60). In designs for title-pages, too, he usually had reversal in mind, and this led him also to make compositional changes in drawings after his own pictures made as the basis for Jegher's woodcuts (p. 136). A succession of engravers made many authorized prints after pictures, often preparing their own drawings; some of these were reversed so that the print would follow the handedness of the painting, but many were not. Rubens evidently did not mind very much; he often reversed figures in drawings, and the importance of the prints for him was to publicize his work and to make an income, which he obtained copyright privileges to ensure.

Some of the official pupils are known by name, among them Willem Panneels (1600–16??) whom Rubens left in charge of the studio during his Spanish and English journeys,

for which Panneels received a good testimonial in 1630 before moving to Germany. We are poorly informed about pupils before the 1620s. The firmest statement about Deodato del Monte (or Van der Mont, other spellings *ad libitum*, 1582–1644) is Rubens's certificate in 1628 that Deodato, having been his apt pupil, accompanied him to Italy and on all his travels there. We also know that in 1608 Deodato witnessed Rubens's contract for the altarpiece for the Oratory Church at Fermo (p. 106), but scholarship has so far made nothing more of him than a refuge for unsolved problems. In the 1610s Rubens collaborated with Jan Brueghel, setting figures into some of his flower-garlands and small landscapes as well as writing his letters (p. 50). He also had the expert help of Frans Snyders (1578–1657) in animals and still life, Jan Wildens (1586–1653) in landscape (p. 52) and others. In 1617–20 the young Van Dyck (1599–1641), never his pupil but already a master, was his principal assistant. In the 1630s Jacob Jordaens (1593–1678) worked, like most other Antwerp artists, on the *Pompa Introitus Ferdinandi* and the enormous series of mythologies for the Torre de la Parada which Philip IV wanted in a hurry (pp. 74, 87). Some of the Brueghel works are signed jointly, and we have Rubens's word for Snyders's part in a painting like *Prometheus* (Plate 76), but more detailed conclusions about the part of individual collaborators have varied – and still do so – according to the initial preconceptions of individual scholars. Except for a small group of works in 1613–14 Rubens rarely signed and dated pictures. In 1620–21 there was a serious misunderstanding with Carleton and Toby Matthew who had acquired, believing it to be autograph, a *Hunt* which Rubens had to admit was studio work retouched by him; but when dealing with Carleton in 1618 he had been careful to specify originals (Plates xv, 78), joint works (Plate 76) and pictures by 'the best of my pupils' (meaning Van Dyck) and other assistants. The assistants' work had been or would be retouched by Rubens himself. There are worse preconceptions to start from than this: that Rubens aimed not only at a sure *technique* for producing Rubenses (as Sperling noted) but also at a common *style* which could be reproduced or shared in the studio by different individuals. In the mid 1620s, as his own brushwork became broader and more fluid he was able to paint large works very thinly and directly, and the 1624 *Adoration of the Kings* in Antwerp (Plate xxi) and another a decade later (now Cambridge, King's College Chapel), both autograph, were according to tradition painted in a few days.

Rubens's craftsmanship was remarkable even for his time, and caused his work to survive to a degree he can hardly have foreseen: he was used to repainting older pictures himself and would be amazed at the reverential treatment his own works now receive. Basically he used good and tried materials, the minimum of paint, and clean brushes. Even for very large works he often preferred to use wooden (usually oak) panels, the making of which still flourished as a skilled trade in Antwerp. One prime reason for using canvas was that it could be rolled up for transport if a painting had a long way to travel. The panels of the *Fishmongers' Altar*, however, were taken from Malines by canal barge to Antwerp to be painted and back to be installed (Plate 83). But much of the *Raising of the Cross* was painted in position in St Walburga's (Plate 72, Figure H) behind a big sailcloth hung across the sanctuary. The *Assumption* was also completed on site in Antwerp Cathedral (Plate 89) and

the paintings in the Chiesa Nuova are of course framed murals (Plates 43–5). (It is sometimes said that Rubens painted in Paris the *Felicity of the Regency* for the Luxembourg Gallery, but this is a misreading of the fact that it was a late substitution for another subject.)

The great Venetians of the sixteenth century had used canvas, often prepared with a ground of red bole (a greasy red clay) which could give a special warmth to the final painting by its reflection of light passing twice through thin and translucent surface paint layers: Titian is recorded as building up his paint surface slowly with successive glazes of infinitesimal thickness. In Italy Rubens often used a similar red or brown ground on canvas, and in later years he used both grey and, notably in *Peace and War* (Plate 10), red lead and red ochre, which give that picture unusual warmth. But the optical properties of very thin layers could best be exploited in an adaptation of the traditional Netherlandish panel technique which also offered a very smooth surface to his gliding brush. A panel of seasoned wood was coated with gesso (gypsum) and glue (or in Rubens's case often chalk and glue) which was then burnished and sized. Instead of a mixture of powdered charcoal and size-glue he then applied, with a broad coarse brush in raw umber oil paint, a layer of irregular hatched scrubbed strokes, which changed the brilliant white reflective surface to a shimmering silvery brown. The oil produced a smooth porcelain-like surface, the raw umber (which the contemporary Edward Norgate described justly as 'a course, greazy and foule colour, yet very useful for shadows, haire, perspective and almost any thing') gave a middle tone between light and dark as a starting point, and the coarse brushwork left an irregular pattern of thin lines, alternately pigmented and transparent, which reflected light in the same way as satin or velvet. When dry this surface would take charcoal drawing (and in some cases took pencil annotations) but most of the picture would be outlined with a brush in burnt umber oil paint. This dark brown brush drawing might be restricted, like Titian's, to the principal contours, but on a wooden panel the main shadow areas of flesh would be brushed in at the same time in the same paint. A single layer of flesh colour would then almost complete the modelling of figures, for in the half-tones on which the modelling of fair skin largely depends Rubens exploited the same optical principle as that which gives the skin its translucency, vibrancy and variety of hue. Light seen through a thin pale film (whether light oil paint or the epidermis) appears pinkish, darkness seen through the same film appears bluish; so the setting sun looks red and the distance in haze, our surface veins and Rubens's middle tones all look bluish. He often achieved blue and grey tones in this way without painting them at all, by varying the opacity of the flesh colour over the brown under-modelling (Plate XVII). In this portrait some white highlights and dark or red shadows are added, but most of the work required very few stages and the process was much faster than the succession of many glazes used by Titian. As oil paint becomes more transparent with great age, some of the brushed hatching is now visible at close range in the very thin area of the face shaded by the hat. Often a panel and sometimes a canvas (Plate 10) or a drawing would need enlargement as the painter's ideas developed or if he wanted more surrounding space. After three and a half centuries it is clear how he enlarged the portrait of Susanna Fourment, gluing on extra pieces of wood less thoroughly prepared than the main one.

In all but his earliest autograph works Rubens began and ended with drawing, using his skill acquired as a lad in brush drawing to pull together and sharpen the areas of colour that constitute the picture; the same process gave authenticity to assistants' work (p. 140). Moreover, this process of overdrawing ensures that what we see is a painted picture, not an illusion. In a number of paintings, most notably in the Medici cycle, he used gold leaf for things like candle flames and gold coins, a device that is paradoxically both realistic, in its metallic glint which shifts as the beholder moves, and abstractive, in its emphasis on the picture surface.

In 1635–6 Rubens sent his friend Peiresc some observations on colour, in which Peiresc took a scientific interest. Until the end of the eighteenth century a treatise on the subject by Rubens was widely believed still to exist, but scattered statements purporting to come from it say less about Rubens than about the later colour theories they are used to corroborate. He knew neither the nature of Newton's spectrum (his rainbows do not contain seven colours) nor the exclusive concept of red, yellow and blue as the three primaries from which all other colours can be made. Painting from these primaries is of course only an academic exercise, not only because it is laborious but also because common pigments only approximate to theoretical primaries.

Rubens was painting *Juno and Argus* at the time when his friend Aguilon was completing his book on optics, published in 1613, but although Aguilon proposed five primaries, red, yellow, blue, black and white, it is difficult to sustain the idea that either the *Argus* or any other picture was intended to illustrate Aguilon's theories about colour. Nevertheless it is undeniable that like most painters before Monet (and many since) he used black and white as colours. The idea of a few essential colours is older. Rubens knew the testimony of Pliny and Cicero among others that famous painters of Antiquity such as Apelles and Zeuxis used only four: white, yellow ochre, red and black; Pliny even considered that painting had deteriorated with the introduction of a wider palette. These four are the commonest colours in Rubens's oil sketches (p. 146). It would, however, be difficult to prove that the limited palette of *Brigida Spinola Doria* (Plate VIII) was a Plinian demonstration, or that Rubens had learned from Palma Giovane in Venice that Titian used just these colours for underpainting.

Analysis shows that Rubens normally used a wide range of pigments, and study of his pictures suggests that his attitude to colour was empirical and practical rather than theoretical. Within established techniques he had few hard and fast rules, and in drawings he often carried experiment as far as adding oil paint to pen, chalk, watercolour and gouache. He learned more about colour from the work of Pieter Bruegel, Titian and Barocci than from any other source. Whether within the limitations of an oil sketch (Plate XXII) or of red, black and white chalks in a figure or portrait drawing (the classic 'three chalks' of eighteenth-century France) or in the full range of his most chromatic paintings (Plate XXIX), he aimed both to harmonize, like Titian, the colours of all parts of a picture, and to enrich the whole by the opposition of warm to cool, red and brown to blue and green. Hogarth indeed writes of Rubens's juxtaposition of reds and blues in flesh painting, but it is evident that by his time the optical basis of Rubens's method was no longer known.

VIII FIGURES AND MODELS

The human figure is the basis of Rubens's art and of his studio practice, and a study of his drawings answers many questions about how his pictures were produced. So far attention has been concentrated on drawings for study and reference and the design of compositions. In many cases he followed the Central Italian practice of making detail studies of individual figures, even heads and limbs, after the composition was settled (Plates 3, 73) and even after he had made oil sketches: in the case of the Jesuit altarpieces life drawings were made during the wholesale adjustment between *modelli* and finished pictures (Plates 84–7). Except for tapestries he did not extend the Italian practice to making full-size cartoons, but most of the portrait drawings were preparations for paintings, not finished works in themselves. Sometimes figures were arranged in poses taken from earlier works of art. Sometimes models are recognizable because, although anonymous, they recur, like the one used for Mary Magdalen in the *Deposition* (Plate XII); a young woman in a servant's dress with plaited hair was drawn in several poses, which reappear in paintings of *c.* 1616–18, with her face changed in one case to an old woman's. She also appears reduced in scale in the *Prodigal Son* (Plate 32) and in a landscape, and many of the landscape figures were probably adapted in this way. But unlike some Italian painters Rubens did not pose models unclothed to establish the articulation of figures that become clothed in the painting: studies for Christ in the *Raising of the Cross* are nude because the painted figure is nude.

There is no doubt that large-scale studies (about a fifth lifesize) were drawn from life in the poses chosen for pictures, and although it might be significant that Sperling did not mention it, the question whether Rubens ran a life room needs to be raised (p. 153). On the other hand Rubens was always prone to adaptation or idealization of what he saw (p. 144). His note on Ancient statues (p. 143) stresses that the heroes of Antiquity, whether mythical or historical, were a different race: 'The opinion of many writers shows that the stature of men both religious and secular has decreased from the age of heroes, giants and cyclopes, for although many of them were fictive yet some were certainly described truly. The chief reason why men of our age differ from the Ancients is their idle and inactive way of life; drinking does not contribute to the activity of the body. So the paunch is weighed down and distended . . . on the contrary in ancient times all exercised daily in gymnasiums and schools to the point not only of perspiration but of exhaustion. Thus the idle parts [the abdomen]

were reduced, tightened and turned into sinew'. The phrase *mens sana in corpore sano* was part of one of the quotations from Juvenal which Rubens had inscribed in the courtyard of his Antwerp house.

Rubens's standpoint was not only that of the Neo-stoic moralist: the ideal human body, male and female, was at the centre of both theory and practice in the Renaissance. Dürer learned in Venice of a canon of ideal proportions, but he had to work it out for himself, and his print of *Adam and Eve* of 1504 was intended to propagate the results of his study in the North; Adam was based on the recently excavated *Apollo Belvedere*, Eve on Classical statues of Venus. Dürer later measured two or three hundred persons and came to believe, as, according to the Milanese Lomazzo, Raphael did, not in a single set of ideal measurements but in a range of figures of different types. Thus Lomazzo gives detailed dimensions for youthful and mature figures of both sexes, and also for the horse, alone among quadrupeds. Since that animal's prominent part in human life has only recently been taken over by the tractor, the tank, the steam engine and every sort of motor car its inclusion ought not to surprise us.

Rubens was less concerned with dimensions of parts of the body than with Pythagorean shapes: one of the few surviving pages from his notebook propounds that images of Hercules and all male figures should be based on cubes and squares, female figures on circles and round forms, while the triangle and pyramid are the basis of the torso in strong figures (*robustiores*) and the arms and legs in general.

Since Rubens painted the female nude often, and superlatively, and since this aspect of his art has received the most sentimental adulation as well as the strongest prejudice, it deserves more serious critical attention than it sometimes receives. His attitude was consistent, practical, frank and also discreet. While Flemish writers like Molanus, whose *De Picturis et Imaginibus Sacris* (1570) was reprinted four times by 1626, disapproved even of a naked Christ-child, and while clerics thought Rubens's *St Christopher* improper (Plate 75) the Renaissance had brought the nude into art to stay. In Ripa's *Iconologia* (1603) a female nude is an emblem for Beauty, Genius, Friendship, the Soul, Clarity or Brilliance, Eternal Bliss and Truth. The fact that in current popular speech 'nude' means 'female nude' may be due to the fact that in history most artists have been men, or to customary attitudes of men and women to the body, but a sense of identity in gender plays a far more general part in human behaviour than a merely sexual one. While the Florentine painter Furini attributed his ruin to the employment of female models, Rubens was, from all we know, of a very different moral fibre (p. 11) as well as a better artist. In corresponding with Peiresc about Ancient fertility amulets he revealed an intimacy with feminine anatomy predictable in a father of several children but attributed by Peiresc to his profession as an artist. In adapting a work by Titian he explicitly painted *putti* of both sexes, to make more credible the worship of Venus (p. 156) and he made the message equally clear in a late picture of his own composition, on a similar theme in Vienna; everywhere else he followed the conventions of Hellenistic sculpture, of discreet moulding and the elimination (a frequent cosmetic practice in Antiquity) of body hair. But he did not, like gallant Renaissance writers on beauty, pass rapidly from

the clavicle to the knee. In another note (which Van Dyck thought worth copying) he compared the beauties of woman and mare. He prescribed the head not large or fleshy, the eyes dark and large, the neck long and broad, the breast broad, the hair or mane long, the back straight, the flank short, the stomach moderate, the buttocks ample but firm, the private parts small, the thighs full, the hair (some of these colours may be peculiar to the horse) white, blonde, russet, chestnut, hazel, red or black. In his paintings he tried to apply to ideal women, as to everything else he depicted, a process in which ideal and real are blended and fused.

During the course of his career his feminine ideal did change, or rather mature. With a visual imagination as complex as Rubens's it is impossible to say more about his wives' share in this process than that the ideal becomes more sensuous about 1610, less glossily athletic about 1615 and softer in the last decade. In the early *Judgement of Paris* (Plate 11) the figures indeed look like statues; painted in a generally artificial palette, they glow like marble. Burckhardt thought Rubens's draped women were taller and slenderer, but the example he chose on the left of St Ildephonsus (Plate xxiv) shows him as gullible as others to the illusionism of costume. In spite of its flowing lines the saintly attendant's dress encases a figure no less ample, and stockier, than the left-hand sister in the *Graces* (Plate 17). She is about $7\frac{1}{2}$ heads high, the Graces and Paris's contestants about 8; the early St Helena is 7, as are the late Venus (Plates 61, xxvii), present-day department-store dummies and girls who model lingerie. Lomazzo prescribes 7 for earth figures and sibyls, over 8 for Venus and 'natural' figures, 9 for Minerva, Diana, Muses and nymphs. The Mannerist elongation which was Lomazzo's ideal found its extreme in the figures of Fontainebleau, 9 or 10 heads; Rubens reproduced them faithfully (Plate 18) but otherwise his figures are more natural in proportion.

It is commonly assumed that Rubens used female nude models, and in the last decade specifically his second wife. From the early sixteenth century many short-lived academies of art were founded on the notions of lectures and the regular provision of a nude model for drawing. Many academies foundered on the lack of either amenity, but the notable ones in Rubens's lifetime were in Bologna, Rome and Haarlem; elsewhere life drawing as a discipline was more discussed than practised, whereas in a later period it came to be the basis of the art of painters from David to Renoir and, until recently, of every art school. In Calvinist Holland Rembrandt ran a life room with female nudes, as we know from his own and pupils' drawings and from a story recorded by Houbraken of a pupil who tried to play Adam and Eve with the model in his painting cubicle. In seventeenth-century France the Jansenists considered painting the nude a grave sin, but the French Academy hardly shared this opinion. Although the views of the Council of Trent were unequivocal towards propriety in art in churches, the Roman Catholic Church has in general been less narrow-minded than is sometimes supposed. The Cardinal-Infante Ferdinand certainly thought the figures too naked in the near-lifesize *Judgement of Paris* ordered by Philip IV (Madrid, Prado) but he accepted that for Rubens they were 'the value of the painting'. Neither Rubens nor his patron found the '*Great*' *Last Judgement* unsuitable for the Jesuit Church at Neuburg (Plate 82) although by the end of the century taste had changed. Rubens could, like Renoir, have

chosen his servants for their figures and expected them regularly to disrobe in the studio; like Renoir (who was a modest and easily embarrassed man) he might well have given a coarse answer to a stupid enquiry about his work. But there is no evidence that he did any of these. There are many surviving drawings with female nudes but less than half a dozen have any claim to be from life. More than one study was made from a male figure and then suitably adjusted – which was a common Italian practice – though some others seem too pneumatic to be faked.

There is a fragment of a letter in which Rubens asks a contact in Paris 'to secure for me the two Capaio ladies of the rue du Verbois, and also the little niece Louysa. For I intend to make three studies of Sirens in lifesize, and these three persons will be of infinitely great help to me, partly because of the wonderful expression of their faces, but even more by their superb black hair, which I find it difficult to obtain elsewhere, and also by their stature'. The original of this letter is lost, and since French writers from the sixteenth to the nineteenth century certainly knew the rue du Verbois as a street of ill repute, this may be a case of romantic compensation for the lack of knowledge of Rubens's models and his practice. If so, it was eminently successful, for it led the author of a standard encyclopedia on *Woman* to characterize Rubens's models as Parisian even though Capaio is hardly a French surname. Even if the letter is genuine it is not very helpful, since in it Rubens seems to be more concerned with the ladies above the shoulders; moreover, neither the sirens (bifurcated mermaids, Plate XIX) nor any other groups of three in the Medici cycle have black hair. The fact that some, though few, figure studies survive suggests that there was no censorship between Rubens's death and the sale of drawings in 1657, that proportionately there were always few, and that like many artists of his time and the preceding century he relied on sculpture, memory and adaptation and it did not occur to him to do otherwise, any more than it occurred to him to *paint* a landscape out of doors (p. 52). Indeed he told Norgate both that he painted a certain landscape 'by the life' but '*un poco ajutato*' (a little assisted), and that in Rome he had found 'divers of his nation had followed the Academy course for 20 years together to little or noe purpose' and that 'when the Italians have not the Life to draw by, they make use of Models which are heads, Armes, hands, and other parts of the Body . . . of the *Anticaglie* [antiquities]'.

When Rubens married Helena Fourment in December 1630 a type which he had painted from imagination for years, blonde, sensuous and vivacious, became real and actual. She was not only pretty and shapely but probably somewhat animal and exhibitionist compared to the rather reserved Isabella (Plates IX, 27). Rubens's friend Gevaerts claimed in a Latin poem that whereas Zeuxis of Croton in depicting Helen of Troy had combined the best features of five maidens, the Zeuxis of Antwerp needed only one Helen. Helen of Flanders has gone to the heads of writers ever since, and even in looking at her portraits one can see why (Plates 5, 24).

She provided the ultimate, and sometimes the intimate, for those who like to identify an artist's family in his work. Quite serious scholars of the past and present have seen Isabella Brant in every woman in a history picture before 1626 and Helena in all those after 1630; in

XVII *opposite* **Susanna Lunden,** *née* **Fourment** *c.* 1622 Panel 79 × 54.5 *London, National Gallery*

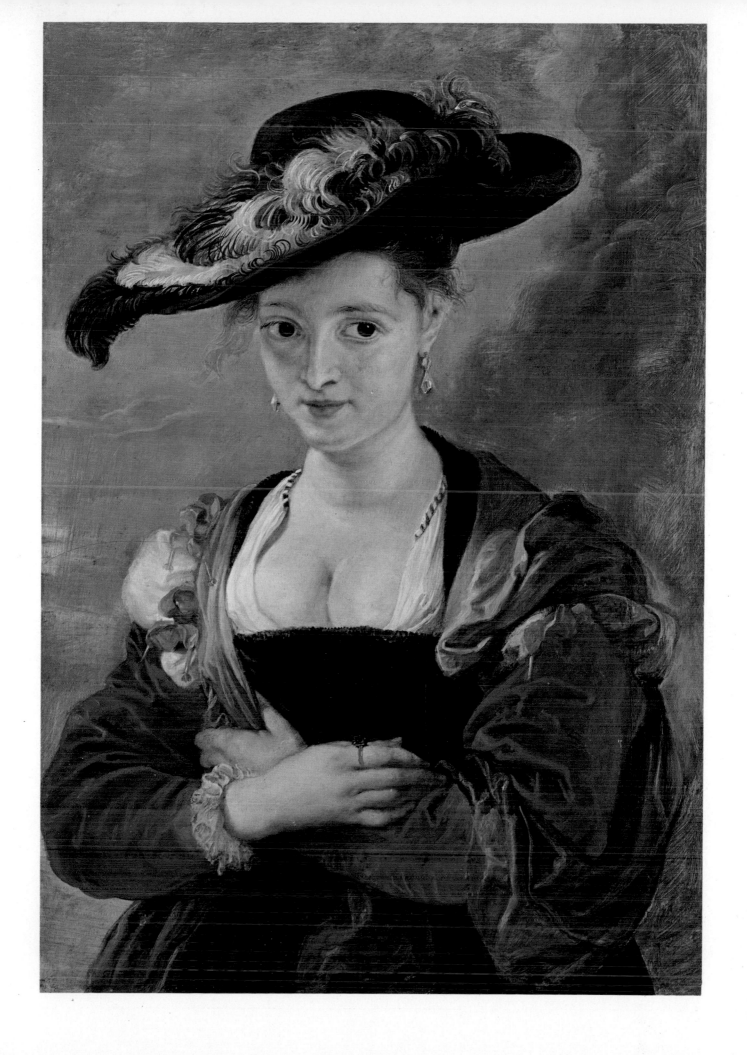

XVIII The Education of Marie de' Medici 1622–5 Canvas 394 × 295 *Paris, Louvre*

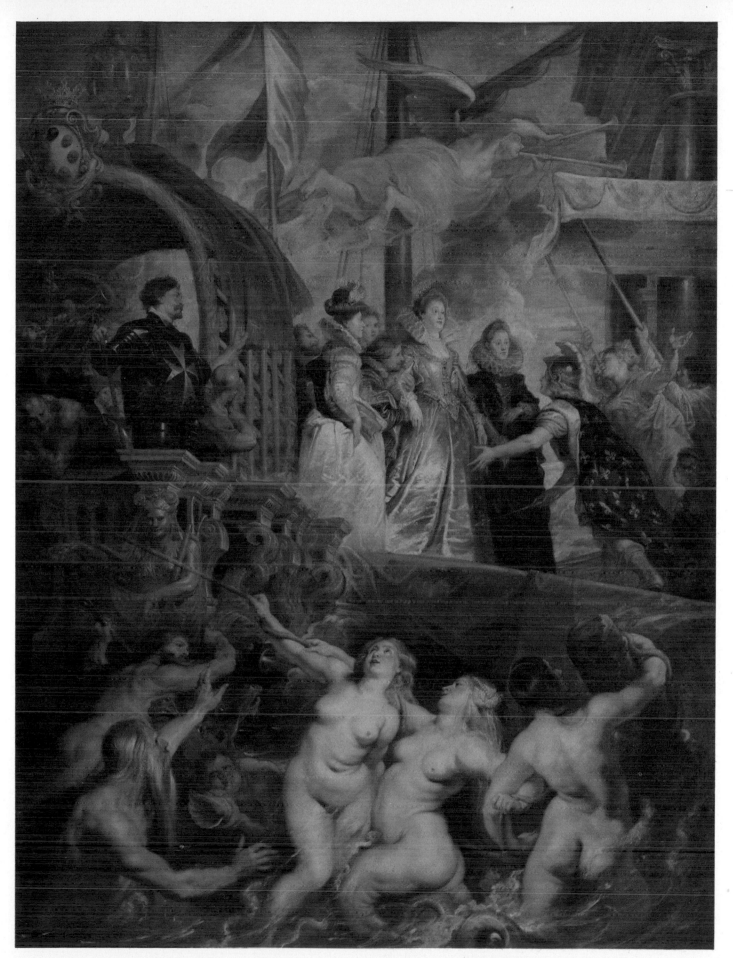

XIX **The Arrival of Marie de' Medici at Marseilles** 1622 5 Canvas 394 × 295 *Paris, Louvre*

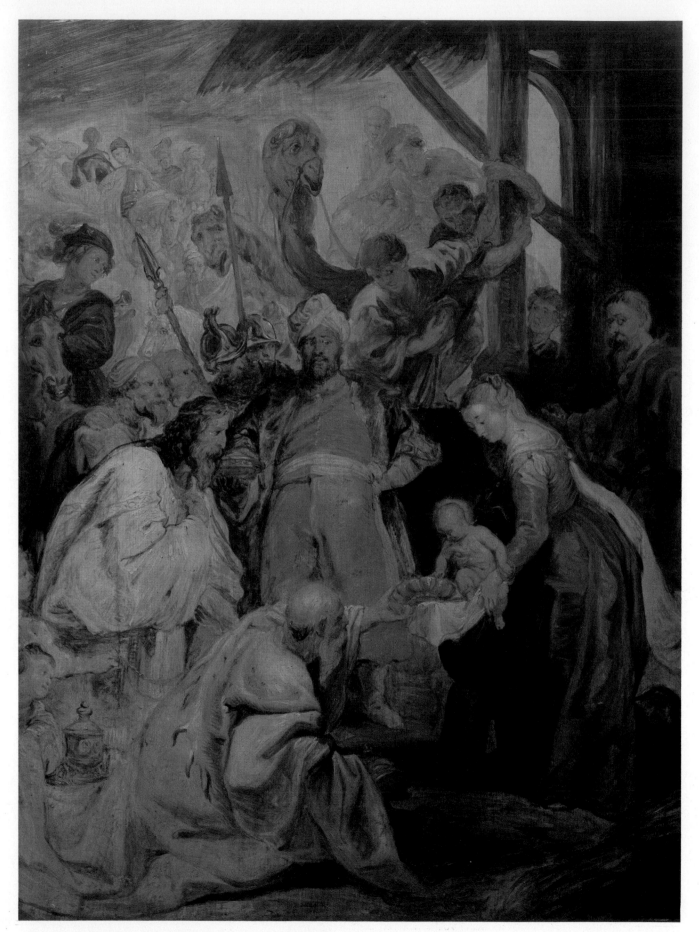

XX The Adoration of the Kings *sketch* 1624 Panel 63 × 47 *London, Wallace Collection*

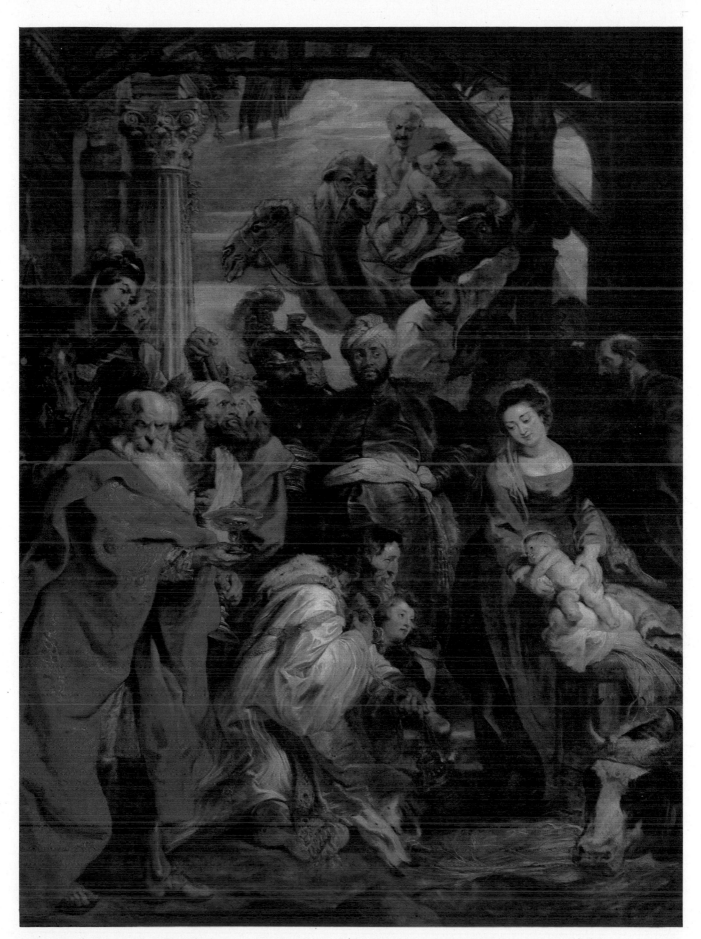

XXI The Adoration of the Kings 1624 Panel 447 × 336 *Antwerp, Koninklijk Museum voor Schone Kunsten*

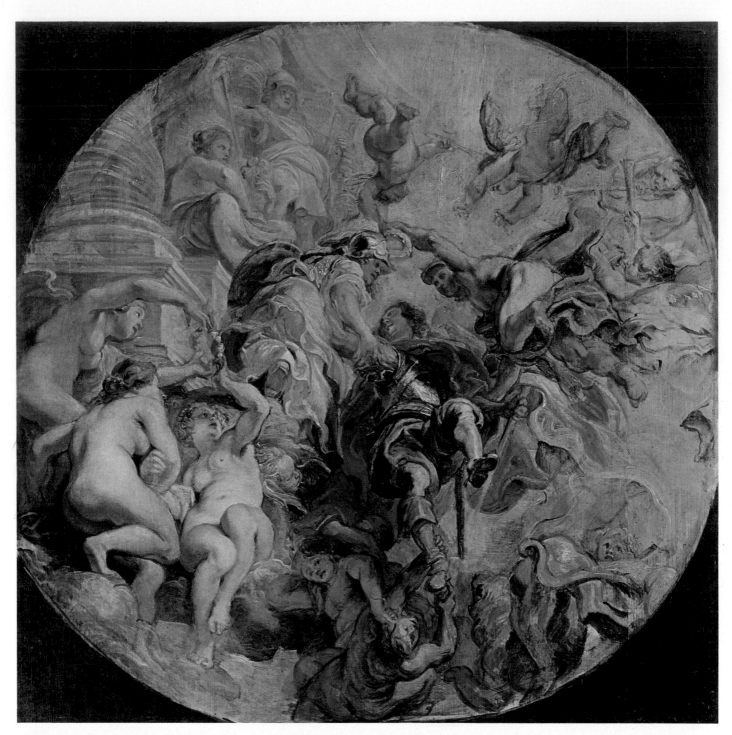

XXII **The Glorification of George Villiers, Duke of Buckingham** *sketch* *c.* 1625–7 Panel 62 × 62.5 *London, National Gallery*

XXIII *opposite* **Madonna Enthroned with Saints: the Mystic Marriage of St Catherine** 1628
Canvas 564 × 401 *Antwerp, St Augustinuskerk*

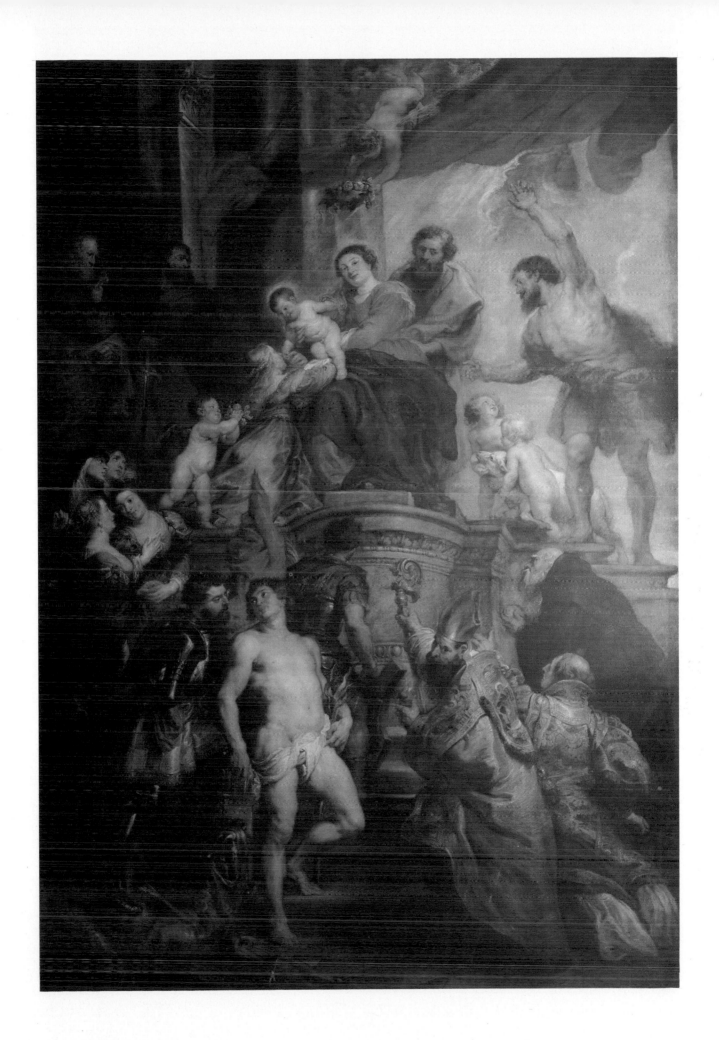

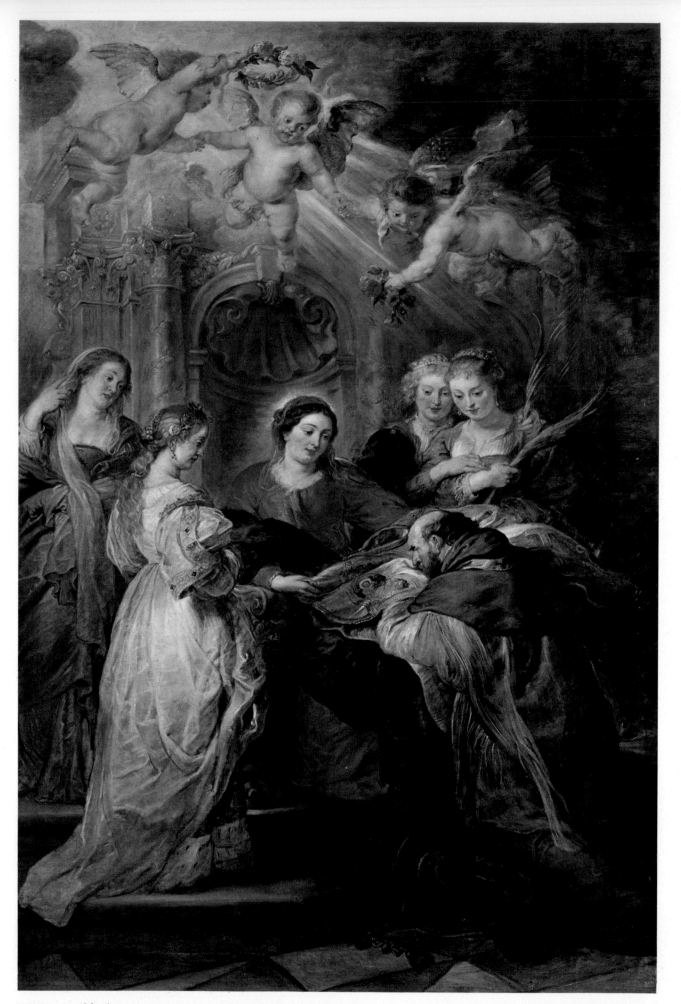

XXIV St Ildephonsus Receiving a Chasuble from Our Lady 1630–32 Panel 352 × 236 *Vienna, Kunsthistorisches Museum*

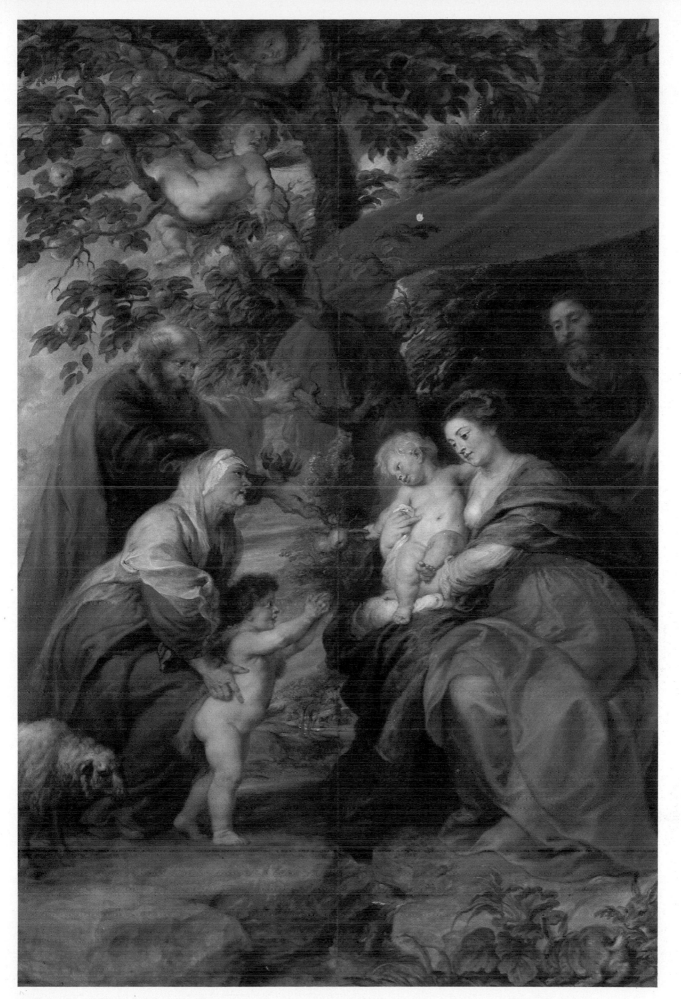

XXV The Holy Family under the Apple Tree 1630–32 Panel 353 × 233 *Vienna, Kunsthistorisches Museum*

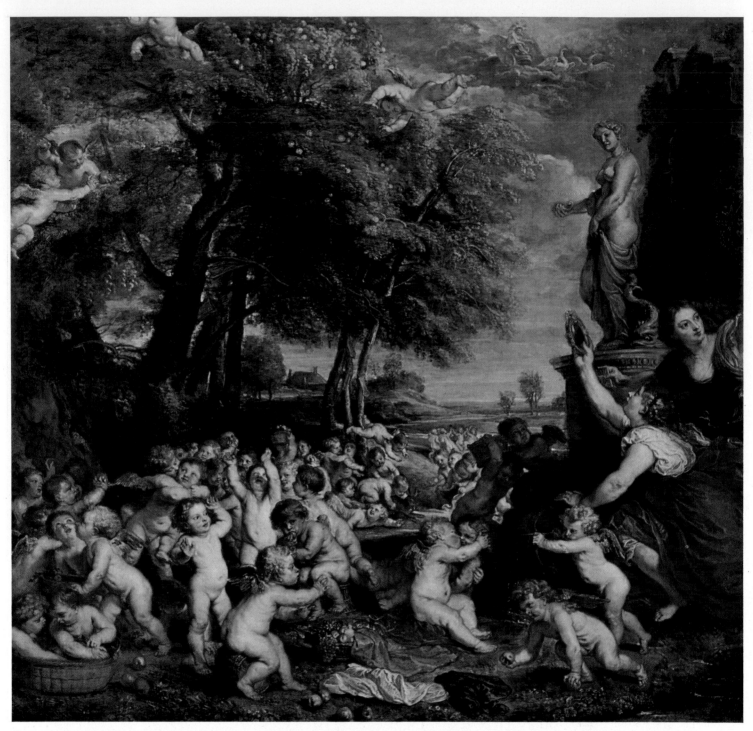

XXVI **The Worship of Venus** *after Titian* *c.* 1630–32 Canvas 195 × 209 *Stockholm, Nationalmuseum*

XXVII *opposite* **'Het Pelsken': Venus as Helena Fourment** *c.* 1636–8 Panel 176 × 83 *Vienna, Kunsthistorisches Museum*

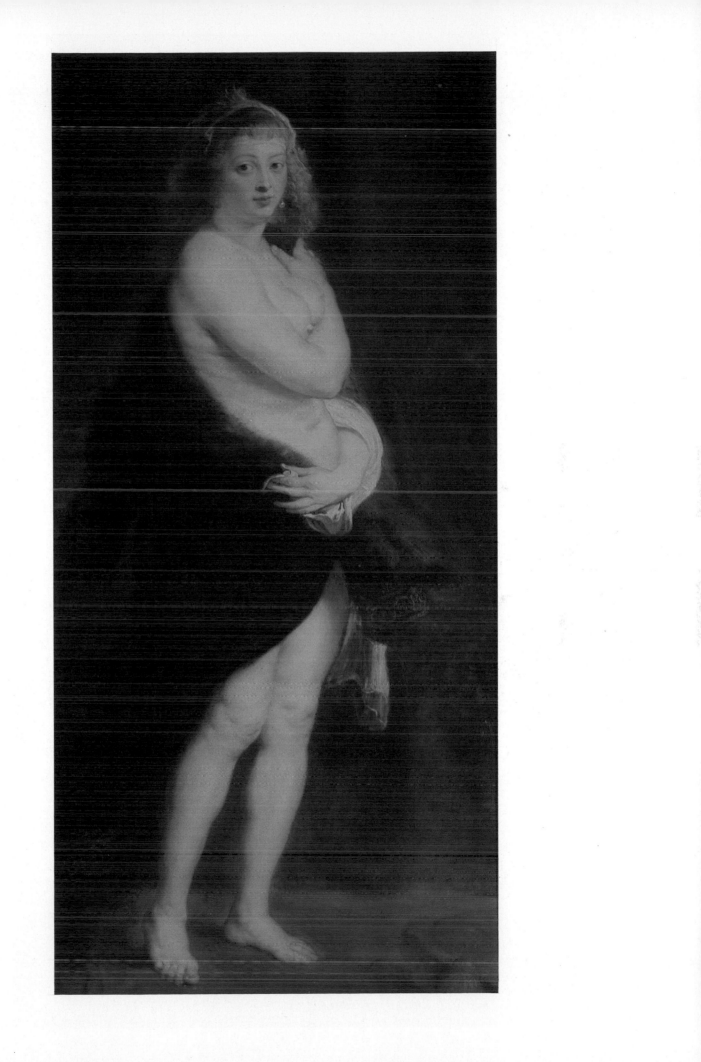

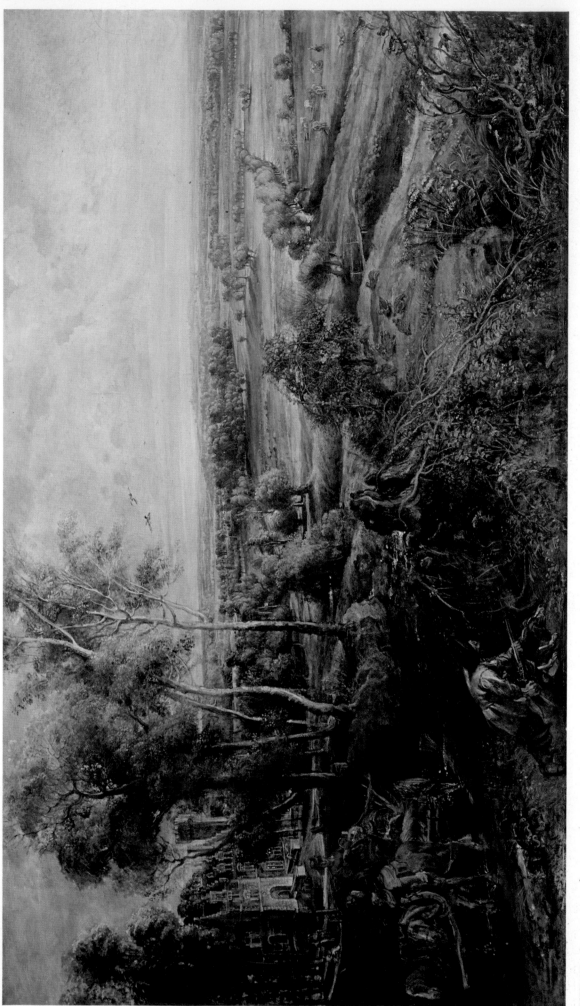

XXVIII Autumn Landscape with a View of Het Steen in the Early Morning *c. 1636 Panel 132 × 230 London, National Gallery*

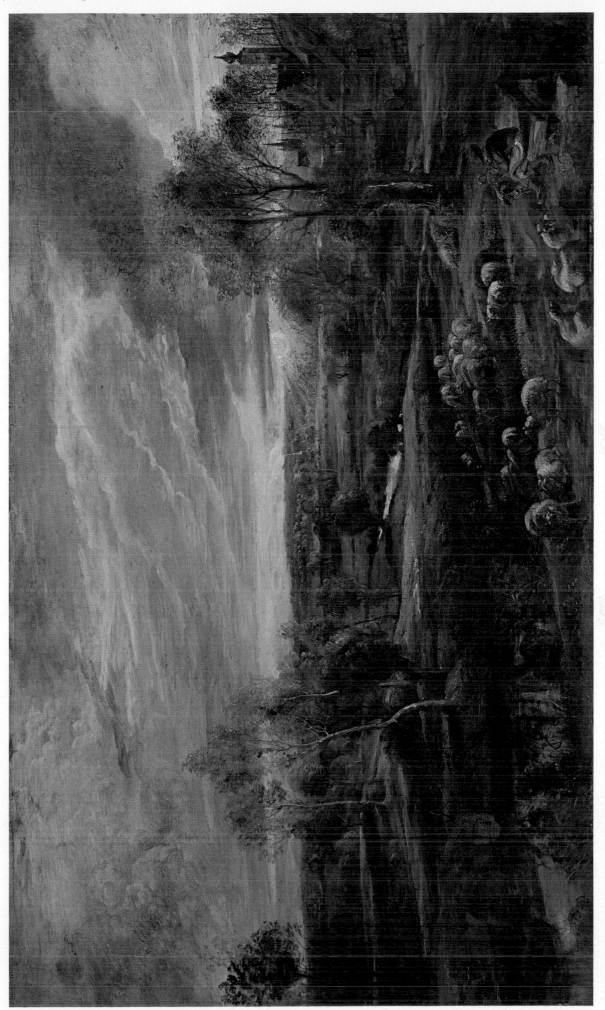

XXIX Landscape with a Shepherd and his Flock *c.* 1638 Panel 49.7 × 83.5 *London, National Gallery*

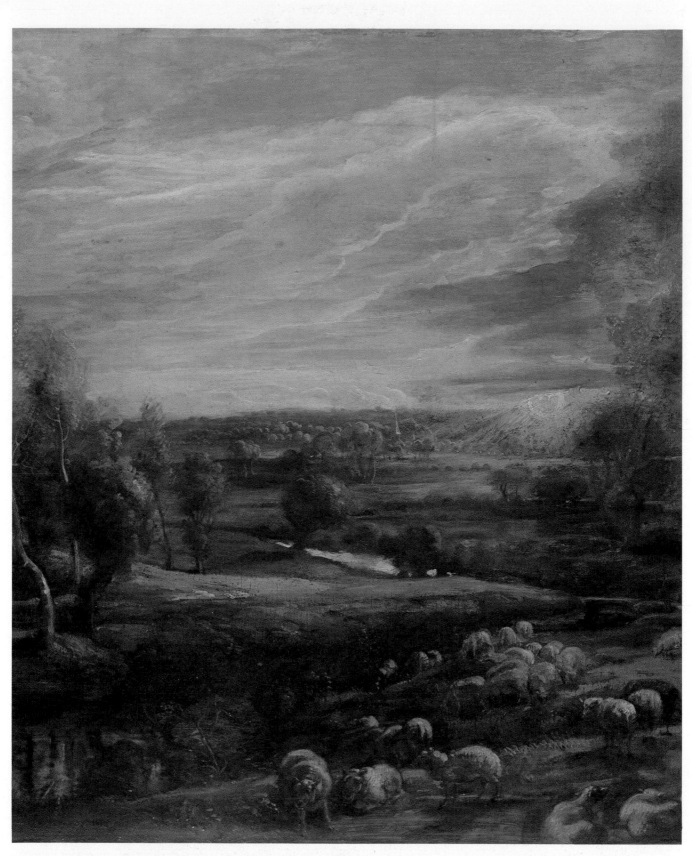

XXX Landscape with a Shepherd and his Flock Detail of Plate XXIX

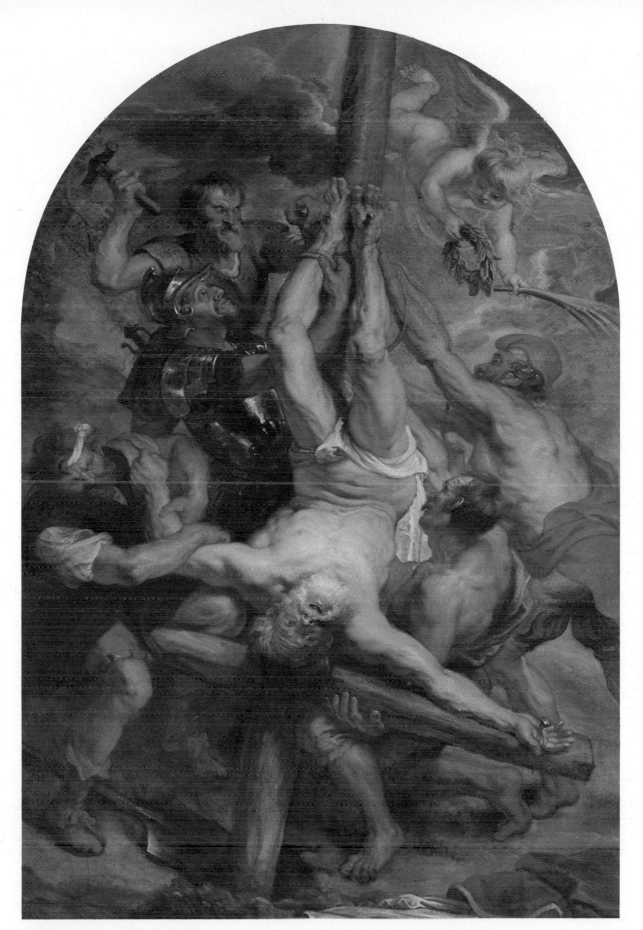

XXXI **The Crucifixion of St Peter** 1637–9 Canvas 310 × 170 *Cologne, Peterskirche*

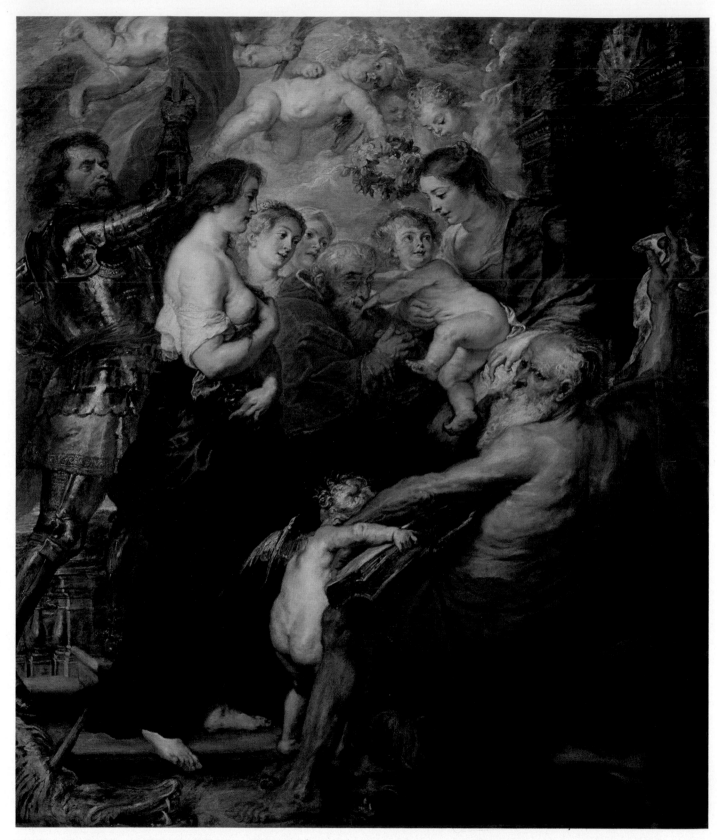

XXXII Madonna and Child with Saints *c.* 1638–40 Panel 211 × 195 *Antwerp, St Jacobskerk*

Peace and War (Plate 10) Venus, though clearly idealized, is sometimes identified as the wife of Balthasar Gerbier. A sketch of a walking couple recently found on the back of a portrait drawing of Isabella (London, British Museum) has been held to represent Rubens and Helena, but this would be psychologically improbable even if likenesses were discernible; they are not. There is also a strange composite picture (Munich, Alte Pinakothek) of Rubens and Helena in the Rubenshuis garden, which although accepted as autograph by many scholars, suggests that there was a market for such identifications soon after the artist's death. The most likely portrait identification in Rubens's work, however, is seldom mentioned: in the Medici cycle Rubens holds the processional cross on the left of the *Proxy Marriage of Marie* – at which he was actually present – and on the right of the formally similar and balancing *Henri Making Marie Regent* Isabella looks out at the beholder. Both figures are after-thoughts and do not appear in the sketches. In the Madrid *Judgement of Paris* the report already quoted claims Helena as the model for Venus, but the face is not specifically hers and from the neck downwards the Cardinal-Infante was in no position to know. It is also unlikely that in *Diana and Callisto* (Madrid, Museo del Prado) Rubens would have painted his wife as the unfortunate nymph.

The 1630s unquestionably saw Rubens produce a magnificent succession of autograph works, whose style owes almost everything to recently renewed study of the colour and brushwork of Titian, both in Madrid and in London. In Madrid Rubens copied several colourful late Titians, and works after his return to Antwerp show the effect of the exercise (Plates XXIV, XXVI, XXIX, XXXII). One of the finest of these copies, the *Fall of Man*, was bought by Philip IV from Rubens's estate and hangs in the Prado near Titian's original. The red parrot added in the left-hand tree shows that Rubens knew Titian's source in Dürer's print of 1504. Other departures from Titian are small but significant. Rubens's Adam and Eve are turned more obliquely to the picture plane, and they are more muscular. They are more sensuous, livelier, more characterful, and less obscured by foliage. The landscape too, although the greens of foliage and the blues and greys of sky and mountains are the same, is more modelled. Yet Rubens retained the lesson of Titian, that flesh painting is best when it is simplest, with few major highlights or shadows.

Among the other pictures bought by Philip IV were free versions of Titian's *Worship of Venus* and *Andrians*, which are now in Stockholm (Plate XXVI). On evidence of style Rubens painted them in the early 1630s, but how he had managed to do so remains an unsolved question. He had probably seen the Titians in Rome, where Cardinal Aldobrandini had appropriated them from Ferrara. He could never have seen them afterwards, for they passed from Rome to Spain in 1637–8; his versions are therefore based either on drawings made in Rome or on painted copies in Antwerp. But the freedom of his versions has more positive causes than indirect transmission. In Madrid he copied late Titians, freely brushed in rich luminous colours; even so, he used a light ground instead of Titian's red-brown and thus achieved a higher key. The Stockholm pictures derive from earlier Titians; in his copies Rubens translated their patches of closely related mellow colours and calm brushwork, by way of his recent experience of the later Titian, into coloured brush drawing of rounded

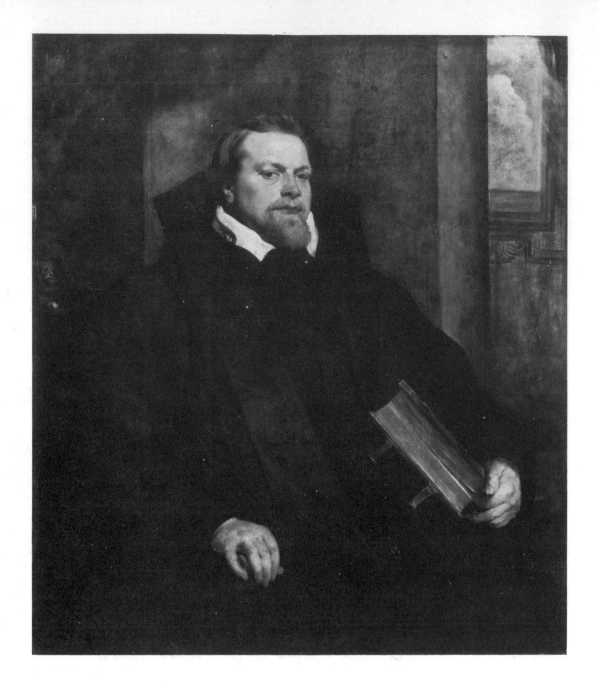

forms. In the *Worship of Venus*, based on Philostratus's description of cupids gathering apples in the goddess's honour, Rubens departed from his original both in form and content. He made more space around and between figures and through foliage. Trees, and Venus's statue, become dynamic and twisting. He added Venus's chariot bridging the sky, made the apple crop more abundant, and, disregarding convention, made some of the cupids female.

Rubens also recognized in Titian a development parallel to his own towards a personal late style, in which form is described by patches of colour which lie on the picture plane, not by masses which occupy space behind it: optical not tactile values. The difference can be seen in detail in two portraits of friends, dating from the mid 1610s and the mid 1630s, which now hang on the same wall in Munich (Plates 97–100). Dr Hendrik van Thulden (1580–1617)

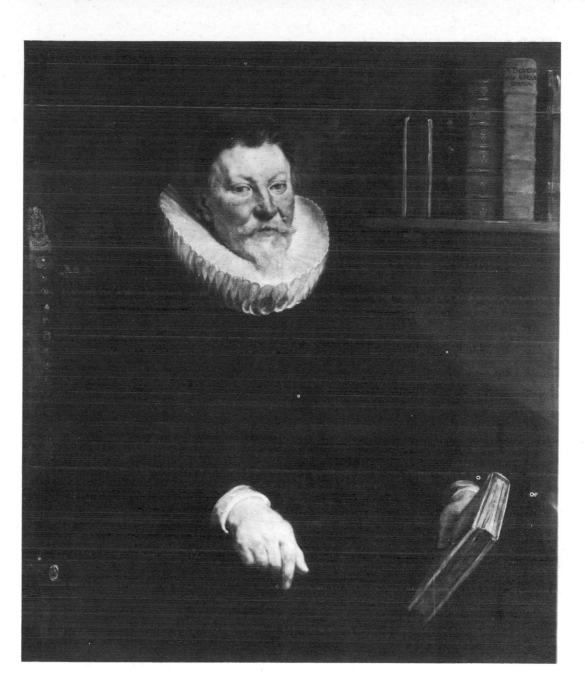

98 Jan Brant
Signed and dated 1635
Panel 110 × 95
Munich, Alte Pinakothek

was parish priest of St George's, Antwerp; a second portrait of him by Rubens, in surplice and stole, formerly adorned his monument there. A chalk sketch for the Munich portrait (London, British Museum) establishes the pose rather than the features, and shows him wearing the biretta as well as the black greatcoat with outspread collar which impresses so forcibly both the physical and the spiritual presence of the sitter. This, one of Rubens's most sculptural portraits, was painted in the middle of his Antwerp decade; the powerful modelling of the head is complemented by the sweeping parallels of the collar, arms and book, by the angular three-dimensional outline and by the diagonally set planes of the wall behind. Even the book is made to project forward by drawing and tone without linear perspective. Contact with the sitter is even more important than his status.

99 Dr Hendrik van Thulden Detail of Plate 97

100　**Jan Brant**　Detail of Plate 98

The portrait of another scholar twenty years later – it is signed and dated 1635 – offers a revealing comparison. Jan Brant (1559–1639) is older – his eyes are watery and his colour is high – but stylistically the picture is more significant for what it reveals of Rubens's continual and renewed study of Titian, especially late Titian. Brant's is a painted, not a sculpted, image; the coat is buttoned, the silhouette is closed but soft. The features, the fore-shortened book and the red leather and shiny studs of the chair are dabs of colour on the picture surface. Rubens, moreover, even chose to emulate his Venetian model not on fine canvas but, like the earlier portrait, on panel.

The treatment of costumes in two 'wedding' portraits shows the same difference in the rendering of textures and decorative detail (Plates IX, 24). Apart from her portraits, Helena's place in Rubens's inspiration in his last decade was not on the studio dais but in helping him to enjoy in every way the greater freedom of gradual retirement and in alleviating the increasing trials of gout. But there are two exceptions, a painting and a drawing.

If literature is marked by the identity between the subject and the method of study (p. 21) the history of art is notable for the extent to which evidence about great works is derived from within them rather than from external sources. But to derive such evidence requires observation, reflection and intuition as well as background and comparative knowledge, and where external evidence fails the urge to invent picturesque stories may be not only easier but irresistible. Smith's *Catalogue Raisonné* (1830) lists as 'a full-length Portrait of Helena Forman . . . prepared to enter the bath' the painting which Rubens left to his widow with a specific mention in his will under the title of *Het Pelsken* (the little fur coat) (Plate XXVII). Clearly it had some special significance which was not stated. A scarlet cushion and carpet lie in the foreground, and there are traces of sky on the left. Subsequent writers have disagreed whether she is going to or coming from the bath, or even keeping warm in a rest pause during modelling. Opinions differ according to individual preference, whether the dimpled and detailed flesh modelling represents the ravages of corsets, garters and small shoes, Belgian puppy fat in 1631, premature middle age in 1639 or unpardonable objectivity on Rubens's part.

The expression of knowing undress, with the mouth almost blowing a kiss, has become a cliché of refined pin-ups. Evers was the first to point out that the picture must have matured slowly; so do most 'instantaneous' images (Plates IV, IX, XVI, XXXI, 70), while even 'news' photographs are often staged. More recently in a rarely studied paper, Julius Held has shown that this is an *outdoor* picture of a woman standing by a fountain (which dimly appears on the right), combining the Classical modest-but-revealing pose of the *Medici Venus* with a tradition of Venus-by-a-fountain pictures. Nor were these the only aesthetic images preceding Rubens's picture: he copied Titian's *Girl in a Fur Coat* now also in Vienna, which belonged to Charles I (Plate 103). The facial likeness of Helena Fourment is unmistakable, but it is not a portrait since the eyes are brown while Helena's were grey-blue. Thus an idealized Lady Rubens appears as Venus and, with Northern realism, Venus appears as Lady Rubens: the aim is ambiguity rather than identity. But it is possible to go further. We may date the picture, on grounds of style, in the later 1630s between the *Judgement of Paris* and

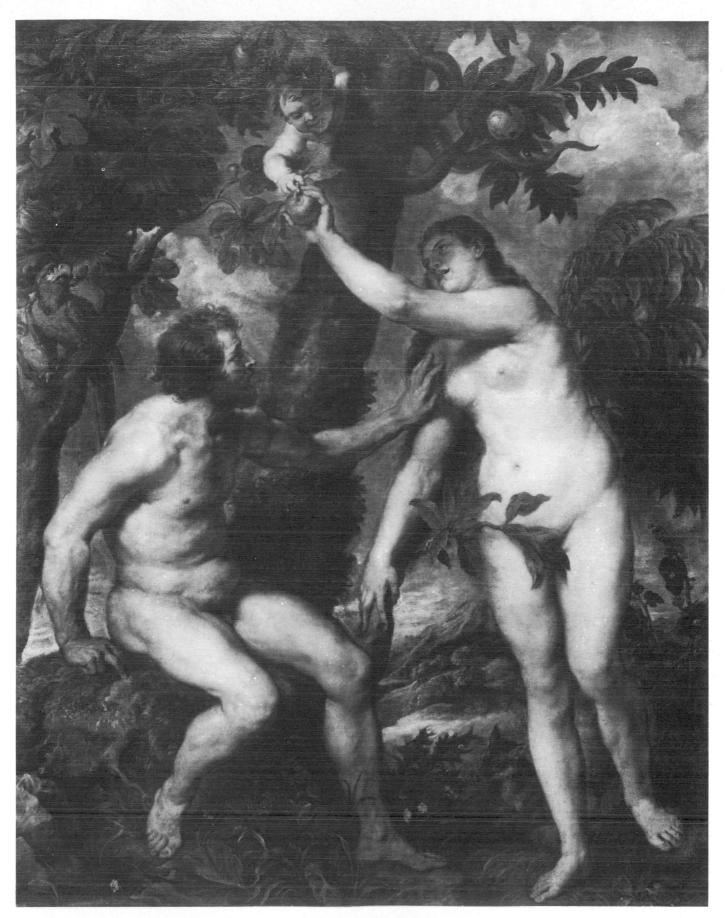

101　**The Fall of Man**　*after Titian*　1628–9　Canvas 237 × 184　*Madrid, Prado*

the *Three Graces* (Plates 93, 17), but we cannot determine the age of a goddess by her dimples as we do a horse by its teeth: Venus is eternally whatever age she wishes to be.

The goddess of love and beauty causes further embarrassment in our own age, in which fashion values the exiguous as an ideal and reserves the 'Rubensian' for the surreptitious glances of coarse males. Those who believe that for Rubens women were sex-objects will not change their minds, whatever the evidence, but the short memory of fashion can be seen from Hollywood musicals of the 1930s, in which real chorus legs in the pre-nylon era are as stocky and as dimpled as those of a seventeenth-century goddess. The wrinkle under Venus's arm is not unusual, and in a portrait in Munich (Alte Pinakothek) the young Frans Rubens sitting on his mother's knee has the same fold of skin. Rubens did not, obviously, believe the female breast to be inevitably conical or hemispherical, as men are supposed to believe, mainly on the evidence of Antique and Neo-classical art. But then he did not imagine that women were statues. In his notes on the use of sculpture he explains that skin and flesh are more translucent and softer than stone, making both shadows and contours softer (an observation which had already appeared in Castiglione's *Libro del Cortegiano*). Moreover, he writes, 'some parts of the body are changed by every movement, and because of the flexibility of the skin are now stretched and smooth, now contracted into folds. Sculptors generally avoid this, though the best sometimes take account of it, whereas in painting – if done justly – it is absolutely necessary' (Plates xv, 18, 96).

In his straight portraits Rubens was as much concerned with status as with likeness, and his genius allowed him to establish both; in *Het Pelsken* idealism and realism are inextricably interwoven, and while many strands can be seen at the edges of the weave they cannot be separated from the texture. There are others: there may be a memory, in the way she seems to float rather than walk, of Venus borne on the waves or of Leonardo's drawing of a *Floating Lady* which Rubens could have seen in Milan in Leoni's studio many years earlier, or in 1629 when it was in the Arundel collection in London. But certainly *Het Pelsken* was preceded by a unique large chalk drawing which exhibits the small changes in contour, due to movement of the model or re-posing after rests, which are characteristic of a study drawn from life (Plate 102). It is drawn in red chalk except for a little black in the arm, hair and eyes, and white body-colour in the highlights. The head and trunk are the same as in the painting – even to the fillet across the forehead – and the face differs only because in the painting the eyes are widened (p. 50) and the mouth is puckered. The control and precision of the drawing have been seen as a pupil's work, but on the contrary they reveal the hand of the master: one has only to look at his meticulous portrait drawings. Life drawing is very difficult and requires the concentration and the detachment of the surgeon; the boudoir is a different world.

Even this drawing shows no casually adopted pose. It recalls ultimately the *Crouching Venus* of the Ancient sculptor Doidalses, which Rubens had used for Ceres in an early painting (Plate xi). Similar figures appear on the left of the Neuburg *Last Judgement* (Plate 82) and in Titian's *Diana and Actaeon* which Rubens studied in Madrid in 1628–9 (Edinburgh, National Gallery of Scotland, Sutherland Loan). Closest in pose and date are the figures of

102 *opposite*
Seated Female Nude *c.* 1631–8
Red and black chalk with white heightening 46.3 × 28.2
Paris, Louvre

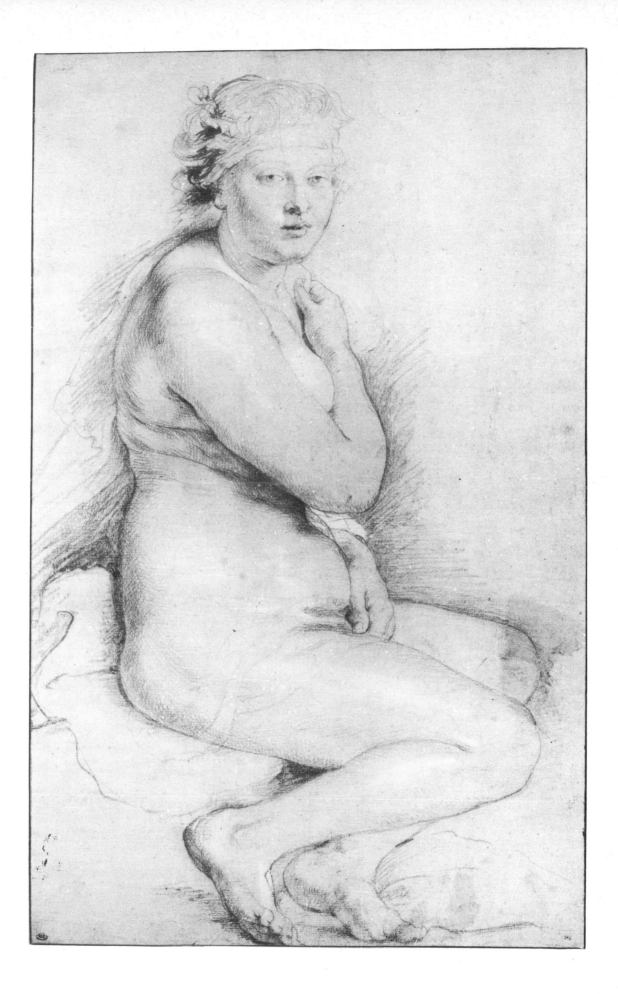

Diana Surprised (formerly in Berlin, destroyed 1945) and the foreground nymph in *Diana and Callisto* (Madrid, Prado).

Thus by way of blessed souls and chaste nymphs another Ancient Venus shares in the genesis both of the fur-wrapped goddess and of the beloved of David in another late picture (Plate 104). David spied on Bathsheba at her *toilette*, seduced her, did away with her husband, repented, married her and made her the mother of Solomon. Rubens's image is symbolic, not narrative: Bathsheba reacts to a message not yet received, and her uneasy posture in a restless composition, her little barking dog and her bemused expression presage all those events which, as King David gazes from the balcony, are still to come. In art the subject is a sensuous one, and the servant combing Bathsheba's long hair is less obvious but no less beautiful than her mistress. The rich reds of the draperies above and to the left are reflected

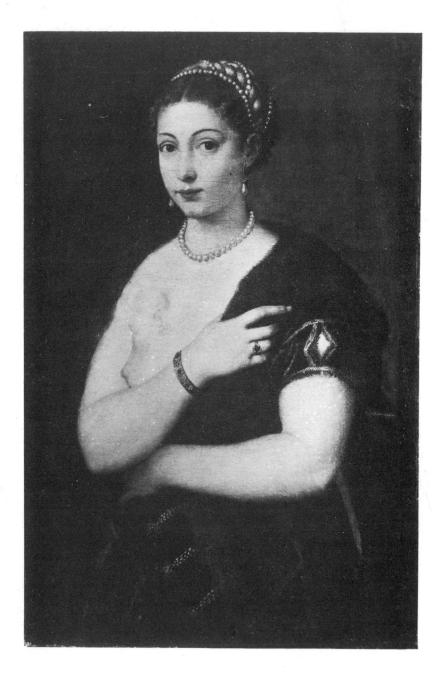

103 TITIAN (died 1576) **Girl in a Fur Coat**
Canvas 95 × 63
Vienna, Kunsthistorisches Museum

104 *opposite* **Bathsheba** *c.* 1635 Panel 175 × 126
Dresden, Staatliche Gemäldegalerie

in flesh tones and echoed in hair ornament, and Bathsheba, like Venus, wears a white shift and a fur cloak.

Held suggested that Rubens may also have entertained a literary prototype in the Cnidian Venus of Praxiteles which according to Pliny was 'superior to anything in the whole world'; Rubens knew the copy in the Vatican which represents her about to bathe. Certainly he was familiar with the literature of Ancient art, and for the outside of his house he designed representations of famous incidents in the careers of Apelles and other Ancient painters. Stories like that of Zeuxis and the five maidens (p. 154) were popular themes, and helped to form the Renaissance artist's idea of himself and the creative process. The process is something that happens between the mind and materials: in some very humble way we have all experienced it some time in our lives, but ultimately neither great creators nor psychologists can explain it, and the historian or critic can at best describe it in terms of its products.

Some scholars have divided Rubens's career into many stylistic phases from Late Mannerist to High Baroque; while such an exercise can be useful for the student, stylistic terms are only valuable as far as they are commonly understood. Rubens was one of a generation of artists who, growing up at the end of the Mannerist age, took elements from that brilliant and artificial era together with others from the High Renaissance to make a new style, based on the art of Raphael, Michelangelo, Titian and Correggio, on the Antique, and (as always) on 'Nature'. In this respect there was little difference in aim between Rubens, Inigo Jones as architect of the Whitehall Banqueting House, and Charles I whose taste was that of a Renaissance prince. But the new generation brought to their art a variety of motive, a range of expression, a desire and ability to make the apparent real and the real apparent, a sense of theatre and of the infinite, a richness but clarity of imagery and a sense of new worlds to be discovered as well as old ones to become better known: altogether a mixture unknown in the Renaissance. We call this style Baroque; they knew it only as of their own time, and Rubens was one of its founders.

BIBLIOGRAPHY

PRINCIPLES. There have been many biographies, picture books and even novels about Rubens; most of them are now of interest only to scholars or bibliographers. A brief guide to the literature should have three functions: it should mention those books which are the foundation of the study of the subject, it should help the reader to find additional information and insight, and it should give some idea (especially in a book without notes) of the author's sources. In this third respect the penultimate section here comprises references of particular relevance to works illustrated in this book; some of the suggestions and conclusions in the text will not be found in the literature because they are my own. It would also be undesirable to limit references to those studies with whose conclusions I agree. I have listed recent rather than older periodical literature, because the latter is better covered by older bibliographies and references from other works, and is in many cases superseded by newer publications. I have included neither everything I have read nor, with the exception of Held's forthcoming standard work on the oil sketches, works I have not used.

Most of the literature up to 1939 is covered by P. Arents, *Geschriften van en over Rubens* (Antwerp 1940) which may be supplemented by the lists in *Encyclopedia of World Art* 12 (New York 1966, article by M. Jaffé) and in the standard general textbook on the period, H. Gerson and E. H. ter Kuile, *Art and Architecture in Belgium 1600–1800* (Harmondsworth 1960).

GENERAL STUDIES. J. Burckhardt, *Recollections of Rubens* (London 1950, translation of critical essay first published in German in 1898). M. Rooses, *Rubens* (London 1904, translation of two-volume biography, unsurpassed although often misleading about pictures and their dates and authors. Based on Rooses's own catalogue raisonné and edition of the correspondence as well as on the eighteenth-century work of J. M. F. Michel and F. Mols and the documentary studies of P. Génard.) R. Oldenbourg, *Rubens, des Meisters Gemälde* (4th ed., Stuttgart/Berlin 1921. *Klassiker der Kunst* volume, largest and standard though inferior collection of plates; earlier editions contain many more doubtful attributions.) C. White,

Rubens and his World (London 1968). A. Braham, *Rubens (Themes and Painters in the National Gallery)* (London 1972). H. G. Evers, *Peter Paul Rubens* (Munich 1942. Critical artistic biography based on all published sources with detailed discussion and illustration of about 100 works, many not previously published.) H. G. Evers, *Rubens, Neue Forschungen* (Brussels 1943. Amplifying essays.) M. Jaffé, *Rubens and Italy* (Oxford 1977). F. Baudouin, *Rubens et son Siècle* (Antwerp 1972, revised ed. 1977). R. Oldenbourg, *Peter Paul Rubens* (Munich/Berlin 1922. Posthumous collection of essays). G. Glück, *Rubens, Van Dyck und ihr Kreis* (Vienna 1933. Collected essays). The papers from the 1977 Antwerp colloquium are published in CR 74 (1976–8)

CATALOGUES OF PICTURES. J. Smith, *A Catalogue Raisonné*, II, IX (London 1830, 1842). M. Rooses, *L'Oeuvre de P. P. Rubens* (Antwerp 1886–92. Standard catalogue, reprint Soest 1977. Supplemented by *Rubens Bulletijn*, Antwerp 1882–1910). *Corpus Rubenianum Ludwig Burchard* (Brussels/ London 1968–): less than a third of the planned volumes have yet appeared: J. R. Martin (Jesuit Church), N. de Poorter (Eucharist), H. Vlieghe (Saints), S. Alpers (Torre de la Parada), E. Haverkamp Begemann (Achilles), J. R. Martin (Pompa Introitus Ferdinandi), F. Huemer (Portraits I), J. R. Judson and C. van de Velde (Book Illustrations). The most notable collection catalogues of seventeenth-century Flemish pictures are: London, National Gallery (1970); Madrid, Prado (1975); Leningrad, Hermitage (1975); A. Seilern, 56 Princes Gate (1955; supplements 1969 and 1971. Count Seilern died in 1978 leaving his collection to the Courtauld Institute of Art.)

RUBENS'S CORRESPONDENCE. R. S. Magurn, *The Letters of Peter Paul Rubens* (Cambridge, Mass. 1955. Complete English edition). C. Ruelens and M. Rooses, *Correspondance de Rubens* (Antwerp 1887–1909, reprint Soest 1973. Texts with French translations, of all letters from, to and about Rubens). W. N. Sainsbury, *Original Unpublished Papers* (London 1859. Documents in the Public Record Office, London). G. Crivelli, *Giovanni Brueghel* (Milan 1868. Letters of Jan Brueghel including those written for

him by Rubens). On 27 July 1619 Rubens wrote in the autograph books of Martin Ruarus (fascimile in Rooses, *Oeuvre*, I, f.p. 1) and Paul Grohé (British Museum MS. Eg. 1238, f. 8). An unknown letter was published by R. W. Scheller, BM 119 (1977) 647.

EARLY WORKS AND SOURCES. The most important seventeenth-century printed biographies, on which others depend, are in the compilations of G. Baglione (Rome 1642), G. P. Bellori (Rome 1672), R. de Piles (in *Conversations*, Paris 1677 and *Dissertation*, Paris 1681) and J. Sandrart (1675). De Piles used a short manuscript life in Latin, generally accepted as by the artist's nephew Philip Rubens; printed in English translation by L. R. Lind, AQ 9 (1946), 37–44. Otto Sperling's account was printed in Repertorium für Kunstwissenschaft 10 (1887) 111; other early references are in J. W. Neumayr von Ramssla's travels (Leipzig 1620), W. Sanderson, *Graphice* (London 1658), H. Peacham, *The Compleat Gentleman* (2nd ed, London 1634), E. Norgate, *Miniatura* (Oxford 1919). Rubens's note on statues was printed in R. de Piles, *Cours de Peinture* (Paris 1708). A. Jombert, *Théorie de la Figure Humaine* (Paris 1773) is an expanded translation of other notes from Rubens's lost notebook; in the absence of their publication, some information about extant copies of the notebook is to be found in M. Jaffé, *Van Dyck's Antwerp Sketchbook* (London 1966); the copy described there as MS. Johnson is now in the Seilern Collection, Courtauld Institute of Art. Rubens's *Palazzi di Genova* (Antwerp 1622) and Gevaerts's *Pompa Introitus Ferdinandi* (Antwerp 1642) have been reprinted in facsimile (Unterschneidheim 1969 and 1971). The drawings Rubens collected for *Palazzi di Genova* are in the Royal Institute of British Architects, London.

EXHIBITIONS. Past exhibitions with important catalogues include Amsterdam, Goudstikker (1933); London, Wildenstein (1950); Rotterdam, Museum Boymans (1953, oil sketches); Elewijt, Château de Steen (1962, *Rubens Diplomate*). The 1977 quatercentenary exhibitions included major scholarly catalogues of drawings in the Albertina (Vienna), paintings in *Rubens Diplomate*). The 1977 quatercentenary exhibitions included major Viennese collections (Vienna, Kunsthistorisches Museum) and Berlin-Dahlem, drawings in the British Museum, London, and the loan exhibition of works relating to the Italian period shown by the Wallraf-Richartz Museum at the Kunsthalle, Cologne. Other important exhibitions were in Antwerp, Museum voor Schone Kunsten (exiguous catalogue), Paris, Grand Palais (*Le Siècle de Rubens*) and Florence, Palazzo Pitti. Among other catalogues published were those for exhibitions in Genoa, Palazzo Ducale; Leningrad; Madrid, Palacio de Velazquez; Paris (drawings); Stockholm. Not all the works described in some of the catalogues were actually shown.

DRAWINGS. There is no complete catalogue yet; criteria for one are discussed by A. M. Logan and E. Haverkamp Begemann in Revue de l'Art 42 (1978) 89–99. Partial collections by G. Glück and F. M. Haberditzl, *Die Handzeichnungen von Peter Paul Rubens* (Berlin 1928); F. Lugt, *Inventaire Général . . . Ecoles du Nord . . . Ecole Flamande II, Musée du Louvre* (Paris 1949); J. Held, *Rubens, Selected Drawings* (London 1959, the principal survey of Rubens as a draughtsman); L. Burchard and R. A. d'Hulst, *Rubens Drawings* (Brussels 1963; reviews in MD 4 (1966) 435–54; BM 107 (1965) 372–81). M. Bernhard *Rubens Zeichnungen* (Munich 1977) includes uncritically 200 drawings from Glück and Haberditzl, about 160 from Burchard and d'Hulst (some are in both) and a few others; the text adds nothing. For drawings see also M. Jaffé, *Rubens and Italy* (under GENERAL above); M. Jaffé in MD 2 (1964) 383–97; 3 (1965) 21–35; 4 (1966) 127–48 (collecting and reworking of drawings); in MD 8 (1970) 42–51, 269–72 (Italian period); G. Fubini and J. Held in MD 2 (1964) 123–41; J. Müller Hofstede in WRJ 27 (1965) 259–356; J. Held in MD 12 (1974) 249–60; J. Müller Hofstede in MD 2 (1964) 3–17.

OIL SKETCHES. L. van Puyvelde, *The Sketches of Rubens* (London 1947) will be superseded by Julius Held's corpus (Princeton 1979). See also G. Aust in WRJ 20 (1958) 163–212.

SPECIAL THEMES, TOPICS AND PERIODS

A. Blunt, *Rubens and Architecture*, BM 119 (1977) 609–21.

J. Denucé, *De Antwerpsche 'Konstkamers'* (Antwerp 1932). Inventories.

E. Dhanens, *Jean Boulogne en P. P. Rubens*, GB 16 (1955–6) 241–54.

M. Diaz Padron, *Dibujos de Rubens en el Museo del Prado* (Madrid 1977). Primaticcesque drawings.

H. von Einem, *Rubens's 'Abschied des Adonis'*, WRJ 29 (1967) 141–56.

D. Freedberg, *Johannes Molanus on Provocative Paintings*, JWCI 34 (1971) 229–45.

D. Freedberg, *The Representations of Martyrdoms during the Early Counter-Reformation in Antwerp*, BM 118 (1976) 128–38. Up to Vaenius.

K. Fremantle, *Themes from Ripa and Rubens in the Royal Palace of Amsterdam*, BM 103 (1961) 258–64. The same writer's *The Baroque Town Hall of Amsterdam* (Utrecht 1959) offers important observations on Rubens's art and his influence.

J. G. van Gelder, *Rubens in Holland in de Zeventiende Eeuw*, NKJ 3 (1950–51) 103–50.

J. G. van Gelder, *De Waardering van Rubens, een Terugblik*, Antwerpen 30/4 (1977) 1–20.

G. Glück, *Die Landschaften von P. P. Rubens* (Vienna 1940).

J. A. Goris and J. Held, *Rubens in America* (New York 1947).

J. Held, *Rubens and Vorsterman*, AQ 32 (1969) 111–29.

J. Held, *Rubens and Aguilonius: New Points of Contact*, AB 61 (1979) 257–64.

R. Ingrams, *Rubens and Persia*, BM 116 (1974) 190–7.

M. Jaffé, *Rubens and Giulio Romano at Mantua*, AB 40 (1958) 325–9.

M. Jaffé, *Rubens in Italy*, BM 100 (1958) 411–22; 110 (1968) 174–87.

M. Jaffé, *Rubens and Raphael*, in *Studies Presented to Anthony Blunt* (London 1967) 98–107.

M. Jaffé, *Rubens as a Collector*, Jnl. Royal Society of Arts 117 (1969) 641–60.

E. Kieser, *Antikes im Werke des Rubens*, MJ 10 (1933) 110–37.

M. de Maeyer, *Rubens's Terugkeer uit Italie*, GB 11 (1945–8) 147–65.

J. R. Martin, ed., *Rubens before 1620* (Princeton 1972).

E. McGrath, *The Painted Decoration of Rubens's House*, JWCI 41 (1978) 245–77.

M. van der Meulen, *Petrus Paulus Rubens Antiquarius* (Alphen 1975).

V. H. Miesel, *Rubens's Study Drawings after Antique Sculpture*, GBA 61 (1963) 179–215.

O. Millar, *Rubens's Landscapes in the Royal Collection: the Evidence of X-Rays* BM 119 (1977) 631–5.

J. Müller Hofstede, *Zur Antwerpener Frühzeit von P. P. Rubens*, MJ 13 (1962) 179–215.

J. Müller Hofstede, *Bildnisse aus Rubens' Italienjahren*, Jb. Staatl. Kunstsamml. Baden-Württemberg 2 (1965) 89–154.

J. Müller Hofstede, *Rubens und Jan Brueghel, Diana und ihre Nymphen*, JBM 10 (1968) 200–32.

J. M. Muller, *Rubens's Museum of Antique Sculpture*, AB 59 (1977) 571–82.

O. Neverov, *Gems in the Collection of Rubens*, BM 121 (1979) 424–32.

C. Parkhurst, *Aguilonius's Optics and Rubens's Colour*, NKJ 12 (1961) 35–49.

H. Rodee, *Rubens's Treatment of Antique Armor*, AB 49 (1967) 223–30.

J. L. Saunders, *Justus Lipsius* (New York 1955).

N. Scheuer-Raps, *Deodat del Monte* (Aalter 1956).

R. de Smet, *Een Nauwkeuriger Datering van Rubens' Eerste Reis naa, Holland in 1612*, JKMSK (1977) 199–218.

W. Stechow, *Rubens and the Classical Tradition* (Cambridge, Mass. 1968).

C. V. Wedgwood, *The Political Career of Peter Paul Rubens* (London 1975).

F. van den Wijngaert, *Inventaris der Rubeniaansche Prentkunst* (Antwerp 1940).

WORKS ILLUSTRATED (Plate numbers)

II M. Jaffé in BM 110 (1968) 174–80.

III Cologne, Wallraf-Richartz Museum, *P. P. Rubens, Katalog 1* (1977) 76–83.

V See 39.

VI M. Jaffé in BM 110 (1968) 180–83.

VII M. Jaffé in BM 100 (1958) 418–21.

VIII L. Burchard in Jb. Preuss. Kunstsamml. 50 (1929) 319–49.

IX H. Kauffmann, *Peter Paul Rubens* (Berlin 1977) 33–49.

X C. Parkhurst in NKJ 12 (1961) 35–49.

XII See 74.

XIII S. Alpers in JWCI 30 (1967) 272–95.

XV M. Jaffé in Washington, National Gallery, Report and Studies (1969) 7–22.

XVI M. F. S. Hervey, *Thomas Howard Earl of Arundel* (Cambridge 1921) 171–81.

XVIII, XIX J. Coolidge in AB 48 (1966) 67–9; J. Foucart and J. Thuillier, *Rubens's Life of Marie de' Medici* (Milan/New York 1967).

XXII G. Martin in BM 108 (1966) 613–18.

XXIII F. Grossmann in BM 97 (1955) 337.

XXV J. Held in BM 118 (1976) 775–7.

XXVI J. Walker, *Bellini and Titian at Ferrara* (London 1956); F. Grossmann in BM 93 (1951) 25.

XXVII J. Held in *Essays in the History of Art Presented to Rudolf Wittkower* (London 1967) 188–92; C. Pedretti in BM 111 (1969) 345–6.

8, 10 R. Baumstark in Aachener Kunstblätter 45 (1974) 125–234; J. Müller Hofstede in Boymans Museum Bulletin 13 (1962) 86–118.

11 M. Stuffmann in Staedel Jb. 1 (1968) 196–8; J. G. van Gelder in NKJ 3 (1950–51) 115.

12 Genoa, Palazzo Ducale, *Rubens e Genova* (1977) 221–9.

13 U. Krempel in GB 24 (1976–8) 83–93.

14, 15 D. Rosand in AB 51 (1969) 29–40.

21 W. Prinz in AB 55 (1973) 410–28; M. Vickers in BM 119 (1977) 643–4.

26 H. Vlieghe in Bull. Musées Royaux de Belgique 15 (1966) 177–88.

34–5 G. Martin in BM 108 (1966) 180–84.

39–41 F. Huemer in Studies in Iconography (Northern Kentucky University) 3 (1977) 105–44; C. Norris in BM 117 (1975) 73–9; U. Bazzotti, *Rubens a Mantova* (Mantua, Palazzo Ducale 1977).

42–5 J. Müller Hofstede in BM 106 (1964) 442–50; in NKJ 17 (1966) 1–78; M. Jaffé in Proporzioni 4 (1963) 209–41; J. Held in BM 118 (1976) 775–7; G. Castelfranco in Boll. d'Arte 51 (1966) 83–5; J. G. van Gelder in BM 120 (1978) 455–7.

46 See 71.

52–4 O. Millar in BM 98 (1956) 258–67; O. Millar, *Rubens, the Whitehall Ceiling* (London 1958); J. Held in BM 112 (1970) 274–81; B. Fredlund in GB 24 (1976–8) 43–50; K. Downes in BM 120 (1978) 167.

55 D. Dubon, *Tapestries from the Samuel H. Kress Collection* (London 1964); J. Coolidge in AB 47 (1965) 527–9 and 48 (1966) 67–9; in GBA 67 (1966) 271–92.

56 See XVIII.

57–8 J. R. Martin, CRLB 16 (1972); E. McGrath in Les Fêtes de la Renaissance 3 (Tours 1972) 173–86; in JWCI 37 (1974) 191–217.

59 C. Scribner in AB 57 (1975) 519–28; N. de Poorter, CRLB 2 (1978).

60 E. Haverkamp Begemann, CRLB 10 (1975).

61–3 M. de Maeyer in GB 14 (1953) 75–88; J. Müller Hofstede in JBM 12 (1970) 61–110.

64–5 J. Neumann in Jb. Kunsthist. Inst. Graz 3/4 (1968–9) 73–134.

66 J. Müller Hofstede in Zeitschr. f. Kunstgeschichte 28 (1965) 69–112.

68 H. Vlieghe in CRLB 8/1 (1972) 73–8.

71–2 J. R. Martin, *Rubens, the Antwerp Altarpieces* (London 1969); S. Heiland in BM 111 (1969) 421–7.

74–5 J. Bialostocki in AB 46 (1964) 511–24; J. R. Martin (see 71–2).

76 F. Kimball in BM 94 (1952) 67–8; J. Held in Philadelphia Museum Bulletin 59 (1963) 16–32; C. Dempsey in JWCI 30 (1967) 420–25.

78 Berlin, Gemäldegalerie, *P. P. Rubens* (1978) 79–86.

79 A. E. Popham in BM 94 (1952) 237.

80 See XV.

84–7 M. Jaffé in BM 98 (1956) 314; M. J. Lewine in AB 45 (1963) 143–7; J. R. Martin, CRLB 1 (1968); G. Smith in Jb. Kunsthist. Samml. Wien 65 (1969) 39–60.

89 C. van de Velde in JKMSK (1975) 245–77; K. Fremantle, *The Baroque Town Hall of Amsterdam* (Utrecht 1959) 127–8.

90 See XXIV.

91 W. Burchard in BM 105 (1963) 428–32; A. Glang-Süberkrüb, *P. P. Rubens, Der Liebesgarten* (Kiel 1974).

OTHER INDIVIDUAL PAINTINGS

I. Bergstrom, *Osias Beert the Elder as a Collaborator of Rubens*, BM 99 (1957) 120–24.

L. Burchard, *Rubens's Feast of Herod*, BM 95 (1953) 383–7.

J. Held, *Rubens's Leopards*, Montreal Museum of Fine Arts Review 7 (1975) 5–11.

J. Held, *On the Date and Function of Some Allegorical Sketches*, JWCI 38 (1975) 218–33.

J. Held, *Rubens's Sketch for Buckingham Rediscovered*, BM 118 (1976) 547–51

M. Jaffé, *The Death of Adonis*, Duits Quarterly 11 (1967) 3–16.

I. Jost, *Bemerkungen zur Heinrichsgalerie*, NKJ 15 (1964) 175–220.

E. Kieser, *Rubens's Madonna im Blumenkranz*, MJ 1 (1950) 215–25.

R. Klessman, *Rubens's Saint Cecilia*, BM 107 (1965) 550–59.

G. Martin, *Rubens's 'Disegno Colorito'*, BM 110 (1968) 434–7.

J. Müller Hofstede, *An Early Conversion of St Paul*, BM 106 (1964) 95–106.

C. Norris, *The 'St Jerome' from Sanssouci*, BM 95 (1953) 388.

C. Norris, *Rubens's Adoration of the Kings of 1609*, NKJ 14 (1969) 129–36.

A. Seilern, *An 'Entombment' by Rubens*, BM 95 (1953) 380–83.

Abbreviations. AB, Art Bulletin. AQ, Art Quarterly. BM, Burlington Magazine. CRLB, Corpus Rubenianum Ludwig Burchard. GB, Gentse Bijdragen tot de Kunstgeschiedenis. GBA, Gazette des Beaux-Arts. Jb., Jaarboek, Jahrbuch. JBM, Jahrbuch der Berliner Museen. JKMSK, Jaarboek, Koninklijk Museum voor Schone Kunsten (Antwerp). JWCI, Journal of the Warburg and Courtauld Institutes. MD, Master Drawings. MJ, Münchner Jahrbuch der Bildenden Kunst. NKJ, Nederlands Kunsthistorisch Jaarboek. WRJ, Wallraf-Richartz Jahrbuch.

INDEX